The *Bicycle*

Designed and typeset by

agence comme ça, Paris

Edited by

Scott Steedman

Color origination by

Graphic Color,

Wasquehal, France

Printed by *Aubin, Ligugé*

Bound by *Diguet-Deny,*

Breteuil-sur-Iton

Flammarion

26, rue Racine

75006 Paris

200 Park Avenue South

Suite 1406

New York NY 10003

This book is dedicated to Cantinflas who, in the role of Passepartout, rides a high wheel bicycle in London

at the beginning of the film based on the Jules Verne classic, "Around the World in 80 Days." Many years after

I had begun my collection of bicycles I realized that my attraction to high-wheelers had started when at the age of seven I saw Cantinflas in this scene.

The *Bicycle*

by *Pryor Dodge*

Introduction by **David V. Herlihy**

Flammarion
Paris-New York

Contents

Introduction

by *David V. Herlihy*

Mention the word "bicycle" in the context of social or technological history, and the Gay Nineties are likely to spring to mind. Indeed, a century ago—at the dawn of the automotive age—the two-wheeler truly ruled the road. In the United States alone, some three hundred firms produced over a million cycles a year, making that prolific industry one of the largest in the nation. This celebrated machine was both a vital means of transportation and a wildly popular recreational amusement. It was, in short, the triumphant culmination of the age-old quest for a practical, self-acting vehicle.

Few inventions, in fact, have ever exerted such a profound influence on society. For women especially, the bicycle proved a great liberator—hastening the adaptation of "rational dress" and providing unprecedented personal mobility. It was also a most fruitful catalyst in industrial development. Much of the technology eventually used to mass produce automobiles, for example, was originally developed for the bicycle. And many of the great transportation pioneers of the early 1900s, such as Henry Ford and the Wright brothers, started their careers as bicycle mechanics.

No wonder social commentators of that day and since have lavished praise on this simple yet remarkably useful contrivance which has invited so little change over the years. "One of the world's great inventions" touted *The Atlantic Monthly* in 1896 (Crouch 11). Other contemporary reviews spoke glowingly of the bicycle as a "boon to all mankind" and a "national necessity" (ibid.) In later times, William Saroyan called it "the noblest invention of mankind" (Starrs 11), while Iris Murdoch pronounced it "the most civilized conveyance known to man" (Murdoch 29).

Clearly, there are many fascinating aspects to the "Golden Age" of cycling which gave us the modern machine. But viewed from a broader perspective, it was but one chapter in a rich tradition stretching from the French "boneshaker" of the 1860s to the American "mountain bike" of today. Indeed, the two-wheeler continues to play a vital—if somewhat more subtle—role in twentieth-century life. No longer restricted to the wealthy, it has become the primary vehicle for ordinary citizens in many parts of the world. Even developed countries accustomed to motorized travel are rediscovering its considerable merits as a cheap, efficient, and clean mode of transportation.

Cycling has also developed into a popular professional sport, especially in Europe, where the Tour de France started in 1903, as well as a favorite childhood pastime throughout the world. And in the past twenty years, it has even re-emerged in western countries as a popular form of adult recreation. Indeed, many citizens have discovered that cycling offers a healthy and welcome respite from the frantic pace of modern life. The latest craze in particular—the mountain bike, originally conceived for off-road use—has proved especially appealing to urbanites

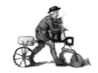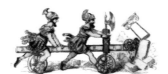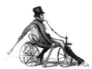

longing for outdoor exercise and adventure.

To tackle the full history of this remarkable invention is thus an ambitious undertaking. Yet Pryor Dodge, the author of this colorful work, succeeds brilliantly. His comprehensive, thorough, and exhilarating account addresses three basic questions at the core of bicycle history. First, how did the machine arrive at such a state of mechanical perfection? Second, why—its novelty value long spent—has it proved such a perennial attraction in so many different cultures and in so many roles? Finally, what can we expect from the bicycle of the future?

As the author so ably demonstrates, the latter issues are in fact contingent on the first. By exploring the technological evolution of the machine with such precision, sweeping away numerous longstanding myths and misconceptions, he reveals the bicycle's fundamental allure: its inherent simplicity, utility, and appeal. Let us briefly sketch here how the bicycle has been developed and adapted over the years to serve such a great variety of human interests and needs.

The primary impetus for an efficient mechanical vehicle was the restrictive state of personal transportation. Even as late as the early nineteenth century, the individual destined for a neighboring village had but few options. Those who could afford a horse or carriage rode, others simply walked. True, the industrial revolution had brought about many important advances in transportation, such as steamships and locomotives. But these were primarily useful for long-distance group travel. Left unfulfilled was one ancient and elusive desire: a practical, personal vehicle propelled by sheer muscular effort.

In a noble attempt to fill that void, the German baron Karl von Drais introduced his novel "aid to walking" in 1817. Drais appreciated that a mechanical vehicle with two wheels would encounter less resistance than a vehicle with three or four, as had been tried before, with little success. In the process, he discovered that the two-wheeler could be temporarily balanced at sufficient speeds, with the result that the rider could travel some distance before needing to resume his propulsion. The result was a mechanical vehicle of unprecedented promise.

The initial excitement, however soon gave way to disappointment as frustrated patrons discovered that every journey cost a pair of boots, a steep price to pay for a marginal gain in efficiency. Yet although the Draisine proved short-lived, it helped underscore the great potential for a practical "mechanical horse"—an ever-willing steed which never demands feeding. As one British magazine mused in 1819, "the proudest triumph of mechanics will be the completion of a machine without horses or other animals to drag it" (*Monthly Magazine*, November 1819).

The French pedal-powered bicycle of the late 1860s was that momentous breakthrough. True, certain British tricycles and quadricycles had achieved a modicum of success in the near half-century since the disappearance of the

Draisine. But these were no match for the two-wheeler's superior efficiency, or its more compact and economical design. Besides, they did not offer the opportunity to balance on two wheels, a seductive thrill which induced numerous athletic men and women to subdue the "fiery steed."

The distinguishing feature of the new design was the pedals attached to the front axle, which allowed for steady and continuous travel. Not only did this simple modification do away with the tiresome need to strike the ground, it opened an entirely new and encouraging path of development. In retrospect, the core discovery seems almost obvious—yet it was not. As a contemporary observed in *Scientific American*: "One of the most surprising feats of practical mechanics is that a carriage with but two wheels, propelled by the feet of the rider by simple crank motion, should maintain an upright position" (23 September 1868).

For the first time, it actually seemed possible that a mechanical vehicle might someday replace the horse, at least in certain situations. Keenly sensitive to this rivalry in the making, the nascent bicycle industry drew on equestrian imagery to help its revolutionary product vie for popular affection. Early races, for example, were invariably modeled after horse meets, complete with "jockeys" in traditional garb. And like many earlier Draisines, the machines themselves occasionally sported animal heads or tails.

No doubt such clever marketing ploys enhanced the friendly, almost lifelike, aura of the two-wheeled novelty. But of course the bicycle's future ultimately depended on its ability to deliver a practical and enjoyable means of transportation. Clearly, enthusiasm would not last long if the vehicle remained in such a primitive state. After all, there were still many fundamental inconveniences besides the excruciating ride. Manuals, for example, cheerfully instructed cyclists to march their bicycles up hills, leaning on them like a cane for extra support. And long-distance travelers were advised to keep an oil can handy so that the wheels could be re-greased every few hours.

By the early 1870s, with the introduction of the British high-wheeler, most of these technical obstacles had been overcome. Not only did this peculiar new profile (inspiring the whimsical moniker "penny-farthing") allow for faster speeds, but the bicycle's construction was also radically improved. Indeed, many of the basic features which would make the safety bicycle such a resounding commercial success were perfected in this period. These essential innovations included tubular frames, wire tension wheels, ball bearings, and rubber (though not as yet inflatable) tires.

At last, the bicycle proved itself of permanent value independent of fickle fashion. It could now be ridden pleasurably over a hundred miles in a single day, attracting legions of wealthy, athletic male practitioners the world over.

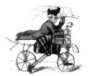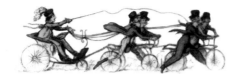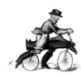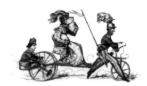

In 1884, the American Thomas Stevens dramatized the bicycle's great progress with his celebrated voyage around the world. The cycle industry had finally settled into a stable, albeit still relatively modest, niche.

Yet, despite its evident progress, the bicycle still fell short of delivering its original promise: a practical vehicle for the general population. Women in particular, who had responded so enthusiastically to the boneshaker, were effectively shut out. Children and the elderly were also generally excluded. Although cycle makers tried to appease these "outcasts" with less intimidating alternative designs such as tricycles, such marketing initiatives won limited success. An enormous pool of would-be cyclists awaited impatiently for the advent of a truly practical bicycle.

The English Rover "safety" bicycle of 1886, with its rear chain-drive and strikingly modern profile, proved to be that coveted machine. As its maker justifiably boasted, it truly "set the fashion to the world" (Clayton 25). Shortly thereafter, Dunlop's inflatable tire added unprecedented comfort and efficiency, and thus the bicycle finally fulfilled its original promise. Public reaction to the new machine was swift and staggering, shocking even cycle industry magnates. Almost overnight, the beloved highwheeler disappeared, and an unprecedented demand for the new design exploded worldwide.

Since this "Golden Age" bicycle technology has, of course, continued to progress. The last century has witnessed, for example, the development of remarkably resilient multiple-gearing systems, as well as ever lighter and stronger frame materials. Pedal power has also been extended in intriguing new directions. In 1979, the *Gossamer Albatross*, a human-powered airplane, completed an historic flight across the English Channel. More recently, a horizontal bicycle named *Cheetah* exceeded the legal speed limit. No doubt there will be many more exciting cycling innovations ahead, as people find new ways to exploit this extraordinarily versatile and fertile technology.

Indeed, the bicycle has now reached such an advanced mechanical state that the quaint machines of earlier times, so vividly illustrated here, might seem woefully removed from the modern era. Yet the author proves to us that there is indeed a continuity to this long, rich, and colorful history. Even at the dawn of cycling, certain visionaries had already identified the bicycle's fundamental and timeless qualities. One astute American writer confidently predicted during the original cycling craze of 1869 that the bicycle would outlast the initial fad. In the first place, he insisted, it would acquire ever greater utility. But most importantly, the new sport would never die: "The bicycle will always hold a fascination for those who enjoy athletic sports; there is an oddity and an audacity about the machine that will commend it to that large and growing class of people who love fun" (*Cincinnati Commercial*, 11 January 1869).

Before *the Pedal:*
Running
Machines

The inventor of the earliest two-wheeler was a member of the nobility, a baron from Karlsruhe, Germany: Karl Friedrich Drais von Sauerbronn (1785–1851). Son of an important judge in the grand duchy of Baden (and godson of Karl Friedrich, the grand duke himself), Drais became, at the young age of twenty-five, a high-ranking forest official. His real passions, however, lay elsewhere; taking leave from his less than onerous duties, he experimented in a range of technologies. The application of technology to industry in the service of a growing consumer market—what we call today the Industrial Revolution—only developed in Germany after the Napoleonic domination of Europe ended in 1815. But well before this date aristocrats such as Drais were already experimenting with new applications of technology. Drais himself devised a submarine, a periscope, and a typewriter-like apparatus for writing piano music and coded script.

In 1813, Drais invented a *Fahrmaschine* (Driving Machine), a four-wheeled, foot-propelled carriage capable of transporting up to four people. When, following the defeat of Napoleon, the Russian czar passed through Karlsruhe on an official visit, Drais was able to demonstrate his invention. For centuries, czars, kings, and queens had enjoyed the exclusive privilege of awarding patents to individual inventors; in this instance the czar, noting the ingenuity of the machine, rewarded Drais with a diamond ring. The baron's own emperor

To speed up my trot

And to save some time

A machine I bought

Made by Drais in Mannheim

Far left: Draisine illustration from von Drais's prospectus sent to the Prince of Fürstenberg.

Left: Plan of a Draisine from the Prince's prospectus.

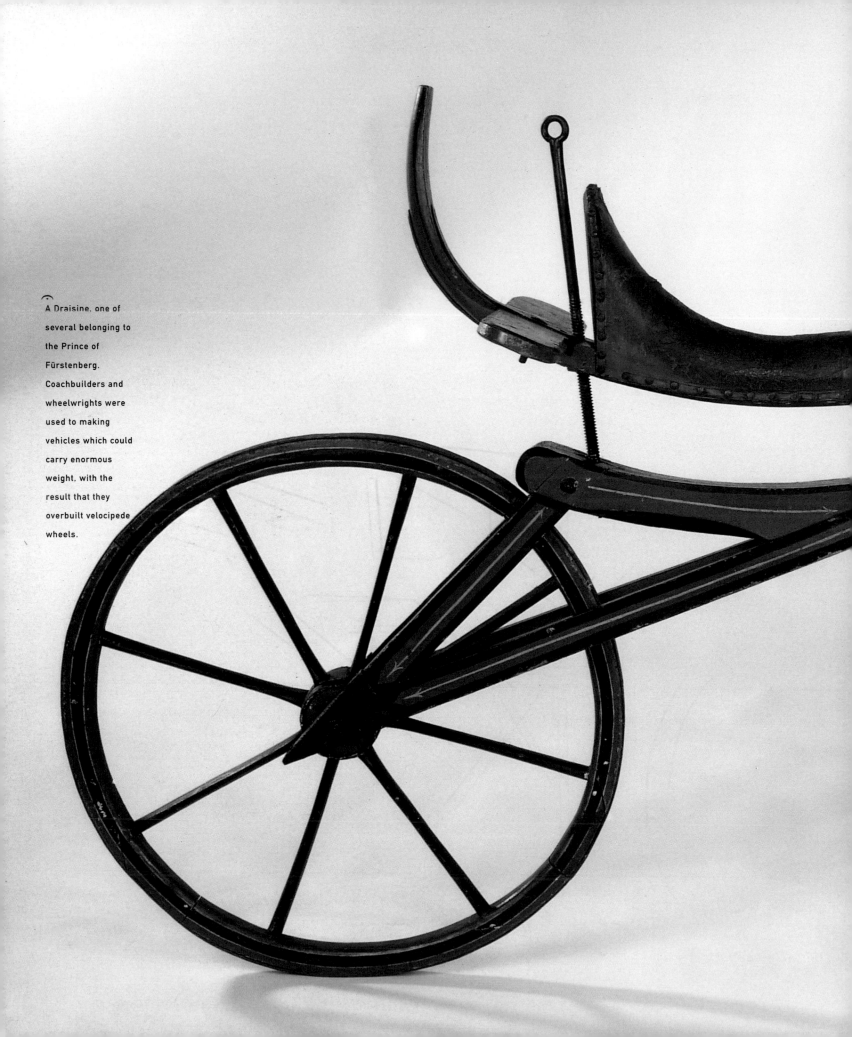

A Draisine, one of several belonging to the Prince of Fürstenberg. Coachbuilders and wheelwrights were used to making vehicles which could carry enormous weight, with the result that they overbuilt velocipede wheels.

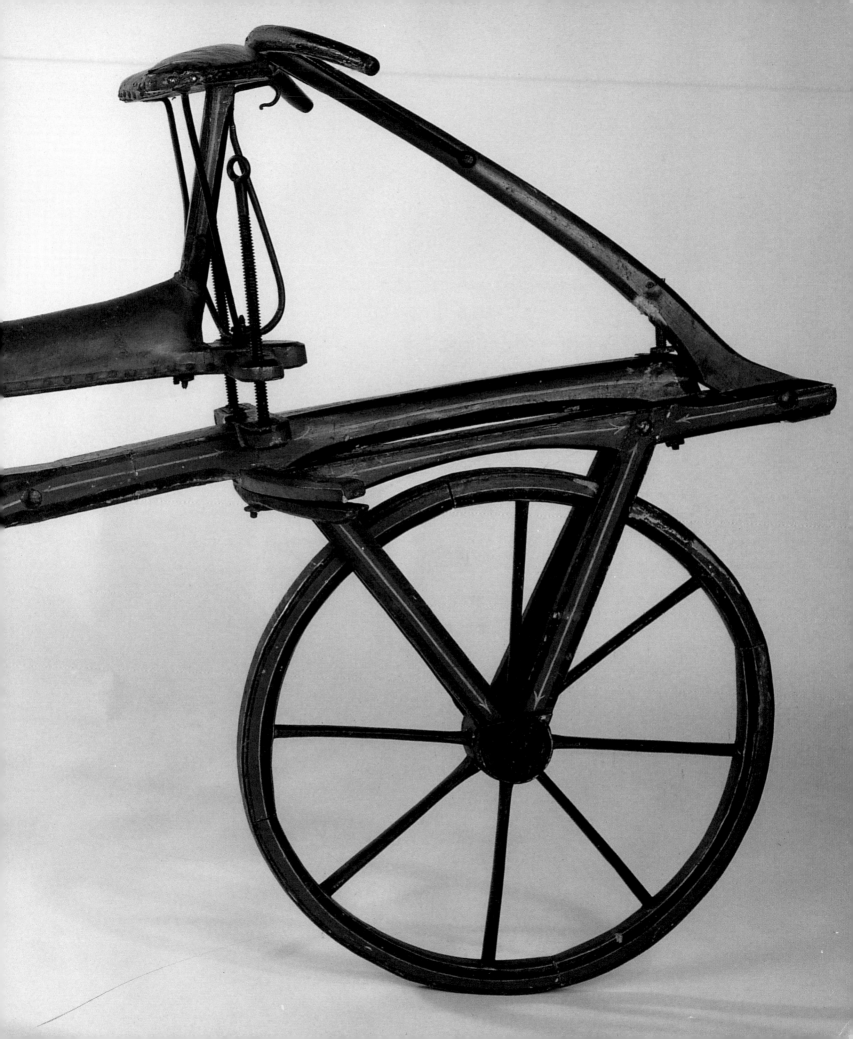

in Vienna was less impressed, refusing to issue a patent.

Undeterred, Drais constructed his *Laufmaschine* (Running Machine) in 1817. This vehicle had an upholstered seat and two wooden wheels connected by a wooden beam. The rider straddled the beam and propelled himself with his feet against the ground, steering with the front wheel while leaning his forearms on the upholstered balancing board to maintain equilibrium. The original design included a brake on the rear wheel which could be activated by pulling a leather cord attached to the balancing board.

On Thursday 12 June 1817, Drais tested the Laufmaschine on a trip from Mannheim to Schwetzingen and back, a total distance of nine miles. He

January 1818. The baron painted his vehicles either yellow or orange, the colors of the grand duke's coat of arms, perhaps in honor of his patrons.

From the beginning, Drais had conceived his invention as a serious commercial proposition. He distributed a prospectus with a description of how the machine functioned and a list of the different models that were to be made available, complete with their dimensions. He quickly obtained a patent in Paris for the machine, and the French version of his prospectus, although abridged, listed such accessories as an umbrella or parasol, a sail to take advantage of the wind, lamps, and other finishing touches available by special order. In analogy to the express coaches known as *vélocifères*,

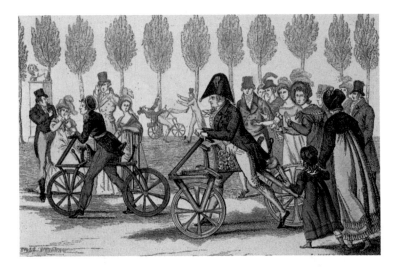

completed the round trip in under an hour, less time than it took the mail-coach. Drais immediately requested a patent from Vienna, only to be turned down again. So he sought the support of the grand duchess of Baden, whose patronage helped him secure his first privilege—valid only in the duchy of Baden—on 12

the name Laufmaschine was translated as *vélocipède*. This term appeared in the French patent, and was frequently used in Britain and the United States. Colloquially, however, the machine was named after its inventor, and was known in Germany as a *Draisine* and in France as a *Draisienne*.

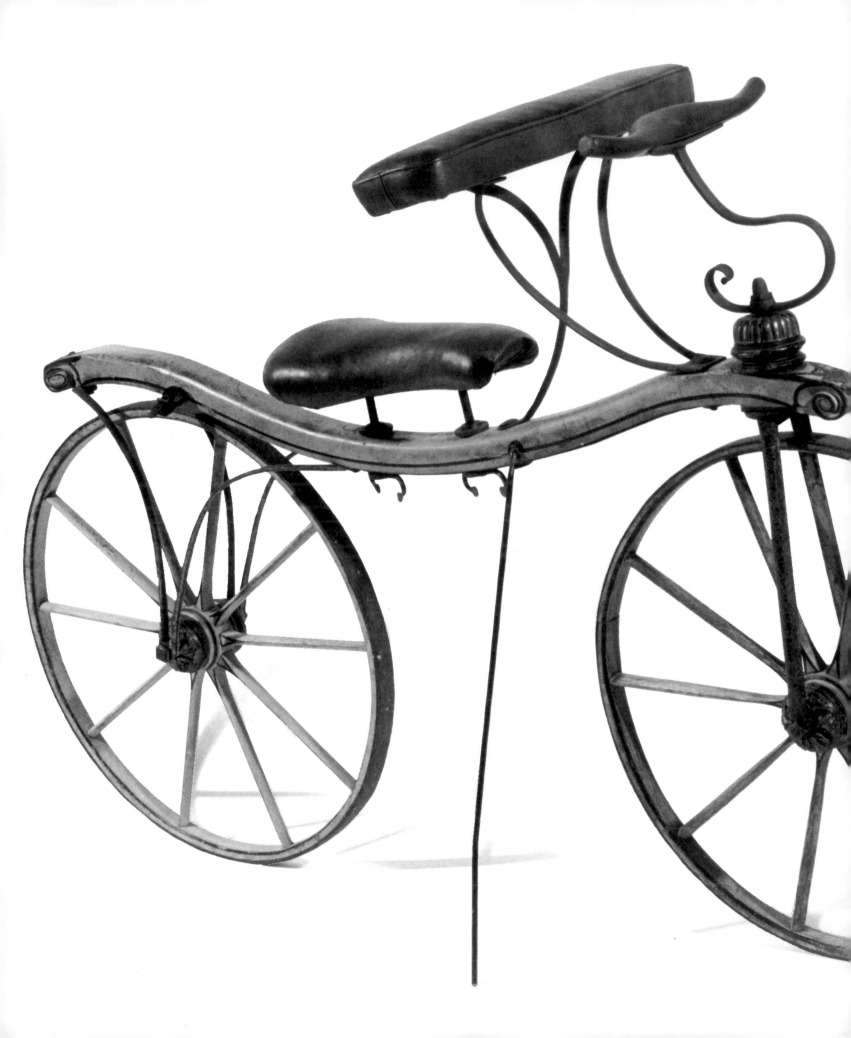

As Drais considered his leave of absence from civil service to be only temporary, he did not enter into manufacturing the invention himself, an activity that in any case would not have been acceptable in his position. Instead the inventor engaged cartwrights to help produce Draisines for his clients. Since his privilege was valid only within Baden, beyond the duchy's borders, in the more than 350 separate jurisdictions of which Germany was comprised after 1815, Drais could only rely on the honor of those possessing his prospectus to pay him a royalty upon having a Draisine made by a local cartwright. As proof that a machine was authentic, he supplied the owner with a silver plaque bearing the Drais family coat of arms, stamped with either the owner's initials or a number corresponding to a certificate bearing the owner's name.

Unfortunately for Drais, his running machine was of such a simple, carriage-like construction that it proved easy to copy, and it soon became difficult for him to protect his commercial interests. Within three months of the baron's first ride, similar models were becoming popular in cities as far away as Dresden and Leipzig. In Vienna, ballerinas even danced with Draisines, thus associating the vehicle with an aesthetic lightness of movement. The machines which appeared in Milan were illegal, since a police order of September 1818 forbade the use of velocipedes in the city center. Nicéphore Niepce, the inventor of photography, is known to have ridden a Draisine in France. It was probably made locally to a modified design

Far left: Denis Johnson hobby-horse. Number 100 was purchased by Sir John Leicester of Tabley in the spring of 1819 for £10.

Left, top to bottom: Detail of Denis Johnson's name plate on hobby-horse number 25.

"Stop Him Who Can!!" Print. London, 1819. As Denis Johnson was the only manufacturer known to have patented a hobby in England, the rider in this print must be none other than Johnson himself.

Pedestrian hobby-horse. Staffordshire plate, c. 1819.

incorporating some of Niepce's own improvements.

In the early nineteenth century, Paris was the cultural center of Europe, and a fashionable new technology like the Draisine had to prove its worth in the French capital. Drais's French agent, Garcin, arranged its first public demonstration in the form of a race in the Luxembourg Gardens on 5 April 1818. The occasion was to be a charitable benefit for the victims of a recent fire at the nearby Théâtre de l'Odéon. Over thirty-five hundred people attended, including such notable figures as the diplomat and historian Count Louis-Philippe de Ségur. Drais himself was unable to attend and sent his manservant who, inexperienced at riding the machine, kept having to jump off and push. This ineptitude meant that he barely stayed ahead of the following crowd, leaving Ségur to comment dryly that, "To my great surprise, I saw a rider on a saddle between two wheels, who only kept them turning by constantly pushing against the ground with his feet" (Kobayashi, 1993: 42).

As might have been expected, a number of published engravings ridiculed the invention, and it was the subject of several theatrical plays that ran for some months. But not all the spectators were critics or skeptics, and enough people were interested for Garcin to establish a small rental business. Appropriately enough, he rented his Draisines from a riding academy he created near Monceau, one of the first instances of the overlap between early forms of bicycling and horse riding. Garcin also hired out Draisines at fairs on the outskirts of Paris during the summer of 1818. In the fall, Drais himself finally arrived to help his agent, giving a much more successful demonstration in the Tivoli Gardens near Saint Lazare on 21 October.

An unauthorized copy of the Draisine appeared in England when a certain Bernard Seine of Mannheim took Drais's prospectus with him on a trip to Bath. There Seine rode about on a running machine made locally according to the original design. Velocipedes were soon all the rage in the fashionable spa town. For the next few years the gentlemen of Bath rode Draisines in the outlying hills as part of their health regime, making short trips of twelve to fourteen miles and day trips of up to forty.

But the Draisine was not used for exercise alone. In early December 1818, a London coach builder, Denis Johnson of Long Acre, acquired an unauthorized copy. Within weeks he had submitted a patent application for a "pedestrian curricle or velocipede," described as "a machine for the purpose of diminishing the labour and fatigue of persons in walking, and enabling them at the same time to use greater speed" (*Boneshaker* 77, 1974: 192). The machine was known, more appropriately perhaps, as an "accelerator," but soon took on a name which evoked the mode of transport it was destined to replace—"hobby-horse" (named after the child's toy and sometimes shortened to hobby) or "dandy-horse" (which

Left: "Family Party takeing an Airing." Print by T. Tegg. London. 24 March 1819.

Right, from top left: "Match against Time or Wood Beats Blood and Bone." Print by T. Tegg. London. 17 April 1819.

"The Ladies Hobby." Print by J. Hudson. London. 21 May 1819. The rider's feet activate two long boards used as treadles to turn a cranked axle.

"The Ladies Accelerator." Print by George Cruikshank. London. 1819. Note the breast rests!

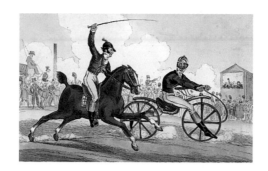

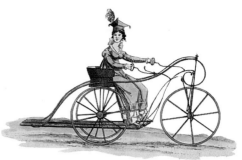

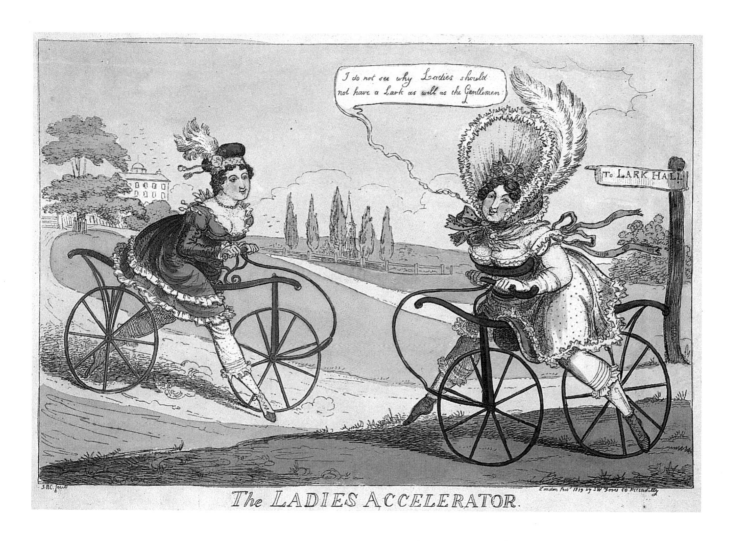

The *LADIES ACCELERATOR*.

referred to its aristocratic riders).

Each of Johnson's machines was stamped in roman numerals under the seat, and at least three hundred were made. His model was a marked improvement on Drais's design. It was less cumbersome, had more efficient steering, and was in appearance far more elegant due to the use of wrought iron, especially for the front and rear forks. But Johnson did not include a brake to the rear wheel, although he did introduce the first lady's model, said to possess "equal power with the Gentlemen's," and which had a drop frame to allow "the drapery [to] flow loosely and elegantly to the ground" (ibid).

Following the equestrian model, Johnson promoted his hobbies at two special riding schools in central London, on Brewer Street and the Strand, where he hired out machines and personally gave lessons. The Strand location was only a few doors away from the premises of J. Sidebethem, Jenkins and Ackermann's Repository of Arts. Along with T. Tegg and George and Isaac Robert Cruikshank, these printmakers created almost eighty different caricatures of hobbies and their riders, evidence of the reading public's fascination with and tendency to ridicule the hobby-horse. Several of these prints even caricatured women riding mechanically propelled two- and three-wheeled vehicles.

In the years after Johnson introduced the hobby-horse in England, a number of inventors experimented with variations on the basic design. In May and September 1819, Charles Lucas Birch produced

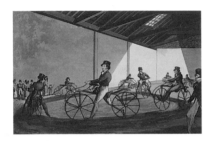

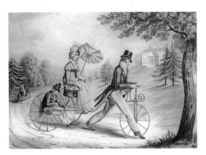

two curious contraptions—the Velocimanipede and the Manivelociter, also known as the Trivector—neither of which enjoyed much success. Nor was Hancock of Saint James's, London, more successful when he introduced the Lady's Hobby, also known as the Pilentum. This design was meant to encourage ladies to participate in the pastime, but its weight and inefficient mechanics made its use impractical.

In America, the hobby-horse fashion swept the eastern seaboard cities of Boston, New York, and Philadelphia, and riding schools soon opened. The London manufacturer Denis Johnson visited New York to promote his machines, and seems to have engaged a local agent, as hobby-horses quite similar to his appeared in Troy in the years thereafter. In New York City, the most popular area for riding was the fashionable Bowery district, although the truly adventuresome could continue south, coasting down the hill on Chatham Street to City Hall Park.

The fashion for hobby-horses, which came to be immortalized in illustrations and verse, lasted less than two years. By the end of the summer of 1819 the machine was attracting few new enthusiasts. Many had been discouraged in part by the inefficient and impractical aspects of the machine itself, and moreover by the poor condition of the roads. Frequently riders had taken to using sidewalks and footpaths, leading local legislators to prohibit the use of hobby-horses on sidewalks. Many riders refused to take responsibility for the accidents

and injuries they caused, often blaming the machine rather than their own recklessness. Perhaps most importantly, hobby-horse use was accessible only to the wealthier and more privileged classes, who were sensitive to the constant ridicule of their pastime in prints and newspapers, not to mention the inconvenience of torn coattails and worn-out heels.

In short, the first running machines failed to establish themselves as a useful item, even among the wealthy. It was not that hobby-horses proved too expensive: indeed, they were much cheaper than horses. In 1820s England, a riding horse cost about £40 to buy and between £30 and £40 a year to keep, while a hobby sold for about £10. But riders had

of those who could afford it.

One exception was Lewis Gompertz of Surrey, England, whose enthusiasm for the velocipede came in part from his radical interest in animal rights. A vegetarian who helped found the Royal Society for the Prevention of Cruelty to Animals in 1824, Gompertz was opposed to what he considered to be the abuse of working horses, and saw the hobby as a humane alternative mode of transport. Around 1820, he set about redesigning one of Johnson's models, adding a hand-powered drive mechanism to the front wheel. This used a ratchet system—a mechanism which up to then had been used only in clockwork—and was thus the first known example of a

expected too much from the hobby; some hoped it would actually replace the horse, at least for the purposes of leisure riding and individual transportation. Instead the hobby-horse, which turned out to be a far more strenuous ride than the quadruped, remained little more than a hobby for most

freewheel on a two-wheeler. This technological advance allowed the rider to move some distance under his own power without setting his feet to the ground—providing, of course, he managed to keep his balance. The rider thus needed to use his feet only as an additional form of propulsion

or to balance the hobby.

Gompertz's improvements, though innovative, still did not rekindle the public's flagging interest in hobbies. In 1821, he came to a conclusion about the rise and fall of interest in the machine, laying the blame for the failure of the hobby on the poor quality of the road systems:

It is worthy of observation, how much delighted the public were with the velocipede on its first appearance, and how soon it was thrown aside as a useless toy; the fault, however, seems not to be in the invention, but in the manner in which it has been received by those persons whose patronage they required, and by those also whose injudicious criticism they did not require, and chiefly owing to their having been prohibited the use of the footpaths, which, if necessary in some places, should

despite the continued popularity of the bicycle, the cause of the cyclist has not advanced significantly over a century and a half later.

Meanwhile, Drais's activities were curtailed when he left Germany for Brazil in 1820. His sudden and probably unwilling departure was undoubtedly linked to events that followed the 1819 murder in Baden of the playwright August von Kotzebue, a critic of one of the German student movements for national unification which had first formed in opposition to Napoleonic domination of Europe. Under Napoleon's reign, Friedrich Ludwig Jahn, one of the founders of the student unions, had initiated the gym sports movement to develop people's physical strength and boost their morale.

Left: Draisine with duck's head. c. 1819. Draisines decorated with carved animal heads such as serpents, horses, giraffes and crocodiles were also available, to the delight of the French public.

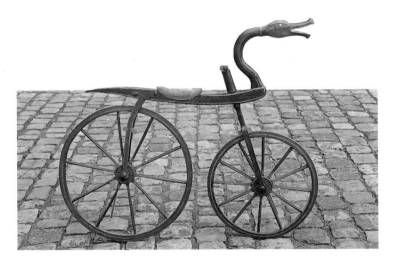

have been accompanied with an Act for allowing them three or four feet of the width of the roads for their sole use, and for that to be kept in very good repair; this they deserve. (Repertory of Arts, Manufactures and Agriculture, vol. 34, 1821)

This complaint at official inaction demonstrates how,

After Kotzebue's murder the authorities arrested Jahn, who they accused of masterminding the crime, and forbade all sports activities among students, suspecting that such events could serve as a pretext for further political mobilization. The edict probably included a ban on the use of Draisines, which had been

popular among students. As Drais's own father, a judge in Baden, did not intervene on behalf of Jahn, the students developed an aversion to the Draisine and its inventor, and Karl Friedrich was thus forced to leave Baden. By the time he returned to England in 1832, the fashion for Draisines had definitively passed.

A Period of Experimentation

The half century between the hobby-horse craze and the introduction of pedal-powered velocipedes was a time of imaginative experimentation in England, Europe, and the United States. Inventions and improvements in transport and communication both symbolized and served the progressive ideals

In England, publications such as *The Mechanic's Magazine* (founded in 1823 under the motto "Knowledge is Power") and *The English Mechanic* (which first appeared in 1865) disseminated information and drawings of early human-powered vehicles. Such magazines also provided forums for readers throughout the country to offer their observations and spread knowledge of their own improvements. The readers of these journals resembled Drais in spirit, although unlike him few were high-ranking members of the nobility. Rather, they were individual entrepreneurs, inventors working in backyards or small workshops, factory workers or professionals in various fields, all caught up in the technological magic of the coal-

A dandy, on a

velocipede,

I saw in a vision sweet,

Along the

highway making

speed,

With his

alternate feet.

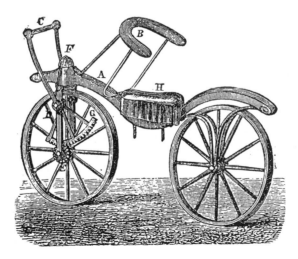

of industrialization. Railroads, transatlantic steamships, and the telegraph all appeared in a feverish atmosphere of change and progress. The same excitement surrounded the mechanics and inventors who tried, with varying degrees of success, to improve upon the hobby-horse.

and steam-driven processes of industrialization. What united them, above all, was the desire to use the new technology to unleash the full potential of human-powered transport.

Several inventors came up with interesting but impractical three- and four-wheeled velocipedes propelled mechanically by hand

and/or foot. Some were made for individual use; others were conceived to carry people, as an alternative to coaches. Thomas Bramley and Robert Parker of Surrey patented a tandem bicycle in 1830; this monstrous machine required virtually all the muscles of the body to put it into motion. Its appearance alone showed the extremes to which an inventor's imagination could stretch.

Inventions and ideas such as these found a forum in the new magazines. For example, the author of an illustration and description of a horseless carriage which appeared in *The Mechanic's Magazine* claimed that it could move "with ease at eight miles an hour, carrying two persons besides the one who conducted it" (17 April 1824). Years later one somewhat skeptical but interested correspondent wrote in response: "The pedomotive carriage of your ingenious Welsh correspondent seems to require rather too much labour for it to become very general, but might become very useful if contrived for one person only. As I am anxious to have such a carriage constructed for my own use, perhaps you would be kind enough to procure K. W.'s address for me" (6 March 1830).

In 1832, however, the editor of *The Mechanic's Magazine* decided that there had been enough speculation about the merits of human-powered transport. In an attempt to discourage further debate on the subject he wrote:

Going for a short distance at the rate of eight miles an hour is a very different thing from travelling for a continuance at the same speed. We

Right: Fantascope. Toy made by R. Ackermann & Co., London, 1833. This device was invented in 1832 in two countries simultaneously. In Belgium, Joseph Plateau invented the Phenakistoscope (Gr. "deceptive viewer"), while in Austria, Simon von Stampfer invented the Stroboscope (Gr. "whirling viewer"). Popular themes included a couple dancing, a child riding a see-saw, a horse trotting.

Said Tom to Dick, the other day,

As they stood gazing on the way;

Why, what is that-there thing,

There? 'tis strange I vow;

It seems two wheels with wooden spring,

Darnation! See it go!

Cries Dick, that's called Velocipede

A creature without tail or head,

That wants nor whip nor prick,

There's nought to do but on and kick,

Away 'tis gone full speed!

And will or stage or coach outrun,

In manner wonderful, indeed!

As very often it has done.

Well! well! but what is that astride,

There kicking so, and tries to ride?

Wounds! how the thing does pant for breath

'Tis dying, sure, a shocking death!

What! that, which looks there, stiff as brass?

'Tis nothing but a Dandy Ass!

do hold it to be impossible for an individual to travel faster in the long run, in a machine propelled by his own personal strength, than he would do by employing his limbs in the usual and natural way. Man is a locomotive machine of Nature's own making, and not to be improved by the addition of any cranks or wheels of mortal invention. The velocipedes which were in vogue several years ago had as fair a trial as invention ever had; and they were universally abandoned, simply because it was found there was nothing to be gained by them. (21 April 1832)

Undeterred by this editorial objection, the search for human-powered vehicles continued. A certain Mr. Franks, an optician from Hitchin, Herefordshire, wrote in a letter to *The Mechanic's Magazine* that, to assist him in his travels with his goods from town to town, he had constructed a three-wheeled horse made of "stout wood, tough iron, and bold brass" (13 November 1841). He found this to be a cheaper solution than keeping a horse and buggy. He averaged ten miles a day, propeling himself by hand lever which at first tired out his arms; but his chest measurement had increased by four inches and the circumference of his arms by two inches. He found his speed to be superior to a crack trotter: his best effort, he boasted, was to cover sixteen miles in one and a half hours from Newton Abbott to Exeter on 17 July 1841. In response to claims in the magazine that such vehicles could never be practical, he wagered quite confidently that he could travel forty miles a day

for six successive days on his "Mechanical Horse."

The small community of inventors and mechanics united by *The Mechanic's Magazine* occasionally found a wider public for their inventions in the daily newspapers, which reported on velocipedes if an unusual model had appeared on the streets, or, perhaps more frequently, if the velocipede was the cause of an "incident." One such "incident" took place in the Gorbals area of Glasgow and was reported, with a mixture of criticism and admiration, by *The Glasgow Herald* on 11 June 1842:

The Velocipede
On Wednesday, a gentleman, who stated that he came from Thornhill, in Dumfriesshire, was placed at the Gorbals police bar, charged with riding along the pavement on a velocipede, to the obstruction of the passage, and with having, by so doing, thrown over a child. It appeared, from his statement, that he had, on the day previous, come all the way from Old Cumnock, a distance of forty miles, bestriding the velocipede, and that he had performed the journey in the space of five hours. On reaching the Barony of Gorbals, he had gone upon the pavement, and was soon surrounded by a large crowd, attracted by the novelty of the machine. The child who was thrown down had not sustained any injury; and, under the circumstances, the offender was fined only 5s. The velocipede employed in this instance was very ingeniously constructed. It moved on wheels turned with the hand, by means of a crank; but, to make it 'progress' appeared to require more labour than will be compensated for by the increase

of speed. This invention will not supersede the railways.

Although the gentleman in question is not identified, bicycle historians often conclude that it was the blacksmith-turned-inventor Kirkpatrick Macmillan, on the basis that he was the first to fit a pedal mechanism to a two-wheeled vehicle. Yet the term velocipede had by then come to include three- and four-wheeled vehicles, and the one described by *The Glasgow Herald* was operated by a hand crank: thus it is very unlikely that it had two wheels and was driven by the feet.

Macmillan may indeed have subsequently built a velocipede, as witnesses attest to having seen it. One such witness, the wheelwright Thomas McCall, built a copy years later, around 1850. McCall's design included a treadle drive to the rear wheel, as did the *c.* 1847 invention of another Scotsman, Gavin Dalzell. Historians today continue to debate the individual merits of Macmillan and Dalzell. But the important point is that the invention of a balancing, two-wheeled, pedal-driven vehicle in Scotland bore no progeny, and therefore had no impact on the evolution of the bicycle.

One inventor who successfully marketed a practical four-wheeled vehicle in the 1850s was Willard Sawyer, a carpenter from Dover in Kent. Sawyer was already in business by 1851, when he rode one of his carriages from Dover to London (a distance of about seventy miles) to display it at the Great Exhibition at the Crystal Palace

in Hyde Park, an event attended by thousands of visitors from around the world. He also exhibited at the American Exhibition of 1854, and later at the relocated Crystal Palace in Sydenham, South London.

Sawyer's velocipedes were driven by a cranked axle on the front wheel operated by treadles with leather footstraps. The steering mechanism was coupled to the rear wheels. One machine weighed a mere 63 pounds, almost half the weight of similar carriages, and was finely engineered with close clearances. Sawyer produced a variety of models, and was quite successful at marketing them to different consumers. He offered a Sociable that could carry up to six people, all participating in the treadling, "thus realizing all the conversational charms and activities of pedestrianism, without its fatigue, and with the advantage of velocity into the bargain," as his publicity material assured (Ritchie 40). The Promenade and Visiting Carriage could be used by military officers, ministers, or lawyers, to allow them to extend the range of their activities; the Lady's Carriage offered dress protection; the Racer was built for speed; and the Tourist and Traveller model was "designed for persons of itinerant habits or avocations having more taste for freedom than ceremony" (ibid. 42).

Sawyer's fame and fortune grew enormously through his successful marketing of velocipedes. His clients reflect the continued aristocratic interest in the human-powered carriage. During a trip to Dover in 1857,

the Prince of Wales visited his workshop. The heir to the English throne subsequently purchased a carriage, which was delivered to Windsor Castle the following year. Sawyer also produced velocipedes for other members of European royalty, including the czar of Russia, the imperial prince of France, and the crown prince of Hanover, as well as various distinguished

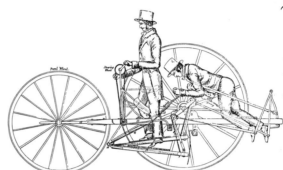

Left:
Bramley & Parker's
Specification
tandem, patented
4 November 1830.

people in Europe, India, Australia, and California. A catalogue published after 1858 stated that the Sawyer carriage "was the first, and is still the chief carriage of the kind used at the Crystal Palace, Sydenham being now in great request there by visitors of all classes for driving on the Grounds" (*Boneshaker* 73, 1973: 69).

Despite Sawyer's claims, however, the Draisine, or its later form as a human-powered carriage for several passengers, was clearly not accessible to all classes. Such vehicles were not only expensive, far beyond the reach of both working class and middle class consumers, they were also awkward and relatively inefficient. Only in the 1860s, with the introduction of cranks and pedals to the front wheel, did the velocipede begin to reach a wider public.

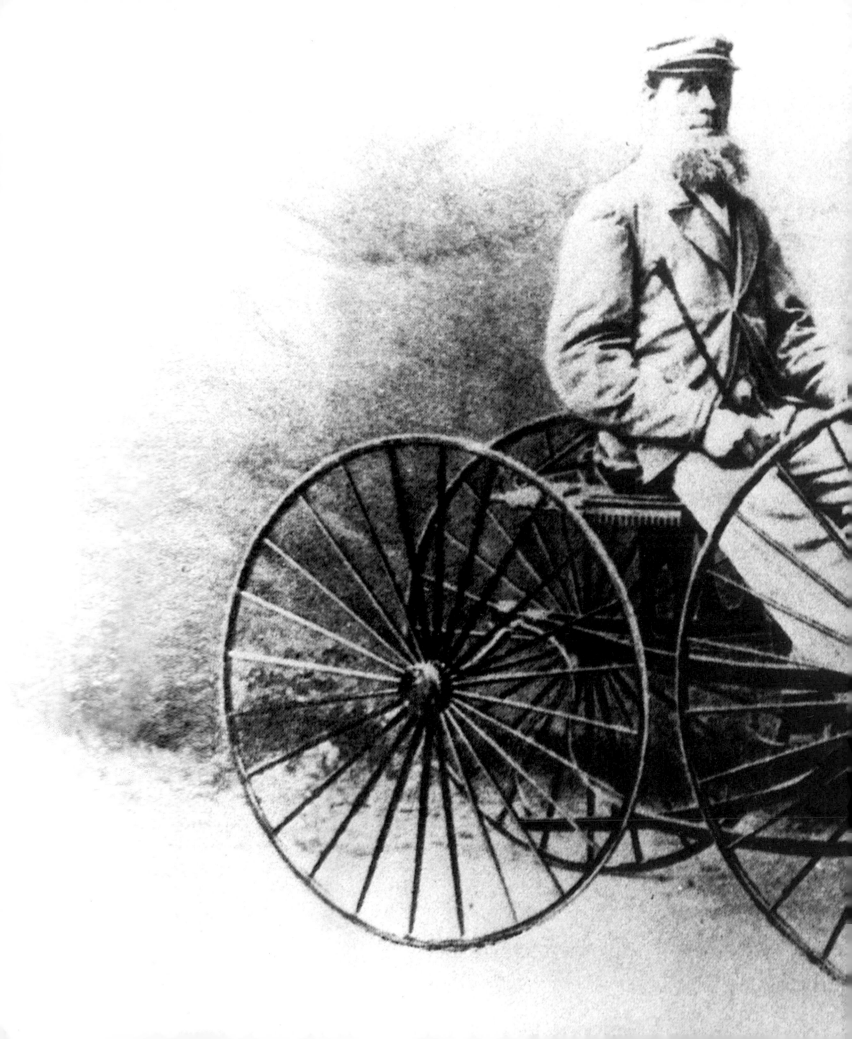

Left: Willard
Sawyer on his
Quadricycle.

C'est étonnant, Bientôt vraiment, On n'march'ra plus qu'à l'aide De son vélo, De son veci, De son vélocipède

The Velocipede: Introducing

the Pedal

The most important technological improvement to the Draisine was the addition of cranks and pedals to the front wheel. The result was the velocipede, the direct predecessor of the modern bicycle. But the simplicity of this innovation stands in stark contrast to the length of time it took to develop. Although the treadle-powered velocipede may well have been invented in Scotland in the 1830s, and cranks had been known for years (and even applied to three-wheeled

It is unclear who first attached cranks and pedals to the Draisine, thus creating the first pedal-powered two-wheeler. The answer remains buried in a mountain of contested claims put forth by manufacturers, historians of the bicycle, and amateur enthusiasts. Much of the debate over origins, which began in the 1880s, coincided with the growth of national sentiment and nationalist movements, and was motivated and distorted by feelings of national honor and pride. In particular, the antipathy

Left: Velocipede with eagle head, detail, and overleaf. George C. Miller of Chicago, c. 1870.

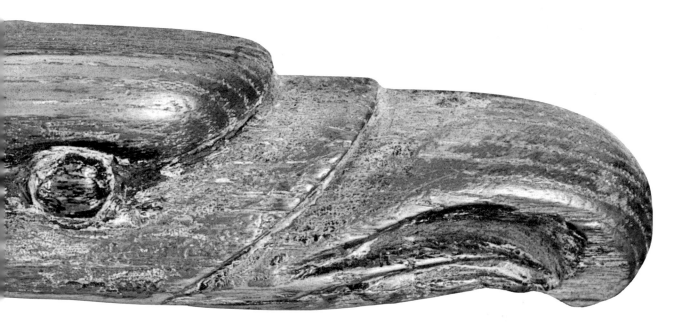

lady's hobbies), it was not until the 1860s that pedals and cranks became universally adopted, thus starting an international fashion.

Why were inventors so resistant to the application of pedals and cranks? Perhaps the experience of the defunct hobbyhorse made enthusiasts shy away from the concept of maintaining continuous balance on two in-line wheels. After all, most designs after 1823 involved three- and four-wheeled vehicles which, if complicated and cumbersome, were at least stable.

between Germany and France—originating in France's desire to recover her "lost daughters" Alsace and Lorraine, annexed by Germany in 1871 after victory in the Franco–Prussian War—led to several competing claims. In 1891, the Frenchman Baudry de Saunier published the first history of the bicycle, which conjured up an imaginary French count whose 1791 *célérifère* had supposedly preceded Drais's Laufmaschine. Two years later, as Germany was erecting a statue to Drais in honor of his invention,

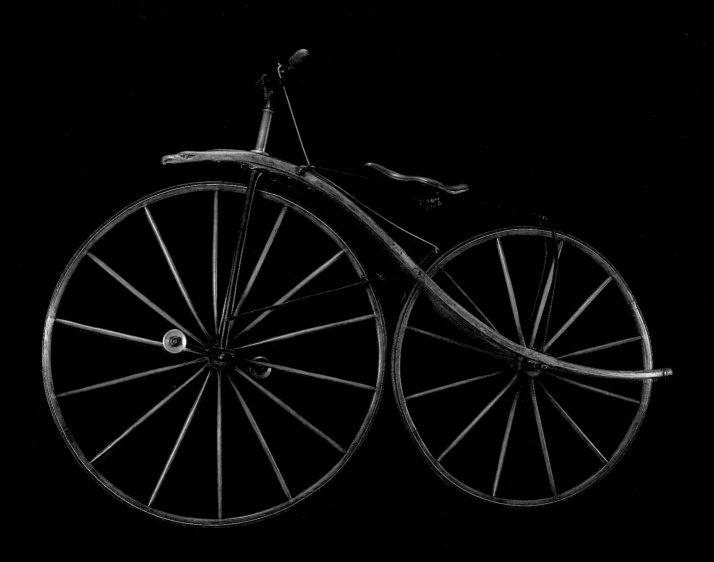

Henry Michaux sought to establish the claim of his father and brother, Pierre and Ernest Michaux, both ironworkers in the coach-building trade. Henry contended that they had added cranks and pedals to the front wheel of a Draisine brought to their shop in Paris for repairs in early 1861. As might be expected, this was countered by various claims. Some experts of a Draisine in 1862. Kech's machine was donated to the Königlich-Bayerische National Museum in Munich in 1888.

Recent research by the historian David Herlihy has added compelling support to the claim of the Frenchman Pierre Lallement. In 1863, the twenty-year-old Lallement was working in Paris for Stromaier, a children's carriage-maker. By his

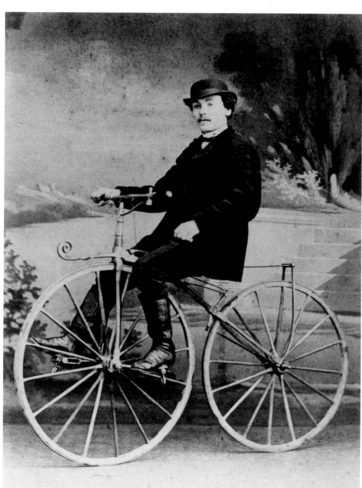

Far left: Lallement patent illustrating original serpentine frame. 20 November 1866.

Left: Pierre Lallement on a velocipede with a diagonal frame.

maintain that Alexandre Lefebvre of Saint Denis built a rear-drive velocipede in 1842 and took it to California in 1861 or 1862: the actual machine still sits in the San Jose Historical Museum. Another claimant is Karl Kech, about whom little is known; he claimed to have attached pedals to the front wheel own account, he constructed and then rode a pedal velocipede through the streets of the city. Two years later he left for America to seek his fortune, taking with him the components of a metal-framed version. He settled in Ansonia, Connecticut, and, on the advice of his new business partner James Carroll,

took out a patent for his velocipede—the first ever for such a vehicle—in 1866. There is, however, no indication that any such velocipedes were actually made. Lallement returned to Paris in 1867 or 1868 only to find that the velocipede business had gained momentum during his absence, and that the Michaux family, aided by the Olivier brothers, wealthy young engineers and cycling enthusiasts, had taken the lead in developing the market. In the spring of 1869, after selling his patent to Calvin Witty of New York, Lallement again attempted to manufacture pedal-driven velocipedes. But by then he was too late, and his business failed.

In May 1868, Pierre Michaux formally joined forces with the Olivier brothers to form Michaux & Company. The alliance gave Michaux an important influx of capital and business acumen, and turnover grew quickly. Soon the company was producing twelve velocipedes a day, each selling for around 200 francs. Michaux, however, controlled only 24 per cent of the company that bore his name, and after less than a year he was bought out. The company name then changed to La Compagnie Parisienne des Vélocipèdes. Michaux continued, illegally, to use the name of the dissolved firm, Michaux & Company, and resorted to still other forms of subterfuge in further attempts to regain his former stature and fortune in the velocipede business. But the Olivier brothers sued him, and Michaux ended up bankrupt.

Meanwhile, the fashion for

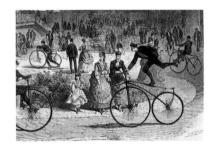

velocipedes had caught on, assisted by the 1867 Exposition Universelle in Paris at which velocipedes had benefited from an international exposure. At least two were on display. Carlo Michel, an Italian, is said to have bought a velocipede produced by Michaux and brought it back to Alessandria, near Turin. Members of the Turin Gymnastic Equestrian Club subsequently imported several machines, which were seen as "the last expression of the gymnastic desires of an uneasy generation" (*The Boneshaker*, vol. 13 no. 126, 18). In 1868, Italian coachbuilders began fabricating velocipedes, and soon the vehicles were being used in Turin's Valentino Park.

Other visitors to the 1867 exposition included Jacob Thonet, of the renowned bentwood furniture factory in Moravia, and Josef Pechácek of Bohemia. Thonet took home a velocipede for personal use, while Pechácek, after carefully examining the examples, succeeded in making three velocipedes for himself and his two brothers, which gained them a certain recognition. Another visitor, Josef Vondùrich, also built himself a velocipede, which he rode prominently at the head of a procession to celebrate the laying of the cornerstone for the National Theatre in Prague on 16 May 1868. These were the only known instances of velocipede production in Austria-Hungary, where no systematic production of the machine took place.

Rowley B. Turner, the Paris agent for the Coventry Sewing Machine Company of England,

Left, top to bottom: "Compagnie Parisienne." Print by Lemercier & Cie., Paris from "L'Illustration." 12 June 1869. A detailed view of Le Grand Manège de la Compagnie Parisienne with an early example of trick riding.

"Almanach Prophétique." Poster by Charles Vernique. Paris. In 1869, the annual poster for the Almanach anticipated the popularity of the velocipede.

Right: "Compagnie Parisienne." Print by Lemercier & Cie., Paris. c. 1869.

PETIT ATELIER D'AJUSTAGE
27, RUE JEAN GOUJON 27
PARIS.

VELOCIPEDES
COMPAGNIE PARISIENNE.

ATELIERS DE PEINTURES ET SÉCHAGE
12 AVENUE BUGEAUD, 12 (derrière l'Hippodrome)
PARIS

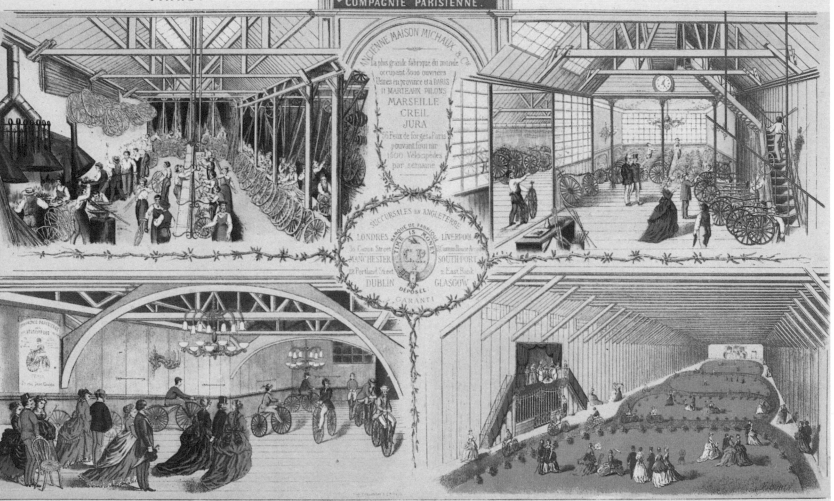

ANCIENNE MAISON MICHAUX & Cie
La plus grande fabrique du monde
occupant 8000 ouvriers
Usines en province et à PARIS
11 MARTEAUX PILONS
MARSEILLE
CREIL
JURA
36 Feux de forge à Paris
pouvant fournir
1500 Vélocipèdes
par semaine

SUCCURSALES en ANGLETERRE
MARQUE DE FABRIQUE
LONDRES LIVERPOOL
MANCHESTER SOUTHPORT
DUBLIN GLASGOW
GARANTI

MANÈGE COUVERT, 27 RUE JEAN GOUJON, 27.
SUPERFICIE 400 MÈTRES

MANÈGE D'ENTRAINEMENT AVENUE BUGEAUD AVEC PISTE EN ASPHALTE.
SUPERFICIE 3000 MÈTRES

was yet another visitor who developed a passion for the velocipedes he saw on display at the 1867 exhibition. He purchased one made by Michaux & Co. in the fall of 1868 and learned to ride it in the streets of Paris. Shortly afterwards he took it over to England, riding from the Coventry train station to his firm's factory, where he demonstrated it to the manager, his uncle Josiah Turner. The young Turner was back in England in early January 1869, delivering a Michaux velocipede to Charles Spencer's Gymnasium in London. There he dazzled onlookers with a demonstration of his acrobatics, as recounted by John Mayall of the Coventry Machinists, son of the celebrated English photographer John Edwin Mayall:

We were some half-dozen spectators, and I shall never forget our astonishment at the sight of Mr Turner whirling himself round the room, sitting on a bar above a pair of wheels in a line that ought, as we innocently supposed, to fall down immediately he jumped off the ground. Judge then of our surprise when, instead of stopping by tilting over on one foot, he slowly halted, and turning the front wheel diagonally, remained quite still, balancing on the two wheels.
(Woodforde 22-3)

In February 1869, Turner, Mayall, and Spencer set off on a ride from London to Brighton to test the capabilities of their machines. They had informed the press, and a reporter from *The Times* followed in a coach. Mayall rode the full fifty-three miles at a leisurely pace, taking about

fourteen hours; Turner and Spencer were less persistent, giving up just after half way and catching a coach at Crawley as soon as the reporter had turned back toward London.

Despite abandoning his discovery for the more traditional coach, Turner had a sense that the market for velocipedes was expanding at a rapid rate. In February 1869 he convinced his uncle that they should go into business producing velocipedes in Coventry for export to France. Initially, Turner expected to sell four hundred machines in Paris. His business premises there included a riding school at 110 rue Bonaparte, near the Luxembourg Gardens. Changing its name to the Coventry Machinists' Company, the English firm advertised its machines as "Vélocipèdes Américaines." Production started quickly, as did publicity. One advertisement not only vaunted the quality of the bicycles, but assured its Parisian clientele that it would discreetly assist them in learning to ride: "Coventry Machinists' Co. bicycles are acknowledged to be the best on the road. For quality of material, high class of workmanship and elegance of design, they are unsurpassed. Prices are extremely moderate. The extensive riding grounds are in excellent condition, and thoroughly screened from observation. Velocipedes on hire. Experienced, skilful riders in attendance to give lessons" (Advertisement in the *Coventry Standard*, 1 April 1986). Turner's inroads into the Parisian market were a promising start

Left: Female performer with her velocipede. c. 1869.

Right: Michaux Velocipede Tricycle. 1868. This extraordinary machine has an elaborately carved griffin's head. burlwood handgrips. and acorn pedals patented by Michaux in 1868. The pedals had an oil reservoir in the acorn— by kicking the pedal around. the oil lubricated the pedal axle. This machine was exhibited in the Exposition Rétrospective du Cycle at the Grand Palais in 1907. and was illustrated in the "Revue Mensuelle du Touring-Club de France" that reported on the exhibition.

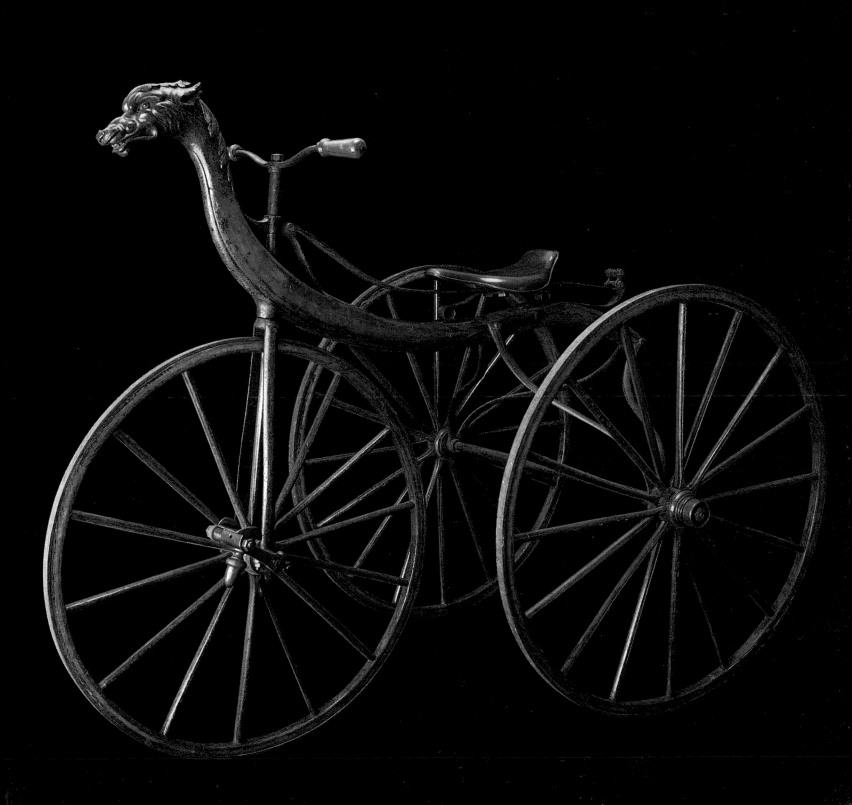

for bicycle manufacturing in England, and Coventry was quickly established as the cradle of the English cycling industry.

In Germany, two advocates of the velocipede, Ferdinand von Steinbeis of Stuttgart and Heinrich Meidinger of Karlsruhe (Drais's home town), worked closely with local government institutions to promote trade and industry. They exhibited velocipedes at the trade shows they organized, to encourage local manufacturers to reproduce them. According to advertisements for twelve manufacturers in the *Illustrierte Zeitung*, a Leipzig newspaper, production began at Tewes in Harburg in 1868. Within a year, producers were established in Stuttgart, Frankfurt, Hanover, Dresden, Berlin, and Leipzig. Heinrich Büssing, the most prominent manufacturer, began producing velocipedes at the age of twenty-two in Braunschweig; much later, he was to take an important lead in the manufacture of motorized buses.

By contrast with the enthusiastic reception which the velocipede received from the aristocracy in Paris, the machine met with great resistance in Germany. Foremost among its opponents were the engineers. Railroads, powered by steam engines, were regarded as state of the art—and the way of the future—in transportation. Moritz Rühlmann of the Hanover Polytechnic, in an engineering textbook of 1868, dismissed "all those who use human power for propulsion of such vehicles" as "people that have learned nothing or have forgotten everything" (Rühlmann

in Lessing 36). Discussion of cycling technology was banned from the pages of Hanover Polytechnic's journal for nearly a quarter of a century, by which time the cycling boom of the 1890s was well under way in Germany as it was throughout Europe and America.

Interest in the velocipede was keener in the United States. Carriage builders expanded their businesses to include the trade, and patent applications for different velocipede designs began piling up in Washington D.C., where nearly four hundred patent requests had been received by early 1869. One American entrepreneur, Calvin Witty, capitalized on the patent which Lallement and Carroll had taken out three years earlier. He contacted Lallement, who had returned to Paris, and purchased the patent from him. Witty then tracked down all the existing manufacturers and charged them a retroactive royalty of ten to twenty dollars on every velocipede they had made to the same design. He used the income generated to subsidize his own production, thus undercutting his competition by selling his machines at a lower price.

Just as Lallement had been slightly premature in his attempt to produce velocipedes in Paris, so his efforts in the United States proved too advanced for the market; ironically, shortly after his return to Paris, the demand for velocipedes in the United States began to develop considerably. Much of the interest was generated by the Hanlon brothers, a troupe of travelling gymnasts and acrobats who performed under

Left: Fashionable "vélocipédeuses." c. 1869.

Below: Hanlons' Patent Improved Velocipede. appeared in the "Scientific American." 19 August 1868.

Right: Betinet, "Mlle. Blanche d'Antigny and her velocipede." c. 1869. Blanche was a very famous and expensive courtisan. A dancer renowned for wearing tights, she posed nude for Courbet, and was the inspiration for Emile Zola's fictional character, Nana.

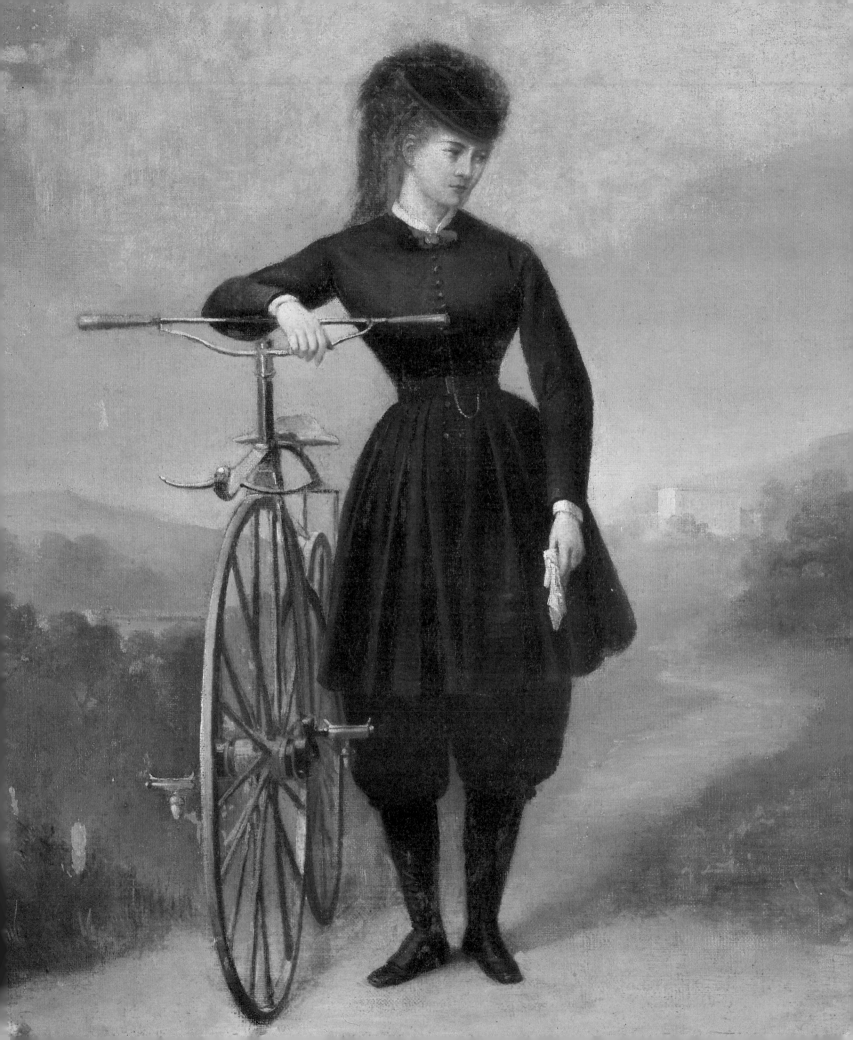

the name the Hanlon Superba. Not satisfied with adding the velocipede to their act, the brothers patented an improved version in 1868. Manufactured by Calvin Whitty, it had a simplified frame and cranks which were slotted to allow pedal adjustment according to the length of the rider's legs. The Hanlons soon developed a reputation as the best riders in the country, touring as far north as the Canadian provinces of New Brunswick and Nova Scotia. In 1869, an early bicycling magazine praised Frederick Hanlon as "a high-priest worthy of offering incense on the altars dedicated to the cause of velocipeding" (*The Velocipedist*, 1 February 1869).

Helped no doubt by the troupe's unrivalled opportunities for publicity, the Hanlons' velocipede rapidly became the best-selling model on the American market. It was not so popular among English enthusiasts, however, perhaps because of its high handlebars and the absence of a brake.

Instead English riders flocked to another American model, a velocipede manufactured by Pickering & Davis of New York from 1869 and marketed as the American Bicycle. The name was somewhat ironic, since Pickering had based his design on a model brought from Paris. His version was simpler, stronger, and cheaper; it was also substantially lighter than its Parisian counterpart, as the American manufacturer used hydraulic tubing in the reach or central section of the frame. The company also introduced a lady's model with a slightly dropped

frame. A special feature of both models was the saddle bar, a seat that also acted as a brake. By simultaneously pushing away from the handlebars and bearing down on the rear of the seat, the rider compressed a coiled seat spring, activating a brake under the seat which pressed against the rear wheel.

Canada's adventure with the velocipede began in the province of Ontario, largely thanks to Perry Doolittle, early cyclist, inventor, proponent of good roads, and race organizer, who became known years later as the "Father of Canadian Bicycling." His own infatuation with the velocipede began as a child when he rode a wooden tricycle on the streets of Toronto. In 1869, at the age of eight, he graduated to a two-wheeled velocipede, suggesting that manufacturers were already producing such vehicles in smaller versions as toys for the children of wealthy families. By the late 1860s, a number of

enterprising Canadian mechanics were building velocipedes for adults. John Turner, an iron and hardware dealer and machinist, made wooden and iron models, possibly based on magazine illustrations. At around the same time Michael & John Goodwin of Stratford began building "substantial constructed

conveyances made of the best malleable iron" (Humber 31). Soon there was a riding school, and in 1869 the sports program of the Victoria Day holiday was able to offer the Ontario public a new and exciting event: the velocipede race.

In the other Canadian provinces, velocipedes were slower in arriving. They were not officially introduced into Nova Scotia, a province on the eastern seaboard, until an exhibition of 1869 (though a Parisian iron velocipede had been sighted in the town of Caledonia a year earlier). Within months there were four riding schools in the capital city of Halifax.

Mastering the Velocipede

Learning to ride a velocipede was as much a test of a person's foolhardiness as of his or her skill. Most manufacturers had riding halls adjacent to their factories where prospective customers could try out the different models while learning the new art. The model for such riding halls was clearly equestrian: just as the upper classes had, for centuries, learned to ride horses in academies, so now they came to schools, halls, institutes, and outdoor rinks devoted to their latest pastime. These private spaces sprang up almost overnight from the late 1860s onwards, as the fashion for velocipedes developed. While strongly marked by their upper class clientele, riding halls and rinks allowed a slightly broader cross section of society to participate. The caliber of teachers, the quality of the

machines for hire, and the condition of the riding surfaces varied markedly, but these dedicated locations—known as velocipedariums or velocipedaria—offered conditions superior to public roads, and allowed riders to continue the sport during the winter months.

An account published by T. Maxwell Witham, who visited Charles Spencer's Gymnasium in London around 1868, gives a good idea of the difficulties involved in simply mounting the velocipede, not to mention riding it. Witham described how, "half a dozen men were learning to ride—apparently the process consisted either in running into each other and collapsing into a heap of struggling arms, legs and wheels, or running boldly into the wall" (Boneshaker 97: 12-14). To mount their vehicles, the men began by

running alongside the machine and vaulting into the saddle. That was what was aimed at, but the timid didn't give a sufficient spring and if they did not hit their knee against the end of the spring and come to grief they landed not on the saddle but on the back part of the narrow spring to which the saddle was fixed, and the bold jumped too vigorously and landed on the spring in front of the saddle or even on the handles themselves, and the lucky ones who landed in the saddle felt frantically for the pedals which they mostly failed to catch and came down sideways with a frightful clatter (ibid.)

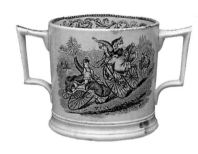

Fascinated by the activities at the gymnasium, Witham returned every day to put himself

Velocipede pedal,
detail, c. 1869.

through the same process as the others. "At the end of the week, although black and blue all over and sore in every joint, I could occasionally land in the saddle and wobble round the room" (ibid.) Witham described himself as an expert ice-skater with a strength and balance greater than most. His struggles and the pain incurred are indicative of the dedication, even fanaticism, of the large number of men and women who managed to learn how to ride.

Riders sought out velocipedaria because the poor condition of the roads posed a considerable threat to health and safety. When riding his new Michaux, Witham commented, he had to stop after half a mile, as his arms became paralysed from grasping the handles so tightly due to the jolting. As there were so few riders out and about at the time, Witham could usually identify who had ridden on the road before him by the amount of wobble left by the wheels' tracks.

The most important riding establishments in the United States included those run by the Hanlon brothers and the Sargent Company. The Hanlons' riding hall, located at the corner of Broadway and Tenth Street in New York, was the largest and one of the most popular in the city, furnished with twenty-five high-quality machines. Taking advantage of their talent as gymnasts, the brothers once gave a "Velocipede Reception and Hop" to exhibit graceful and daring feats to the public. Some of the spectators, including Charles A. Dana, editor of *The New York Sun* and an expert rider, demonstrated their own

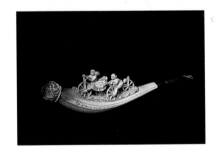

skills afterward.

The Sargent Company opened the first riding school in Boston; later there would be more than twenty in the city. They claimed to offer "thorough and complete" instruction where "all pupils graduate experts. . . . Six different sizes of French pattern velocipedes are used, and the scholar is advanced from one to the other, according to progress." The company also ran the best school for ladies, whose classes were "conducted in a properly private and exclusive manner." The women were provided with private dressing rooms and were taught by women teachers and assistants, "all under the direction of the best 'velocipedagogue' in the city," who was no doubt a man. In assuring its future clientele of its status as a reputable establishment, the Sargent company also let it be known that "many good old Boston names are to be found upon the list of pupils" (Goddard 88).

In Canada, a number of riding schools opened in 1869. In Halifax, Nova Scotia, indoor riding was available day and night at the City Market Building, the Variety Hall, and the Colonial Market. The Sons of Temperance also opened a riding school, quickly spotting moral advantages in such a healthy pastime. In Toronto, Grand's Riding Academy turned riding into a spectator sport, charging ordinary pedestrians twenty-five cents to stand in the center of the ring and watch the velocipedists circle around. As throughout Europe and the United States, many of these riding establishments were

converted skating rinks. This was true of both the Ontario Velocipede Rink and the Saint George's Rink, which stayed open from seven in the morning to ten at night, due to its enormous popularity.

During the summer of 1869, Professor Frank Marston, a skilful rider, made a tour of southern Ontario giving demonstrations as a way of introducing the new sport to smaller communities. Of his numerous tricks, one of the most impressive involved removing the handlebars, then taking off his coat and putting it on again while riding. He offered day or evening instruction on five machines, and even organized local races.

As might well be imagined, Paris was an important center of velocipedism, especially as the sport was closely linked to fashion. Riders went out as much to be seen as for the exercise and amusement. The costume of one Parisian dandy, described by an English magazine in 1869, clearly takes precedence over the machine:

Velocipedes have become quite a social institution in Paris, and velocipeding as necessary an accomplishment as dancing or riding. The 'véloceman' can be observed on his way to the Pré Catalan [a circular path in the Bois de Boulogne] where a velocipede race is to take place. His hat in the shape of a small saucer, his gilet en coeur, fastened by a single button, displays a shirt with stand-up collar starched to the consistency of a breastplate. Cuffs to match are turned back outside the sleeves of this coat which reaches to his hips and is of a pale pea-soup

colour with pants so tight one wonders how he got them on and boots up to his knees (The Girl of the Period Miscellany, May 1869).

One also wonders how he mounted and dismounted his machine.

Another anonymous English book from 1869, *The Velocipede, How to Use It*, gives a taste of the Parisian mania in greater detail, suggesting that the vehicle was not just for recreational activities:

Government employees living in the suburbs ride to their offices every morning on the new iron horse; a hint to dwellers on certain suburban lines of railway on this side of the Channel. You may see them on

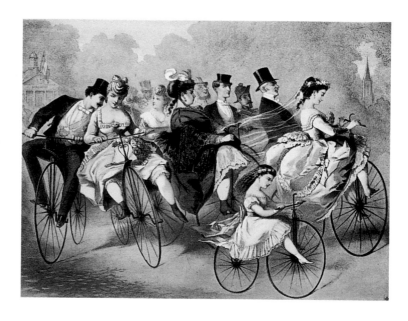

their return journey at night, steering in between the throng of carriages with lighted lanterns swinging in front of them . . . and several of the collecting clerks of the Bank of France have begun to use them. . . Paris is in a perfect state of frenzy with respect to its new toy. The newspapers call upon the Government to order a supply of

Velocipedes to save the overworked legs of the rural postmen and of the messengers attached to the provincial telegraph bureaux; and even advise a limited number of these vehicles being furnished to infantry regiments, to enable outposts to reconnoitre and to communicate rapidly with the main body of the army; and, moreover, that country doctors and curés who cannot afford the expense of a horse should travel about on the new vehicles, which, by the way, have already penetrated to the provinces, for seaside loungers, mounted on them, were to be seen at all the Norman and Breton watering-places, and on the shores of the Mediterranean. Artists use them to go on sketching-tours, and photographers employ them on distant exhibitions. Guests at country châteaux organise races with velocipedes among themselves, just as in England they do games at croquet.

noted. Indeed, had the French infatuation with the machine not come to an abrupt end in 1870, with the outbreak of the Franco-Prussian War, many of the uses suggested by the French newspapers might well have been put into practice. As it was, these new uses would have to wait several decades.

The Birth of Cycle Races and Cycling Clubs

As riders became more competent and confident and their machines more sophisticated and efficient, cyclists began comparing their skills and their steeds in organized settings. Manufacturers and local civic committees arranged races, held either on tracks like those for horse races, or over longer

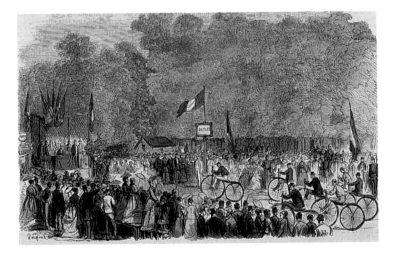

Beyond the entertainment value of Paris' new "toy," this English commentator pointed out many practical applications of the velocipede in an increasingly mobile society. Unlike the hobbyhorse, the velocipede appeared to be a viable transportation alternative to the horse, as more than one writer

distances on roads. The first documented velocipede race in France—arguably the first in the world—took place on 8 December 1867. Around one hundred riders left from the Champs Elysées to finish at the entrance to the Château de Versailles, a distance of about fourteen miles. A second race

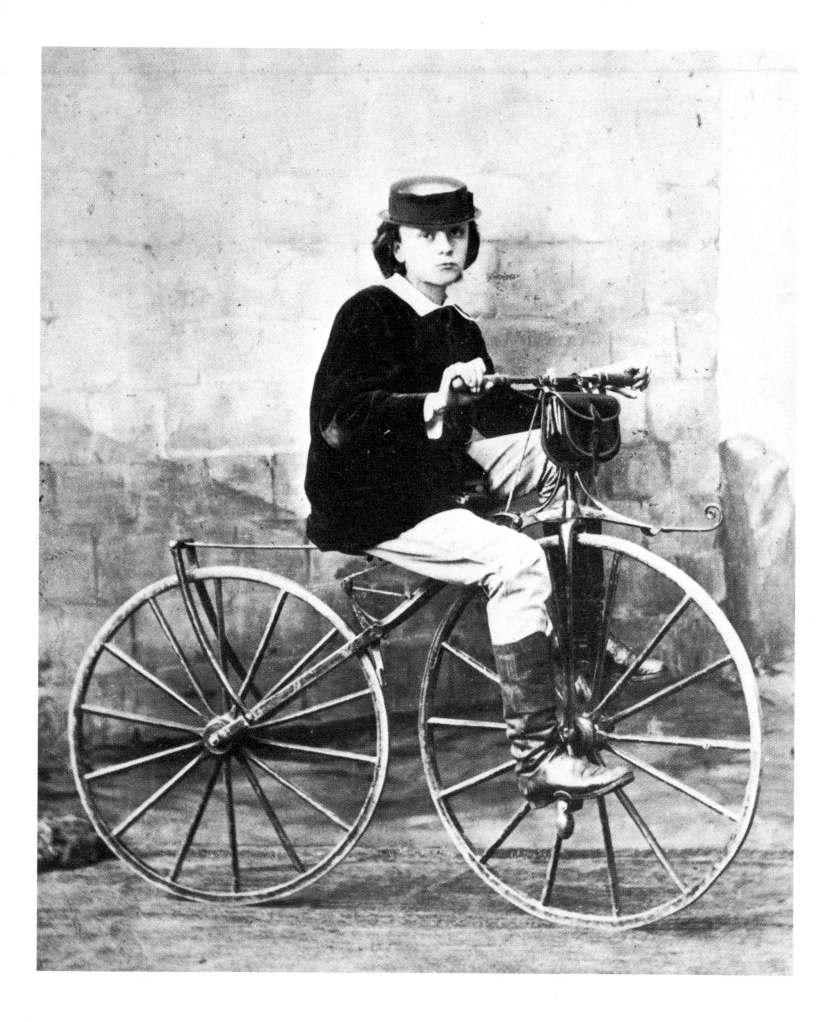

in Paris was held at the Pré Catalan, in the Bois de Boulogne, on 24 May 1868. But the turning point occurred a week later, on 31 May 1868, at the celebrated races held at the Parc de Saint Cloud, a western suburb of Paris. Watched by a large crowd, the Englishman James Moore, riding a Michaux, won his first race. As the event was organized in conjunction with the festival of Pentecost, a concert, fireworks, and an evening ball in the park followed.

Inevitably, velocipede races were modelled on horse races. Both the riders and the organizers adopted familiar accoutrements: brightly colored silk jockey caps, jackets, flags, and banners. In the same way as horse-racing spectators marvelled at the physique of horses, so the velocipede-racing public admired

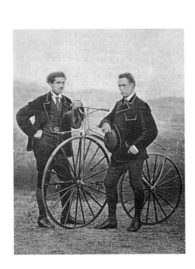

the riders' legs. Velocipede races, like equestrian events, fell into two groups. There were sprints, where the greatest speed was rewarded with victory; and slow races, not unlike horse shows, that tested the rider's balancing skills and ability to go through obstacle courses, often riding "no-handed."

Issue number one of *Le Vélocipède Illustré*, an important cycling magazine, was published in Paris on 1 April 1869. Its editor, Richard Lesclide, advocated a long-distance race, which René Olivier of the Compagnie Parisienne agreed to organize. Following the route from Paris to Rouen, a distance of seventy-six miles, the race was a huge success, due in part to precise rules and a detailed map published by Olivier. The race was to prove that the French velocipede, "an articulated horse, consuming more oil than oats" (Laget 16-17), was a viable transportation alternative to the quadruped.

At seven in the morning on Sunday 7 November 1869, thousands of spectators descended on the Place de l'Etoile to crowd around the riders. Although there were only 202 official entries, over four hundred riders participated. They set off at 7.30 a.m. on rain-drenched roads. About a third of the entrants completed the race, thirty-three of them finishing within twenty-four hours. The winner was the Englishman James Moore, who had rapidly become one of the strongest and foremost racers in Europe. He took ten and three-quarter hours, riding a French Suriray velocipede, the highest-quality machine of its day. Moore's bicycle was fitted with the latest improvements: ball-bearings, rubber tires on metal rims, a front driving wheel measuring forty inches with a freewheel mechanism, and a rear wheel half the size. In essence, it was an early high wheel bicycle. The following month Jules-Pierre

Far left: Medals awarded in the Courses de Vélocipèdes, c. 1869.

Left: James Moore (right) & Jean-Eugène-André Castera, first and second in the first long-distance bicycle race, Paris–Rouen, 1869, with one of the machines which won all of the leading places.

Right: "A Club Run, 1870." The Pickwick Bicycle Club.

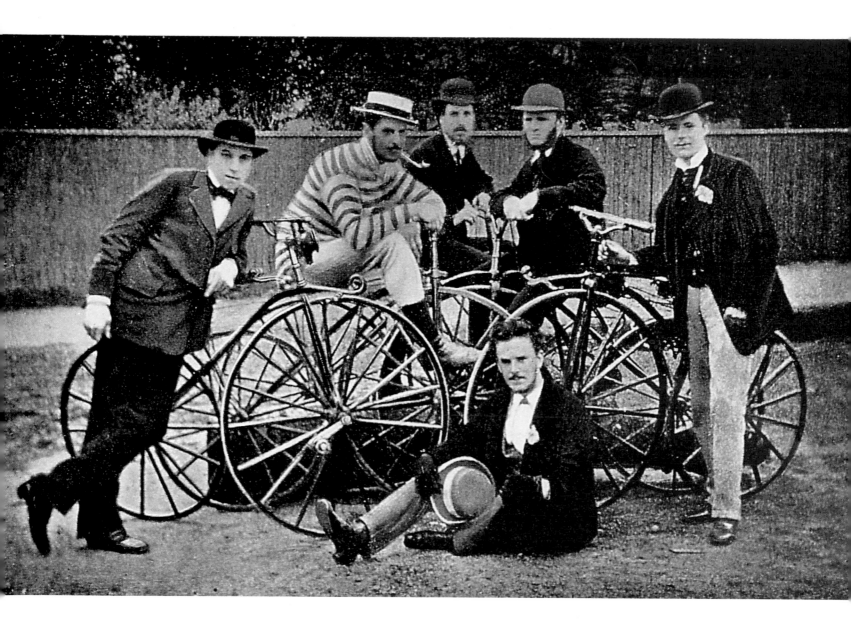

Suriray advertised this very model in *Le Vélocipède Illustré*, making him the first to capitalize on the interest and publicity generated by a race victory.

In twenty-ninth place was "Miss America" Turner, the only woman to complete the race, winning the special lady's prize. She rode with her husband Rowley B. Turner, the manufacturer of Coventry's "American" velocipedes, who came in thirtieth. Ladies' races were usually a different category, and were soon very popular. Between 1868 and 1870 there were three in Belgium and twenty in France, the first in Bordeaux being attended by more than three thousand spectators. "Miss America" won all but two of the races she entered. At the Pré Catalan she lost to "Miss Olga" from Moscow, who was not yet twenty years old. The Russian apparently had greater strength and more developed hamstrings than most male racers of the time; but what impressed the spectators most was her exquisite black velvet outfit, said to complement her distinguished pale features.

Professional racers were relatively few: far more numerous were those who took part in the velocipede craze by joining the large number of clubs and associations which sprang up in the late 1860s. During the 1869–70 season, more than 155 towns in France organized velocipede races, showing a far greater commitment to the sport than other parts of Europe or America. The large number of races was due both to the efforts of the manufacturers and to the increasing popularity of the new *véloce-clubs*. The first of these was the Véloce-Club de Valence, founded in 1868. By 1870, there were more than forty in France, often working to organize races with local festival committees.

In an age of clubs and associations, véloce-clubs provided the organizational infrastructure for the growing popularity of velocipedism. Outside of France, véloce-clubs were usually only found in the larger cities. Brussels and Geneva had clubs in 1869, as did Hamburg, Hanover, Leipzig, Mannheim, Stuttgart, and Braunschweig in Germany. In Italy, the first known races, held in Padua and Udine in 1869, predated the earliest clubs, which were formed in Florence and Milan. The velocipede club of Florence organized the first Italian road race in February 1870, on a route from Florence to Pistoia, a distance of twenty miles. The Milan club, formed in March the same year, held its first race in January 1871. Besides organizing races, clubs often built racetracks, some of which were modified skating rinks, and occasionally acted as interest groups to challenge regulations that prohibited velocipede riding on sidewalks and in parks—an early example of an important function carried on by later cycle clubs.

Four clubs were formed in England, three of them in London: the Liverpool Velocipede Club in 1869, and the Amateur Bicycle Club, the Surrey Bicycle Club, and the Pickwick Bicycle Club in 1870. The Pickwick was named after the great novel *The Pickwick Papers*, in honor of its author, Charles Dickens, who had died earlier that year. Dickens was very popular, and the club members found the characters of *The Pickwick Papers* so vivid that they decided to dedicate the club to the perpetuation of the novel. They resolved that each member be known by a sobriquet selected from the novel, and addressed by that name at all club meetings. It was also proposed "that the club uniform be *simply* a white straw hat with a black and amber ribbon" (Crushton 2).

Like other bicycling associations, the Pickwick Bicycle Club modelled itself partially on a military organization. The club imposed a strict discipline and organization during its excursions. For example, it established a system of signals by whistle, for the guidance of members when riding together on dark winter evenings. More seriously, the club minutes reveal that to disobey the command of the Captain was deemed to be a crime almost deserving of capital punishment.

Membership of the Amateur Bicycle Club was reserved strictly for gentlemen, indicating the desire of some wheelmen to avoid association with their social inferiors. Indeed, while bicycling remained an upper class pastime, it also contributed to the dismantling of class barriers. In attempting to restrict their membership, clubs were swimming against the tide, and rigid membership rules resulted only in an excessively low membership and poor attendance at meetings.

Innovations and Improvements

During this period technological improvements, especially in wheels, had made velocipedes easier to ride, thus increasing their popularity. Wheel design was originally based on the principle of compression, with the weight bearing down from the hub to the lower part of the wooden rim, a technology which demanded thick supporting spokes and a heavy rim. Critics of the old-fashioned wooden wheel complained that it frequently became loose since the metal band holding the wheel together would expand with use and needed to be trimmed periodically. Gradually, the wheel evolved to a system of suspension, with light, elegant, metal wire spokes, tensioned by their attachment to the rim, and providing suspension of the hub from above.

One of the first improvements to heavy compression wheels was the addition of a rubber tire fitting over the metal band. The term "boneshaker" was first used in 1870 to distinguish velocipedes without such rubber tires, although it eventually applied to all velocipedes. Clement Ader, who later became a pioneer aviator, patented the design for the new tire in November 1868. As well as eliminating the clatter when riding over macadam or cobblestones, the wheel had a better grip on the surface, and reduced slippage from side to side. The rider was also less likely to be injured by the sharp edges of the metal wheel should he or she fall. This new comfort and smoothness were especially welcome on steep hills and long journeys, and provided greater speed control for races. James Moore won the Paris–Rouen race using rubber tires in 1870, and in 1872, Mr A. Temple is known to have employed them on a ride from London to Brighton that took a mere five and a half hours—three years earlier John Mayall had taken fifteen hours to cycle the same route.

The introduction of the "spider wheel" was an extremely important step in the transformation of the velocipede into the high wheel bicycle. The first wheels with metal spokes, which appeared in France, still worked on the principle of compression and were therefore quite heavy. An account published in *The English Mechanic* in 1866 and signed by a certain Mr. Tydeman, who constructed wire-spoked, metal-rimmed wheels which he called "spider wheels," described the reaction of passers-by: "It is not a little amusing to witness [their] surprise. . . at a wheel carrying such a weight apparently without spokes, for such is their slenderness that they cannot when in motion be perceived even across the road" (13 July 1866).

Although the Frenchman L. Gonel had patented a suspension wheel for various vehicles in 1867 and updated it for velocipedes in 1869, the all-metal spider wheel—in which individually adjustable metal spokes screwed directly into the hub from a rim with outer tires—was patented by Eugène Meyer in 1869. His patent was revoked, however, when it was discovered that he had sold a pair

Left to right: "Riding Without Using Legs Or Hands." and, "How To Get On By The Treadle." from "The Modern Bicycle."

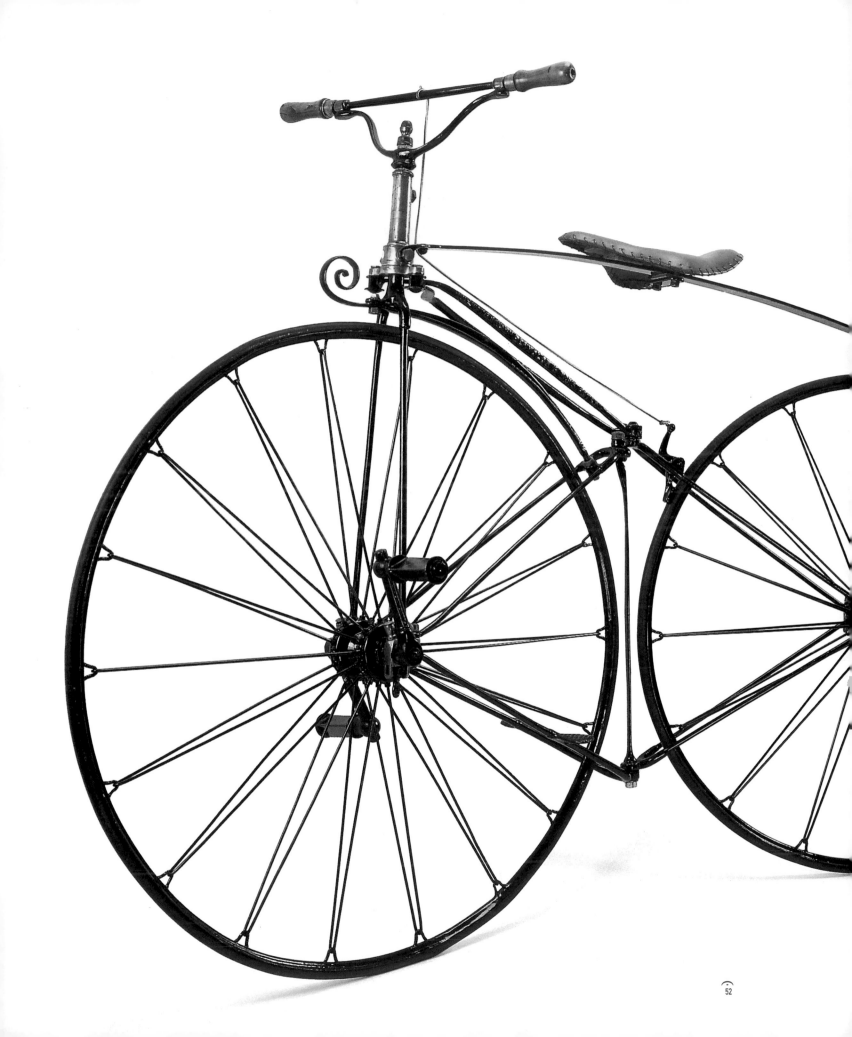

of wheels before the patent had been granted. Other manufacturers, including the Olivier brothers, soon adopted and improved upon Meyer's wheel.

A Meyer bicycle with spider wheels was displayed at the Exposition Internationale de Vélocipèdes at the Pré Catalan in November 1869, and about half a dozen were ridden in the Paris–Rouen race that same year. Meyer naturally rode one himself, and the great racer Jean-Eugène-André Castera finished second on another. In 1870, James Moore won the Paris championship riding Meyer wheels.

The first English velocipede to benefit from the suspension wheel with rubber tires was the Phantom, built by Reynolds & Mays and patented in both London and Paris in 1869. Although the first models had wooden rims, they were soon replaced with rims of V-shaped sprung steel which were stronger and could keep their shape in any weather. The Phantom, ridden by Reynolds himself, made its first appearance at the Velo Derby that formed the finale to the Crystal Palace Velocipede Exhibition of May 1869. Despite a bad start that left him twenty yards behind the pack, Reynolds went on to win the derby's one-and-a-half-mile International Championship race by sixty yards, thanks to the rubber tires.

The steering technology of the velocipede remained somewhat primitive. Riders lost foot contact completely with their outside pedals when turning, thus losing some control

of their machines. The Phantom introduced a central hinge on the frame so that, on turning, both wheels formed an arc: the wheels only pivoted half their usual distance and did not come in contact with the rider's leg. Mounting, too, remained a difficult task until Reynolds improved upon the method: the 1869 Phantom catalogue mentioned "a capital addition in the shape of what is called a stirrup iron. . . this entirely obviates the embarrassment which frequently attends a mount by jumping vault into the saddle" (*Boneshaker* 114: 3). This stirrup iron was possibly the first step added to a velocipede to help in mounting and dismounting, an advance that permitted the eventual use of larger front wheels.

Such innovations and improvements served to revitalize the velocipede, whose popularity had already peaked, partly due to increased opposition. For not everyone approved of the velocipede: city authorities, in particular, judged it to be a dangerous nuisance. Indeed, all too frequently riders paid little heed to the accepted norms of the road, while pedestrians and public authorities looked upon velocipede riders as daredevils for simply having mounted the machine. Part of the problem lay in the status of the velocipede. As heir to the horse-drawn carriage, it belonged on the street; as propelled by human force alone, it belonged on the sidewalk. On the streets, however, velocipedes frightened horses and incurred abuse from horse riders and carriage drivers

The Phantom. Reynolds & Mays. London. 1869. The first English velocipede with a suspension wheel and solid rubber tires. Unlike other steering mechanisms, a central hinge on the frame turns both wheels which then form an arc.

Velocipede

O City Fathers, hear my prayer!
I'm but a student, yet give heed;
And, as you hope for mercy, spare!
Don't, don't outlaw Velocipede!

Why banish him? He does no harm
To any one, — indeed, indeed,
I know the timid feel alarm
And hatred for Velocipede;

But yet I say he harms them not;
Their fancy 'tis which seems to need
Repression; for it makes them plot
And lie against Velocipede.

They fancy riders cannot steer,
And cannot safely move with speed;
And so they feign a foolish fear
Whene'er comes up Velocipede.

Don't believe the stories that they tell
Of accident, or foul misdeed;
The Journal's "horse" long since got well,
Uninjured by Velocipede.

'Tis envy simply that's at work:
The one who must on foot proceed
Feels jealous when, with artful quirk
Another rides Velocipede.

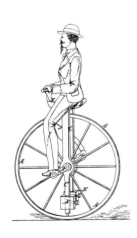

Some, too, there are who hate all fun,
Who count all sport of ill the seed;
And such judge that the Evil One
Himself devised Velocipede.

But those who believe in life, and joy,
And jollity, must fain concede
The many virtues of this toy
We fondly call Velocipede.

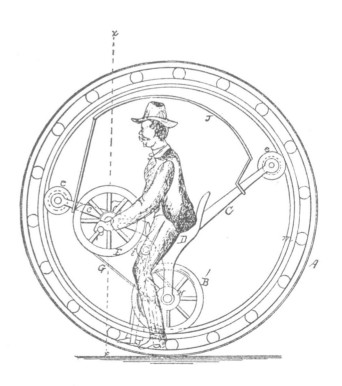

So let him have the right of way;
The sidewalks he will not impede,
Nor force the footmen to delay
Their steps for him, Velocipede.

Or if from Chapel, State, and Church
You order him, we are agreed,
If, leaving these streets in the lurch,
Elsewhere may roam Velocipede.

O, City Fathers, hear my prayer!
I'm but a student, yet give heed
To my poor words, and spare, oh, spare!
My only love—Velocipede!

who felt the newcomers had no right to the road. On the sidewalks, velocipede riders often prompted public outrage, and laws were soon enacted to prohibit them. In some cities and towns they were also outlawed from certain streets, boulevards, public parks, and promenades.

In response to this persecution Karl Kron (under the pen name of Lyman Hotchkiss Bagg), published a poem in the *Yale Literary Magazine* in 1869, the year he graduated (see opposite).

Despite such poetic pleas, opposition continued unabated. Yet if the velocipede craze saw its last days in 1869, it was due less to governmental opposition than to the vehicle's technical limitations, combined with a changing political and social climate in Europe, especially in two of the countries where the velocipede flourished —France and Germany.

Toward the end of 1869, the Compagnie Parisienne experienced a drop in sales and, in an attempt to increase their commercial activity, instituted hire purchase agreements. But what at first appeared to be merely a seasonal adjustment in public interest turned out to be the end of the mania. Manufacturers in Germany had similar experiences, and several companies were forced to close. In the United States, Calvin Witty's exorbitant demands for license fees based on his ownership of the Lallement patent encumbered the industry and hastened its demise.

Perhaps one of the greatest obstacles to the velocipede's continued success was the condition of the roads. The

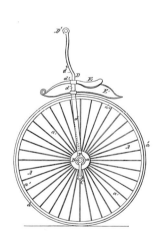

machine had reached a very high state of perfection, but without better roads people were unable to ride without the discomfort of constant physical tension—necessary both to manage the machine and to keep one's balance. In an attempt to surmount this problem, some enthusiasts in New York proposed building an elevated roadway from fashionable Harlem to the Battery which was to be restricted to velocipedes and covered with a hard pine surface. Under these conditions a good rider could have easily covered the stretch of road in only half an hour. Not surprisingly, given the opposition of municipal authorities to the velocipede, this idealistic plan was never realized.

The outbreak of the Franco–Prussian War on 19 July 1870 dealt a fatal blow to the French cycle industry. Symbolically, as the Prussians invaded, Josiah Turner escaped from Paris on a high-wheeler. The devastating effects of the war, the loss of Alsace and Lorraine, and a subsequent war debt of five billion francs, caused the burgeoning industry to collapse. La Compagnie Parisienne, the leading manufacturer of velocipedes and chief supplier of parts to the trade, retooled its machinery to make armaments and converted its riding academies to storehouses for wheat. Even after the war ended the company did not resume bicycle production. It was not until the mid-1880s that France, once the world leader in the velocipede industry, regained its lost stature.

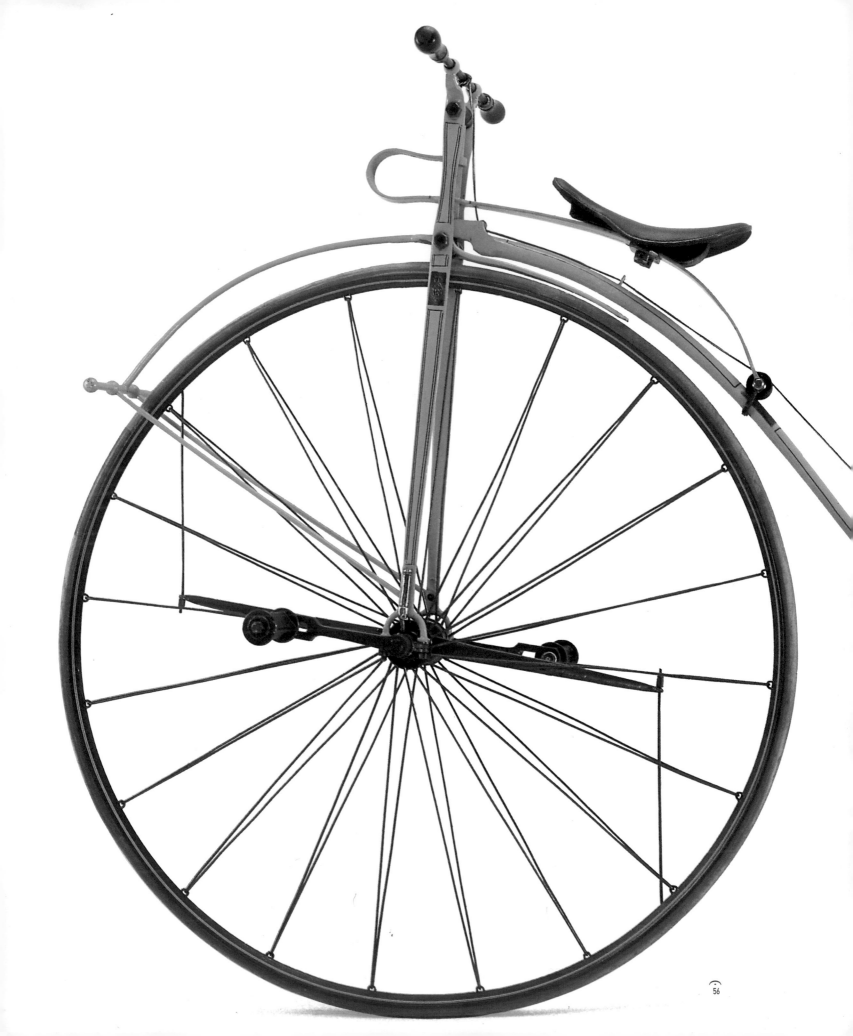

High Bicycles

One Autumn eve, when, sharp and chill,
The wind blew like an icicle,
I met, fast speeding o'er the hill,
A youth upon a bicycle.
"How glorious thus to skim!:" I cried,
"By Jove! I too will try-cycle;
And when like him I've learnt to ride,
Why, then, I'll also buy-cycle."
That very day I made a start,
First practising the tricycle,
Then soaring to that nobler art,
The riding of the bicycle.
So well I liked my hired machine,
That, having ask'd the price-ical,
I bought it, and it since has been
My own peculiar bicycle.
And now, at morn, and noon, and night,
My life is paradisical;
I emulate the eagle's flight,
When mounted on my bicycle.
Oh, all ye gay and festive youth,
Remember my advic-ical,
And haste to prove this precious truth—
There's nothing like the bicycle!

The transition from the hobbyhorse to the velocipede remained the most important technological change until the bicycle took its recognizably modern form in the 1890s. At the height of the velocipede craze in the late 1860s, manufacturers began to enlarge the front wheel and use superior materials to produce what were soon to be called "high-wheelers" or "high bicycles." The front wheels reached gargantuan diameters of over sixty inches, while the back wheels shrunk proportionately to stabilize the frame and make mounting and dismounting easier. The rationale for these bikes was a simple matter of physics: each revolution of the pedal on a larger wheel translated into a greater distance covered by the cyclist. Large wheels also provided a flywheel effect which allowed the rider to maintain his momentum and helped, in the decades before pneumatic tires, to diminish the jolting caused by rough roads. While intended as an improvement on the efficiency and safety of velocipedes, the enlargement of the front wheel also produced an unanticipated result, as it eventually led to dangerous machines which required enormous skill and courage to ride.

By the middle of 1868, French manufacturers were producing velocipedes with front wheels approximately twice the diameter of the rear. James Moore won the Paris–Rouen race of 1869 on a machine built by Jules-Pierre Suriray with a front wheel forty inches in diameter. His success prompted other manufacturers to produce velocipedes with larger front wheels. In early 1870, just before the outbreak of the Franco–Prussian War, this trend led certain French race organizers to establish a maximum size limit of forty inches for front wheels. As with jockeys before a horse race, riders had to submit their steeds to a "weigh-in" where their front wheels were measured before the cycle race began.

With the Franco–Prussian War, the short-lived experiment of the Paris Commune, the loss of France's eastern provinces of Alsace and Lorraine, and the enormous reparations imposed on a series of unstable governments in Paris, the French economy entered a period of crisis—a crisis which profoundly affected the velocipede industry. English manufacturers were poised to take control; indeed, the center of bicycle manufacturing shifted to England for nearly two decades. The Coventry Machinists' Company (CMC), until 1870 the sole manufacturer of bicycles in Coventry, became a fertile ground for major inventors and manufacturers, including William Hillman, George Singer, and James Starley, the company foreman. While still working for the company, Starley and Hillman received patents for several improvements to wheel technology. In particular, they developed a unique system of rods that tensioned all the spokes simultaneously by slightly rotating the rim in relation to the hub. The spokes thus branched out from the hub tangentially instead of radially. With this patent, Starley and Hillman left the CMC to form Starley and Company, and in late 1870 they

WARNE'S USEFUL BOOKS
THE
MODERN BICYCLE
BY
CHARLES SPENCER
WITH PRACTICAL ILLUSTRATIONS

LONDON: FREDERICK WARNE & CO.

Previous double page: The Ariel Bicycle. Smith, Starley & Co, Coventry, 1872. The first English high wheel bicycle. It was made completely of steel: the front fork extended to the handlebar (an open head) in order to block the wheel from making too great a turn which could cause a spill or trap the rider's leg upon falling. The wheels had solid rubber tires. The Ariel was available in any color, one of them being light blue.

began to produce the first English high wheel bicycle. Called the Ariel, this new velocipede used the improved wheel and a frame made entirely of steel. It was a durable bicycle made relatively cheaply; priced at only £8, the Ariel was a sign of a developing mass market in bicycles.

William Grout of London, inventor in 1871 of the Grout Tension Bicycle, was another early manufacturer of high wheel bicycles. Scholars of the bicycle generally credit Grout with two other inventions: the spider wheel with adjustable metal spokes, and the pedal designed to be ridden with the ball of the foot. In fact Eugène Meyer had developed the same wheel technology in Paris two years earlier. But because the French cycle industry was virtually non-existent at the time, Grout's introduction of these and other improvements helped the further advancement of the industry in England.

In June 1873, in what was to become a publicity event for the developing market for high wheel bicycles in England, Thomas Sparrow, a London agent for the CMC, organized what seemed impossible at the time—a bicycle ride from London to John O'Groats, the northernmost tip of Scotland. Sparrow and three other riders set out on Perfected cycles, later known as John O' Groat's Bicycles (reports of the total number of riders differ, some stating that as many as seventeen took part). All four were members of the Middlesex Bicycle Club, one of the many associations which developed around the high-wheeler. Among the riders was Charles Spencer, whose own gymnasium had hosted the first velocipede demonstrations ten years earlier. The ride was a formidable success that provided the CMC with publicity material for years; in 1879, Sparrow's catalogue, extolling the virtues of the Perfected bicycle, boasted that "during the whole of the long journey not a single case of breakage or failure in any shape or way happened to any one of them" (*Boneshaker* vol. 8, no. 78: 222).

In an age of intensive industrial growth and vast technical innovation, entrepreneurial manufacturers of bicycles constantly sought to improve the high-wheeler. However, a particular technical problem developed as wheels grew larger. With the pedals attached directly to the hub, the latter had a tendency to turn before the rim; its spokes would thus bend slightly, creating a spring effect and resulting in a loss of power. To solve this problem, Starley combined the tangential aspects of the Ariel's wheel with the individual spokes of Grout's tension wheel. In 1874 he patented one of his most important inventions, the tangential or cross-spoked wheel. The spokes left the hub in two opposing directions, crossing over before reaching the rim. The tension thus created held the hub in place and gave the wheel great strength. This is the basic wheel design of today's bicycles.

Starley's design was not widely adopted, however, as some bicycle makers were not immediately convinced of the

Far left: Cover of Charles Spencer's "The Modern Bicycle," published by Frederick Warne & Co., London, 1874.

Left: New True Rapid Tangent Wheel, 1888. Each spoke crosses seven others in its passage from the hub to the rim, and is laced and tied, making the wheel virtually solid.

benefits. Pope, the leading manufacturer in the United States, held out until the late 1880s, and the English company Humber resisted for twenty years before accepting the design which by then had become an industry standard.

Throughout the 1870s, the Ariel set the standard, inspiring several manufacturers to seek further improvements. Daniel Rudge of Wolverhampton, owner of the Tiger Inn, had long been in the habit of repairing and adjusting his customers' carts and wagons. First introduced to velocipedes in 1868, he soon began making them himself in a shed behind the inn. After 1870, Rudge based his designs on the Ariel, and by 1878 he had earned the reputation of a high quality manufacturer. Rudge then added to the design an invention which was to gain him increased fame and fortune: the adjustable ball bearing axle, which he quickly patented.

In 1879, Rudge gave Charles Terront, the celebrated French racer, a demonstration of his ball bearings. Terront was in London for several races, including a six-day race, when Rudge called on him in his hotel room. Taking a carefully wrapped axle out of his pocket, Rudge held it between two fingers of his left hand while spinning it with the right. Impressed with the movement and the sound of the bearings, the racer purchased a pair. Back in Paris, however, Terront met with resistance from Truffault, the maker of his bicycle, as well as Clément, his racing colleague turned bicycle manufacturer. Both tried to persuade him with

drawings that the bearing principle could not work, and both refused to fit the ball bearings. Unconvinced, Terront added them to a bicycle himself and found that he could complete one lap at the Longchamp track in seven minutes five seconds instead of the normal eight minutes.

But it took a bicycle builder who raced his own machines to develop and apply the range of innovations associated with high-wheelers. John Keen of Surbiton Hill had pioneered the use of larger wheels, having won championship races as early as 1872 on a light 57-inch high-wheeler which he had built himself. Known as the Spider bicycle because of its direct-spoked wheels, Keen's machine incorporated a number of improvements, including new designs of bearings, rims, tires, and the now-familiar rat-trap pedals and toe-clips, further perfected in a later model called the Eclipse. Keen gained a reputation for making some of the best-designed and highest quality bicycles of the time. When he died in 1902, an obituary claimed that, "It may safely be said that no rider has done more to develop cycling than John Keen" (Bowerman 98).

Early two-wheelers introduced from Europe had previously created two short-lived crazes in America. The fashion for velocipedes, the last of these, ended in 1870, and manufacturing activity virtually ceased in the United States as it had in Europe. There had been earlier arrivals of high wheel bicycles to America, including the Meyer bicycle brought from

Left: Hub lamp. Joseph Lucas. c. 1882. The first lamps designed specifically for bicycles were hub-lamps, manufactured in England by the Salsbury Company around 1876. They were more effective than hand-lamps rigged to the handlebars as they were lower, and hung from the hub within the front wheel, helping their beam to focus on the road. One problem was the shadow cast by the forward rim. Lamps not only made night riding possible, but extended a day's journey, allowing the rider to return after dark. Rides of 100 miles, called centuries, now became more achievable and therefore more prevalent.

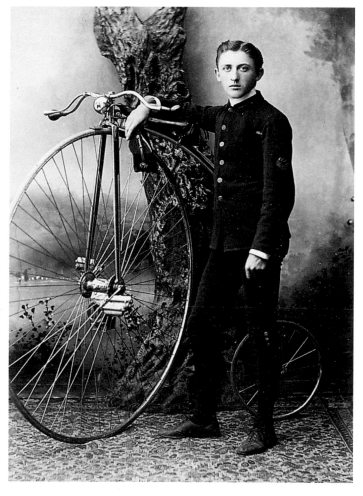

Far left: Riding
at night with hub
lamps.
Columbia trade
card. c. 1885.

Left: Man with
high-wheeler and
hub-lamp on an
Expert Columbia.
c. 1885.

France by William Wright in 1873. But the market for high-wheelers was born with the arrival of English high wheel bicycles at the 1876 Centennial Exhibition in Philadelphia. By this date the elegant, all-metal English machines were incomparable in quality to even the finest velocipedes of the 1860s.

The English bicycle exhibit, which consisted of two high-wheelers, an Ariel, and a Paragon manufactured by Wyatt and Roberts of Coventry, caught the eye of Colonel Albert A. Pope, later heralded as the "founder of the American bicycle industry" and "the father of good roads." His commercial adventure with the bicycle typifies the attitudes and practices of American capitalism of the era.

As he explained years later in a speech at the New York Bicycle Show, Pope returned again and again to study the English exhibit, "wondering each time if it would ever be possible. . . to learn to balance. . .on one of those machines. It seemed then that one must be an acrobat or gymnast to. . . [ride] such a steed" (*Boston Post,* 15 June 1894). Pope had been a successful industrialist making shoe manufacturing supplies, and in 1877 he founded the Pope Manufacturing Company in Boston to fabricate air pistols. But the high-wheeler remained his passion and obsession. On horseback he would frequently follow a friend riding an English high-wheeler around the outskirts of Boston. The cyclist always managed to out-distance him. "It was then," Pope reflected later, that he "began to seriously estimate and realize the

value of the bicycle" (ibid.)

After a visiting English guest helped Pope to construct a bicycle and taught him to ride, he began importing various English models to sell in Boston. In January of 1878, the company moved to a larger location and opened a riding school. His success led Pope to visit London and Coventry that summer, to learn about the growing industry and to decide which model he could use as a prototype. He settled on the Duplex Excelsior, manufactured by Bayliss, Thomas and Company of Coventry. Returning to the United States in November, Pope contracted the Weed Sewing Machine Company in Hartford, Connecticut, to manufacture his own version of the high-wheeler, the Columbia Bicycle.

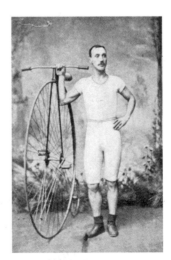

By then, others had invested in the bicycle import business, and it was this competition which led Pope, by now familiar with the patent process, to purchase the Lallement patent. Astutely, in the spirit of a nascent and litigious capitalist society, he then hired a patent attorney, Charles E. Pratt of Boston, who proceeded to

Far left: The Columbia Bicycle. Poster by The Pope Manufacturing Co., c. 1879. Col. Albert A. Pope rides "an ever-saddled horse that eats nothing and requires no care".

Left: John Keen. c. 1875.

Right: Father and son in club costumes. The caption reads: "Man believed to be W. H. Miller of Columbus, Ohio, second president of the LAW on an 1882 Columbia Expert, and boy, possibly his son, on a child's ordinary."

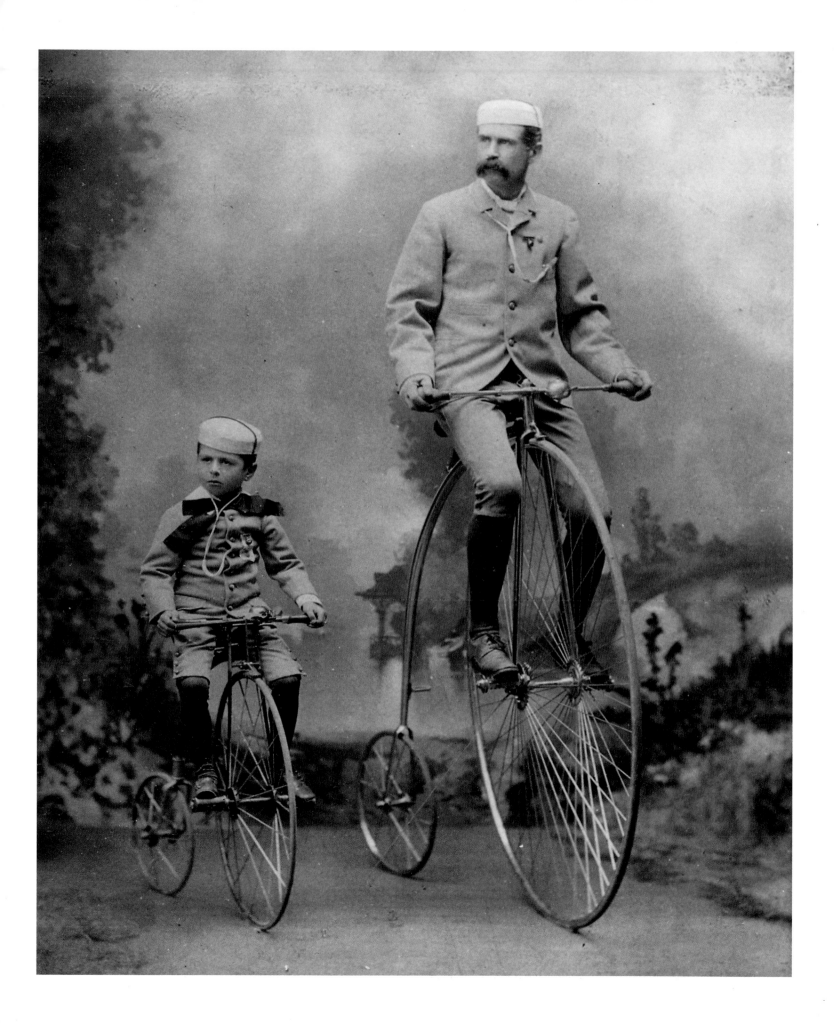

 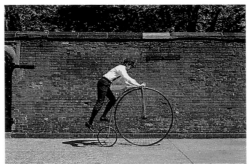 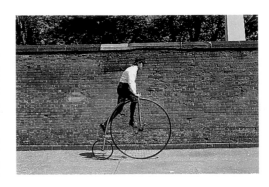

secure both U.S. and foreign patents on every aspect of the production process. In this way Pope managed to gain control of the entire business of manufacturing and importing bicycles. Charging manufacturer's licensing fees for most aspects of bicycle construction, Pope also collected fees on imported bicycles. He announced in the magazine *Bicycling World* in 1881 and 1882 that individuals who brought bicycles into the country for their own use would be sued for the license fee plus court costs. With the help of the thirty-five percent import duties on bicycles plus the ten dollar license fee, Pope managed to keep his prices artificially high, and made a small fortune. He put this to good use funding the $60,000 start-up costs of the magazine *The Wheelman* and subsidizing other aspects of cycling, such as litigation for injured cyclists and instruction in road engineering at MIT and Harvard.

Not content with controlling the actual production and importation of bicycles, Pope sought to capture the media as well. *Bicycling World* had become the billboard for news and views concerning Pope's aggressive business strategies, and he attempted to use the value of his advertising as leverage to control the information the magazine disseminated about the pressure he was exerting on his competitors. But the publishers of the magazine were not to be bullied. In 1882 they responded saying, "Bicyclers generally will be glad to learn that the attempt of the Pope Manufacturing Company to bulldoze the *Bicycling World* has not met with success. The *World* will express its views and allow its correspondents to do so likewise, in spite of the Imperial House of Pope" (*Bicycling World*, vol. V, 19 May 1882: 336).

Enforcement of Pope's patent rights effectively curbed the activities of other companies. In 1883, for example, Albert H. Overman of Hartford, Connecticut, produced his first Victor catalogue, which sold only tricycles. Only after the Lallement patent expired in November 1884 could Overman introduce his first high wheel bicycle, made by the Ames Manufacturing Company in Chicopee Falls, Massachusetts.

Another company which eventually achieved commercial success was owned by R. Philip Gormully of Chicago, who had established a business repairing bicycles and manufacturing parts. In 1884, he joined with Thomas Jefferies to form the Gormully and Jefferies Company, which

Top: The author demonstrating the art of mounting and dismounting a high-wheeler.

Right: Pedals with feet, from Bury and Hillier's 1887 book "Cycling." Proper use of the ankle-joint offers increased pedal-power.

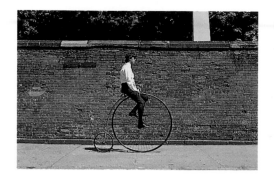
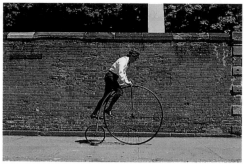
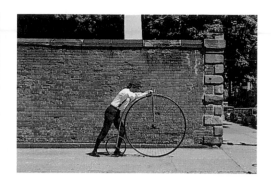

manufactured the Ideal bicycle under license to Pope. Not content with the business arrangement, Pope sued for other patent infringements and even threatened to sue all of their customers. When the suit was settled in Gormully and Jefferies's favor, they took out an advertisement in *Bicycling World* to calm their customers' fears.

The high-wheeler developed more slowly in France and Germany than in the United States and England. France, recovering from the disastrous war of 1870–71, and Germany, in the throes of national unification, were relatively late in developing their own bicycle industries. Two early manufacturers were Adolphe Clément, who in 1878 founded his company in Levallois-Perret, just outside of Paris, and F. H. Dissel and Proll, who started a bicycle manufactory in Dortmund, Germany, in 1879. Both followed closely the development of the English cycle industry, no doubt visiting the annual Stanley shows. In Germany, Dissel was the first to use metal spokes, following the English design. In 1881, Heinrich Kleyer of Frankfurt sold bicycles built by Gebrüder Reichstein in Brandenburg and Express-Werke in Neumarkt.

In 1879, Jan Kohout of Prague,

an industrialist who made machinery for flour mills and other industries, was introduced to the high wheel "ordinary" bicycle by an English visitor. His four sons were so excited over the new machine that the father forged several copies. The great interest these incited led him to begin full-scale manufacturing in 1880. Two of Kohout's sons, Josef and Frantisek, became racers. Josef won the Austrian championship by beating Thomas Walker in a one-mile race in Vienna in 1882. He then took his prize, the Silver Cup, on a tour of Bohemia, where he was welcomed as a hero.

The growing popularity of the high-wheeler in the late 1870s and early 1880s, evidenced by the increasing number of manufacturers, took place despite the fact that riding a high-wheeler was necessarily a dangerous activity. To minimize the risks and increase the efficiency of their efforts, riders chose their steeds by wheel size, generally selecting a front wheel with a diameter that fit the rider's inseam. The size of the front wheel determined the height of the mounting step, located above the rear wheel, as well as the distance between the mount and the handlebars. Perhaps the most difficult part of the ride was the mount, as the

Overleaf, left, top to bottom: Stereo photograph of man falling. c. 1885.

League of American Wheelmen stein with lithophane. c. 1890. After finishing the beer, the stein could be held up to the light to reveal this molded porcelain bas-relief.

Currier and Ives. Print. c. 1883.

bicycle had to be in motion and the seat was usually from fifty to sixty inches off the ground. In club parades, riders performed mounts and dismounts in unison, and a spill might cause embarrassment, if not a chain of accidents.

The ability to dismount with dispatch and efficiency was equally necessary, as the rider might have to alight suddenly to avoid running over an animal, child, or other pedestrian— which critics and caricatures of the high-wheelers suggest was a frequent occurrence. The most efficient, although hardly the most elegant, dismount involved jumping back from the seat without using the step or pedal.

High wheel bicycles were designed to be ridden as high up on the wheel and as close to the handlebars as possible, following the elegant example set by John Keen. This position offered the best pedal power and control, for the rider could pull up on the handlebars as he pushed down on the pedals. Moreover, as most of the weight of the rider remained in front, there was less strain on the small rear wheel (which rotated about three times as fast), so prolonging the life of its bearings, spokes, and tires.

Generally, however, unless they were racing or going uphill, riders preferred to sit farther back to decrease the risk of tumbling forward. But by moving back, the rider lost efficiency, as he was then pedalling forward instead of downward, with each pedal stroke turning the wheel left or right, thus necessitating a counter movement of the handlebar.

Even sitting back, riding a high-wheeler involved frequent

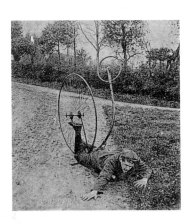

spills, called "headers" in the United States and "croppers" or "imperial crowners" in England. In his essay *Taming the Bicycle*, Mark Twain gave an account of his experiences in learning to ride a high-wheeler—an 1883 Expert Columbia. After eight days of instruction he was off on his own:

Mine was not a full-grown bicycle, but only a colt—a fifty-inch, with the pedals shortened up to forty-eight—and skittish, like any other colt. . . . Of course I had trouble mounting the machine, entirely on my own responsibility, with no encouraging moral support from the outside, no sympathetic instructor to say, "Good! Now you're doing well—good again—don't hurry— there, now, you're all right—brace up, go ahead." In place of this I had some other support. This was a boy, who was perched on a gate-post munching a hunk of maple sugar. He was full of interest and comment. The first time I failed and went down he said that if he was me he would dress up in pillows, that's what he would do. The next time I went down he advised me to go and learn to ride a tricycle first. The third time I collapsed he said he didn't believe I could stay on a horse-car. But next time I succeeded, and got clumsily under way in a weaving, tottering, uncertain fashion, and occupying pretty much all of the street. My slow and lumbering gait filled the boy to the chin with scorn, and he sung out, "My, but don't he rip along!" Then he got down from his post and loafed along the sidewalk, still observing and occasionally commenting. Presently he dropped into my wake and followed along behind. A little girl passed by, balancing a wash-board on her

Introduced in 1884 at the Stanley Show. the Kangaroo was the first successful attempt to gear-up the front wheel and was copied by most manufacturers. It was easier to mount and dismount than high-wheelers as the gearing allowed it to have a smaller wheel. hence the name dwarf safety. Though the smaller wheel provided some safety as the distance when falling was reduced. the rake of the forks and the position of the rider over the front wheel was similar to that of a high wheeler and as such offered little protction against headers. The geared-up 36" wheel rode like a 56" wheel and the extended foot rests made for very comfortable coasting. Club outings were held featuring paper chases. called Kangaroo hunts. When rear-wheel chain drive was available. an experimental tandem was built by Wilson—the front part a kangaroo and the rear. a Starley Rover—called the Kangarover.

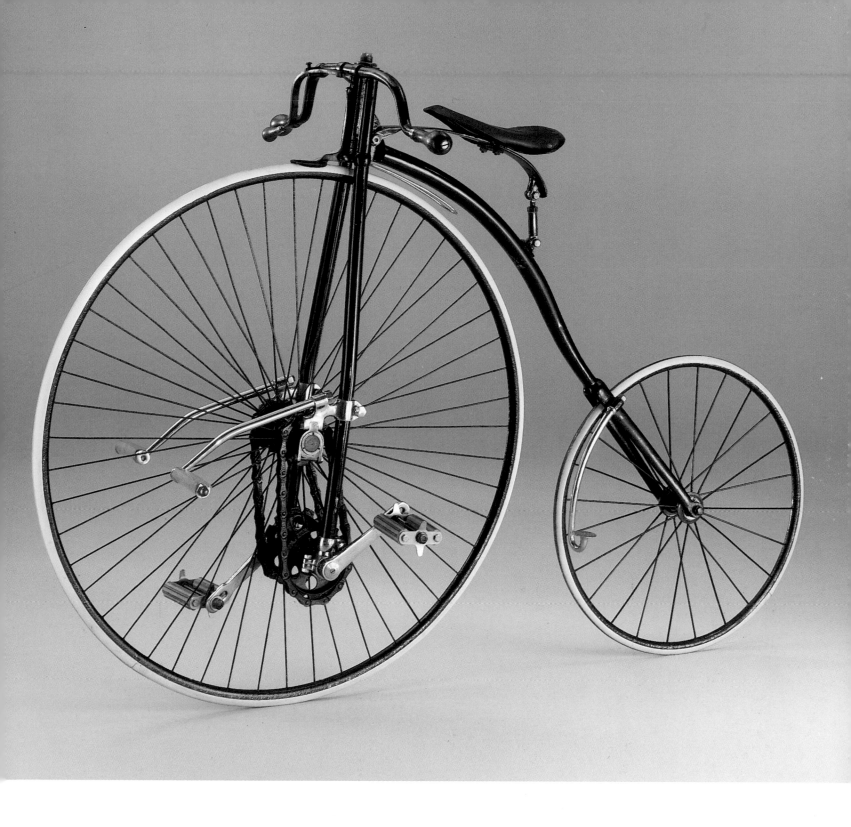

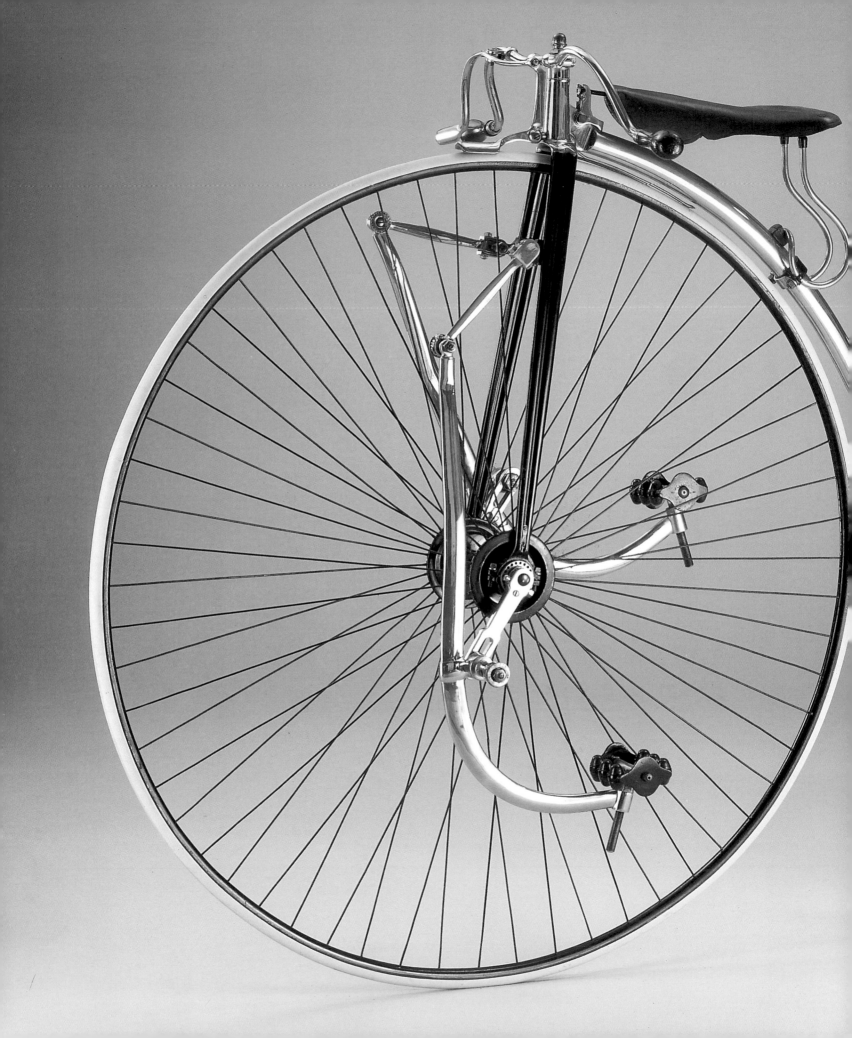

head, and giggled, and seemed about to make a remark, but the boy said, rebukingly, "Let him alone, he's going to a funeral" (Wheelmen, vol. 3, no. 1, winter 1972: 6-8).

Twain must have fallen dozens of times during his training, leading him to remark, "Get a bicycle. You will not regret it, if you live" (ibid.)

Given such experiences, it is no surprise that bicycle manufacturers went in search of a safer ride. The high wheel bicycle was quite literally out of reach of many who might otherwise have participated in the activity. Not only was the bicycle itself difficult to master, but the ride was rendered even more perilous, as had been the case with earlier forms of the bicycle, by the appalling road conditions of the time. As a result, riders had to be in good physical condition, spirited, and young enough to be able to bear possible physical injury. On the high-wheeler, the bicycle rider became something of a hero with his acrobatics of courage, foolishness, and grace. But the bicycle itself remained beyond the capacities of ordinary men and women.

Inventions on both sides of the Atlantic attempted to address the problem of safety to make the bicycle more accessible. The first design modifications involved shifting the weight of the rider back to diminish the chances of a "header." Both the Facile and the 'Xtraordinary, patented in England in 1878, accomplished this by means of pedals attached to levers that extended backward, allowing the rider to sit further back from the

Left: 'Xtraordinary Challenge. Singer & Co., Challenge Works, Coventry, c. 1885. Patented by George Singer, 1878. "The best large-wheeled safety in the market, and one of the few real safeties of any kind...it is almost absolutely safe, and is a fine thing for night riding. The high position of the rider allows him to see the country as well as on an ordinary." Two safety features were the lever action, which enabled the rider to sit further back from the front wheel, and the more pronounced raking of the front fork, which lessened the chances of taking a header and allowed more use of the front brake. The position of the treadles combined with the adjustable pedals allowed a person to ride a wheel up to 10 inches larger than he would on an ordinary. Also known as the 'Xtraordinary, 'Xtra, Camel and Extra-ugly, this design outlived all other high wheel safeties and was in use up to the introduction of pneumatic tired bicycles.

center of the wheel. The American Star, patented in 1880, had an unusual safety feature. The front and rear wheels were reversed, making a forward fall impossible, although the rider had to keep his weight forward in order to avoid a "wheelie," causing him to fall backward, whereby he could simply land on his feet. Through the use of gearing and a reduced front wheel, the Kangaroo, first produced in England in 1884, offered an even safer ride. After the mid-1880s, most manufacturers began to produce models similar in design to the Kangaroo. With the introduction of these high wheel safeties came a new name for the standard bicycle: the "ordinary."

The Adaptable and Sociable Tricycle

At the same time, another solution to the problem of riding a high-wheeler, and to expanding the market for bicycles, was simply to add a third wheel. Indeed, from the beginning, the tricycle had evolved alongside the running machine. But it was only in the 1880s that it came into its own.

The first three-wheeler incorporating the technological advances of high-wheel bicycles was the Dublin tricycle, patented in 1876 by William Blood of Dublin, Ireland. It had a large rear lever-driven wheel and two small front steering wheels. In Coventry, Singer, and later Hillman and Herbert, copied the model, a development which seems to suggest an early popular market for the tricycle.

William Starley, son of James

Starley of the well-established Starley Company of Coventry, introduced a slightly different model, the Coventry tricycle, in 1877 (at first under license to a company called Haynes and Jefferies, which already produced the Ariel). Its popularity lasted until the early 1890s. His father James Starley branched out in a different direction with the technology of the tricycle, this time looking backward to the age of carriages and more sociable modes of transportation. His Convertible Sociable of 1877 had a reversible addition— an extra driving wheel and seat. In effect, the tricycle became a four-wheeled machine for two riders seated side by side.

The Convertible Sociable may eventually belong more to the history of the automobile than the bicycle, for it was in the perfection of a four-wheeled, two-person vehicle that James Starley stumbled across the technology essential to the car. While out with William riding the Convertible Sociable in the hilly countryside around Coventry, each pedalling the large driving wheel nearest to him, he noticed that his son's forceful pedalling on uphill stretches tended to make the front wheel skid and veer off course. James Starley was struck by the phenomenon, and came up with the idea of the differential gear, consisting of a pinion sandwiched between two bevelled gears on the rear axle, which allowed different rates of wheel rotation on curves.

James Starley was not the first to "discover" the differential gear: the Frenchman Onésime Pecqueur had patented the

Left: Stamp of three racers.

Right: Will Robertson, member of the Washington Bicycle Club, riding a Star down the steps of the Capitol in Washington 19 May 1885. The Star was patented by George Pressey in 1880 and manufactured by H. B. Smith Machine Co., Smithville, New Jersey in 1881. A good brake was crucial as the ratchet and strap lever drive did not offer the braking control found on ordinaries. A variation incorporating pedals instead of levers was called the Eagle and was introduced by the Eagle Bicycle Manufacturing Company of Stamford Connecticut in 1889.

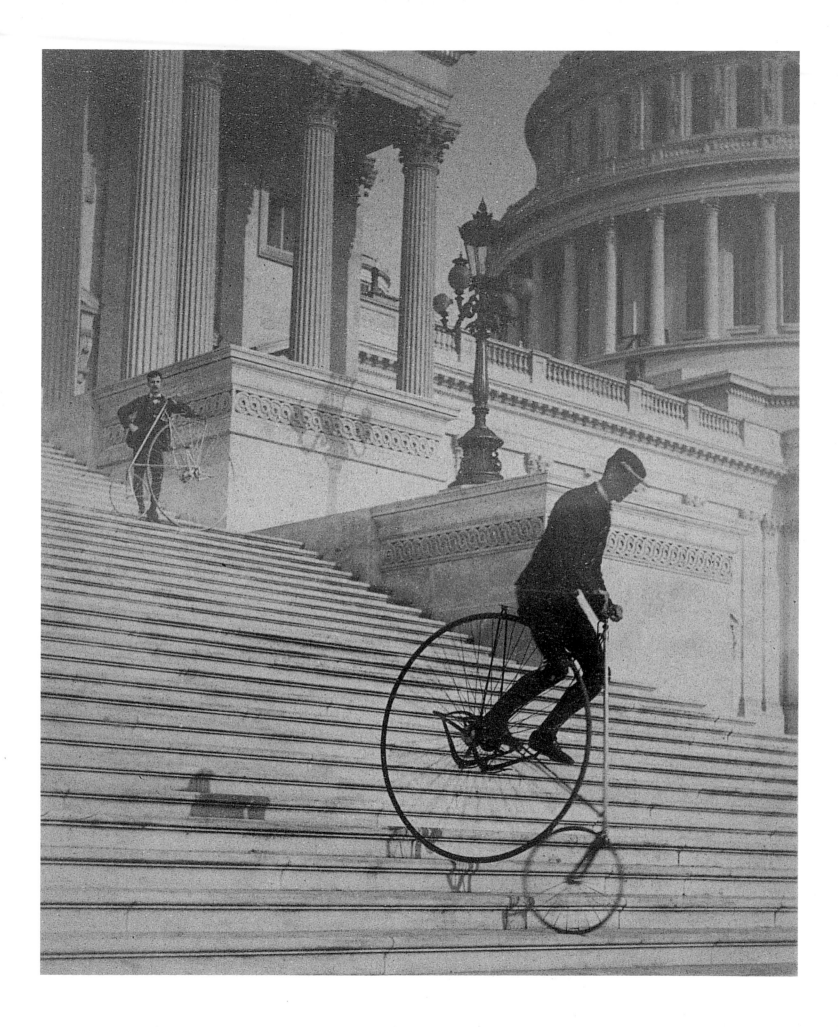

concept in 1828, and the differential gear had long been applied to steam engines. (Writing about the new English railway system, Pecqueur remarked that if the engineers had known about the differential, they would not have had to go to the expense of laying out their track in such straight lines, and could have followed the geographical contours instead.) However, Starley was the first to use the differential gear on a tricycle, the Salvo, patented in 1877. This model included a raised fourth wheel that protected the rider against spills. The differential gear made it the fastest vehicle on the road, capable of outrunning the stagecoach. But the Salvo was not known for its speed alone. It attracted the attention of Queen Victoria, out for a carriage ride on the Isle of Wight. Although no longer in a position to confer patents and privileges on inventors, the monarch did place a personal order for two tricycles in early 1881, a fact on which Starley successfully capitalized. Thereafter his tricycle became known as the Royal Salvo.

The tricycle entered the world of commerce, the professions, and the state. No longer simply a recreational vehicle, it became an agent of speed and progress, blurring class boundaries in the process. Doctors and businesses used tricycles, but so did food delivery services, milkmen, carrier boys, and national governments. The English Post Office even commissioned Bayliss, Thomas and Company to make a model expressly for carrying parcels. But the tricycle had one major inconvenience: at

over three feet in width, it could not be stored easily. Again, technology came into the service of a market need: in 1878, Starley introduced a folding tricycle with a hinged frame and telescoping axle. Launched as the Compressus, it was later renamed the Tom Tit, a model which "could be stowed in any convenient corner" (*Boneshaker*, vol. 4, no. 35, 1964: 94).

The tricycle not only created a safer ride, it also widened the market to attract a new group of riders—women. According to one of the popular bicycling magazines of the time, *The Wheel World*, the tricycle first came into use for "elderly and middle-aged gentlemen whose weight or nerve renders them unsuited for bicycling, and also for such younger men as may by reason of their position prefer the greater dignity of the three-wheeler" (*Boneshaker*, vol. 4, no. 36, 1964: 109). Once attributed to the less capable members of the male sex, the idea of women on tricycles became a logical extension, or so *The Wheel World* suggested: "To these classes is now daily being added the ladies, and we opine that in not more than, say, three years at the most, it will be so common to see ladies riding tricycles as to have ceased to cause more than passing notice" (ibid.)

In the early 1880s, however, women on tricycles were frowned upon. As a poem published in the *Wheeling Annual* of 1884 pointed out, the tricycle seemed to offer women a hitherto unknown freedom and mobility, and thus threatened to become an instrument of disruption in traditional social roles:

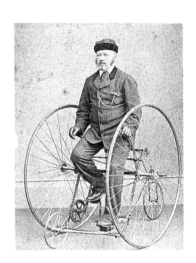

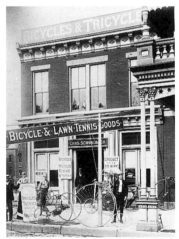

Far left, top to bottom: James Starley on "Salvo" tricycle. This was the first tricycle to which his differential was fitted in 1877. The raised fourth wheel was intended to add stability.

Tricycles for hire. England. c. 1885.

A tricycling the ladies go,
And oh, how fine they feel!
What matters it to them, although
The weary husband down at heel,
Is praying for a good square meal,
Or that at home the babies squeal
Or wallow in their weltering woe?
This is the year for hens to crow;
It is the rule, there's no appeal—
And woman's at the wheel!

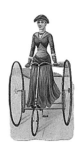

The tricycle, and later the bicycle, not only made ladies feel fine, as the journal remarked; it was also to play an important role in women's social and political emancipation. What had begun as a marketing strategy by cycle manufacturers was to have unintended consequences far beyond their capitalist dreams.

The tricycle permitted women mobility but, its manufacturers advised, only with a male chaperon. Such were the ideas expressed in the first models of tandem tricycles designed for "escorting ladies." Indeed, the first tandems seemed to treat women more like packages than sweethearts: the Dos à Dos, a Coventry Lever tricycle fitted with an extra pair of levers and another seat for the lady, facing backward, seemed to discourage communication of any kind between the riders.

Placing the woman backward on the frame marked a boundary of prudence and dignity appropriate to the gender relations of the Victorian ruling classes. There could be no doubt, after all, who was driving. Moreover, bicycle manufacturers assured the enforcement of Victorian morals. Bayliss, Thomas and Company, for example, introduced the Beatrice Shield to insure against the

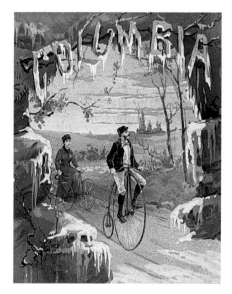

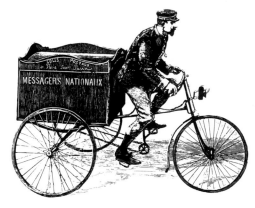

Left, top to bottom:
Cycling vignette,
c. 1890.

Columbia Valentine,
G.H. Bueck & Co,
New York, 1888.

Messenger bicycle,
1890. "La Société
des Colis Postaux
de Paris pour
Paris" was a parcel
service that
delivered
pharmaceuticals.
The service
lasted only four
months, as the rapid
increase in volume
necessitated the
use of horse-drawn
carriages.

Porcelain ashtray,
England, c. 1885.

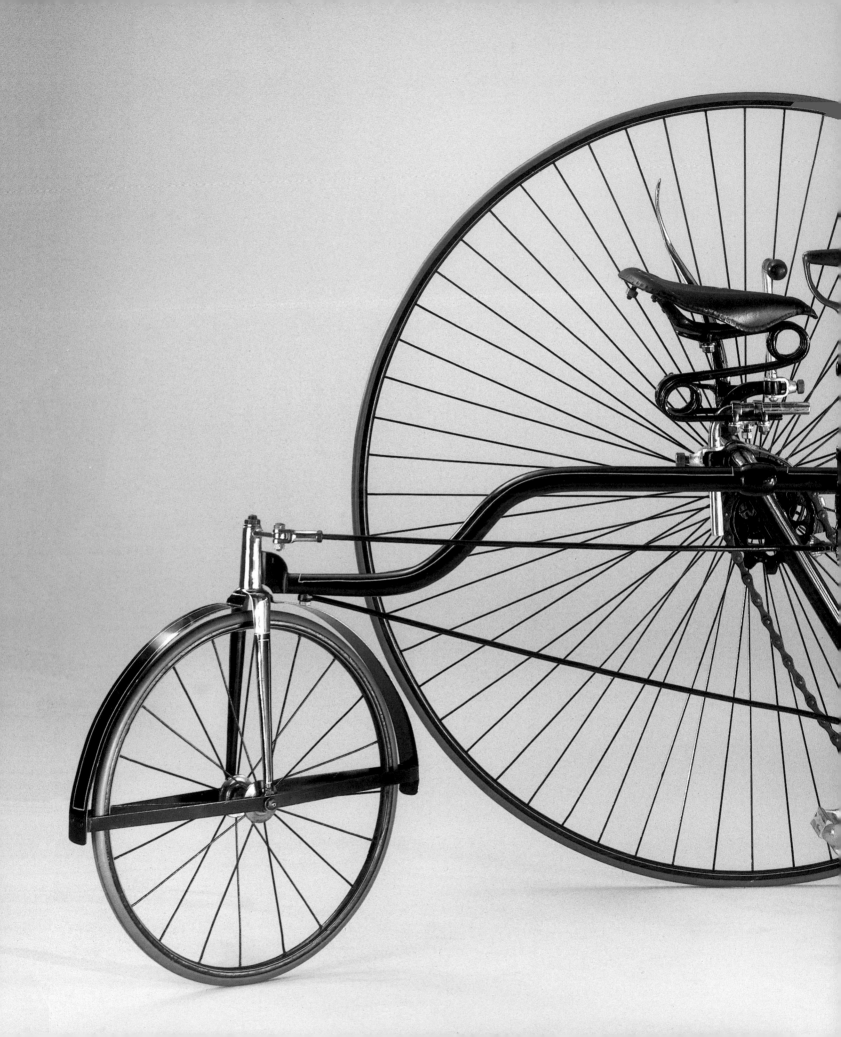

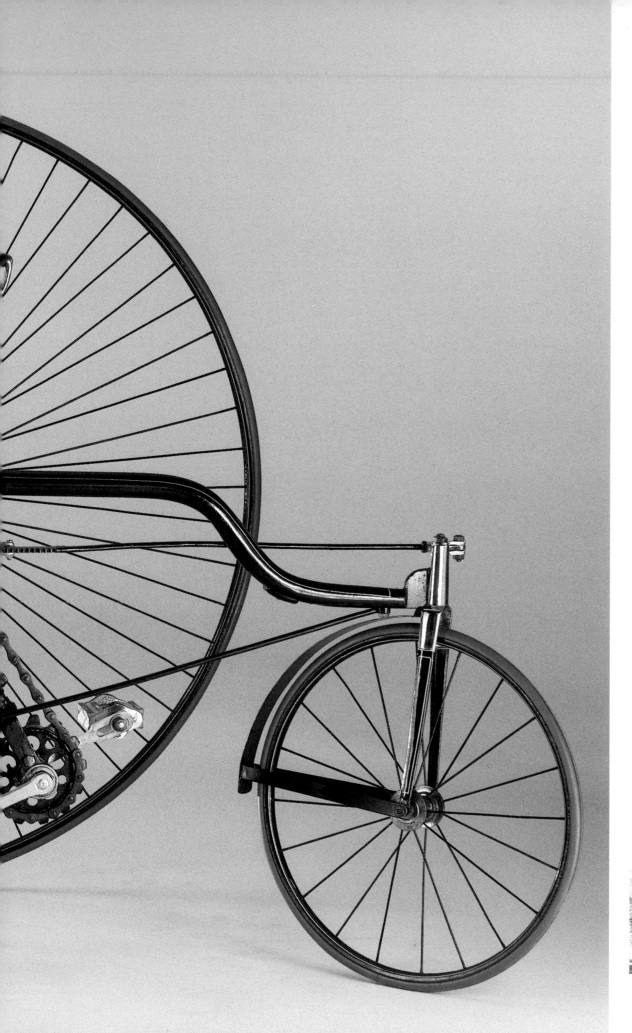

Left: Coventry Rotary Tricycle, c. 1884. This very popular model was available for many years. Its two-track design, with the two small wheels following in the same track, made riding over rough roads easier by comparison with the popular three-track models. It was first conceived in 1877 with lever drive, then upon conversion to chain drive and rotary crank action it was called the Coventry Rotary. With this tricycle, ladies could now safely participate in the world of cycling. They preferred the model with levers as there were no dirty chains to catch their long skirts. They also found the up and down motion to be more dignified, though some still thought this quite suggestive.

Below: A traveling photographer.

accidental exposure of ladies' ankles from a breeze. The shield was a fairing similar to the doors of a hansom cab that could be fitted to a tricycle. One drawback of the device was the resistance it created when riding into a head wind. However, despite the bicycling manufacturers' social conservatism, their placement of women on tricycles had unwittingly opened a debate about the social emancipation of women in the Victorian Age.

At first, the debate over women and tricycles took place on a more mundane level—the question of appropriate seats and saddles, for example. Some voices spoke out against seats for both men and women. *The English Mechanic* stated that a rider on a seat, as opposed to a saddle, was not positioned directly above the pedals or treadles and therefore could not exert a maximum downward pressure on the pedals. The seat was also heavier and created more wind resistance. But as it was considered more appropriate for women to ride on proper seats rather than saddles, the English review *Cycling* suggested that tricycles should be designed to accommodate both choices.

The tricycle developed quickly into an aristocratic form of cycling, to be distinguished from the "lower classes" of bicycles. Tricyclists were dignified, and tricycles expensive. Associations of tricyclists developed among the professional and wealthier milieux, excluding, as the *Bicycling News* reported in 1878, "mechanics, day-labourers, chimney-sweeps, costers etc." (Ritchie 113). In 1881, a group of tricyclists sent out a circular

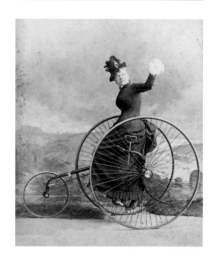

to fellow members of the Bicycle Touring Club, with orders "not to show this to your representative unless you think he is sure to join us" (*Boneshaker*, vol. 7, no. 66, 1972: 160). The tricyclists made explicit their identity as an aristocratic group:

It is desired by most tricyclists to separate themselves entirely from the bicyclists, who are a disgrace to the pastime, while tricycling includes Princes, Princesses, Dukes, Earls, etc. It is plain that the tricyclists are altogether a better class than the bicyclists, and require better accommodation on tours, etc. A new Tricycling Union has been formed, and could not that body make itself a Tricycle Touring Club as well? (ibid.)

As wealthy and influential members of London society, those who formed the Tricycle Union in 1882 put political pressure on the city government to exclude bicycles from the London parks. The Bicycle Union maintained that all riders should have equal rights regardless of the style of wheels used. Such arguments eventually prevailed, and in 1883 the Tricycle Union was dissolved.

The tricycle represented one technological solution to the danger of high-wheelers. However, the major technological innovation which helped manufacturers to create a safer, and thus more saleable, bicycle was to shift to a rear-wheel chain drive. This is the design of today's bicycles. The development of gearing within this design obviated the need for a larger front wheel, just as it made mounting and

Left, top to bottom:
"Wheeling on Riverside Drive." Print by Thure de Thulstrup. "Harper's Weekly." New York. 17 July 1886. The tricycle in the foreground is a "sociable," a term which designated a bicycle or tricycle where two riders sat side by side. The tricycle receding in the background is a tandem tricycle, the name derived from equestrian usage where horses are harnessed "in tandem." or one behind the other. The sociable was an unwieldly machine. it was heavy, offered too much wind resistance and was difficult to store. Their popularity therefore declined when tandem tricycles were introduced. In England, men could only ride with their wives or sisters, as riding with someone else's sister was considered unacceptable. To avoid disapprobation, sister-swapping was the preferred technique.

Columbia Two-Track Tricycle. USA. c. 1887.

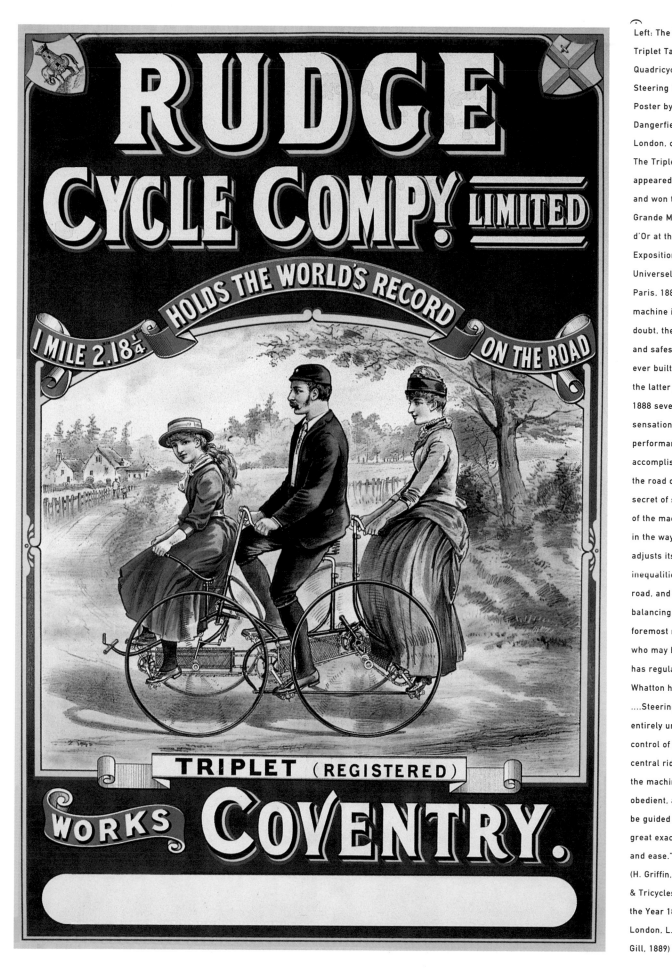

RUDGE CYCLE COMP! LIMITED

HOLDS THE WORLD'S RECORD

1 MILE 2.18¾

ON THE ROAD

TRIPLET (REGISTERED)

WORKS COVENTRY.

Right: The Cross-Channel
Tricycle. On Friday 25 July,
1883, William Terry of
Portsmouth left London to
travel to Paris on his
amphibious rear-steering
tricycle. His baggage
included oars, boom and
tarpaulin. Upon arriving
in Dover, he began the
transformation by dismantling
the frame, splitting the
wheels in half and painting its
bottom to seal it. This
produced a boat of about
twelve feet long and
four feet wide in which he set
sail the next morning at
9 o'clock. He reached the
middle of the English
Channel at about noon, but
began to drift in the fog, and
at around 3 o'clock had to
approach an English fishing
boat whose crew gave
him tea and pointed him in the
direction of land. Around 8
o'clock he came across a
French lugger from whose
crew he received bread, water
and brandy and the news that
he was about ten miles from
shore. Since the tide was
against him, it took until
5 o'clock on Sunday morning
to arrive at Fromeryelles,
by which time Terry had
rowed for about twenty hours.
Once ashore he slept
alongside his boat, but
customs officials soon found
him and gave him a bed
and stored his machine. The
next day, he reassembled
his tricycle and rode
twenty-five miles to Calais
where he exhibited
his machine to the Mayor
and other notables. On
Thursday he set off for Paris.

dismounting easier and safer. These changes produced the "safety bicycle," and the development of this new market brought a decline in the interest in tricycles. By the Golden Age of the Bicycle, in the mid-1890s, the tricycle had declined in popularity despite commentators' insistence upon its virtues, including the absence of "nervous strain" necessary to balance a two-wheeler.

As the high-wheeler was increasingly displaced by the safety bicycle in the early 1890s, the former came to be known by two new names: "grand old ordinary" (or GOO) and "penny-farthing." Although "penny-farthing" was considered pejorative, it is the term most used by English-speaking people today.

A Community of Cyclists

In Europe and the United States, the late nineteenth century was an age of associations within a developing middle-class culture. Clubs and associations organized sporting activities, including tennis, fencing, soccer, and cricket. But such sports were by definition collective or competitive, while cycling was by its very nature an individualistic sport. Cycling clubs, beginning with the véloce-clubs discussed earlier, helped to create a distinctive collective bicycle culture for men, a milieu of both relaxed sociability and passionate competition.

Clubs sponsored rallies, exhibitions, and especially races. In their choice of names, uniforms, and rituals, they reflected a variety of broader concerns in English and

European society. For example, one of the first clubs, founded on May Day 1876 in North London, was named the Stanley Bicycle Club, after Sir Henry Morton Stanley, the Welsh-born American journalist and explorer. Five years earlier Stanley, sponsored by an American newspaper publisher, had trekked into the jungles of Tanzania in search of the Scottish missionary explorer David Livingstone. Reflecting the literary and middle-class public's fascination with colonial adventures, the club pioneered a military style of cycling dress, soon widely imitated, consisting of a close-fitting jacket of thick, dark-blue serge, profusely ornamented with black braid and fastened with hooks and eyes up to the throat; tight knickerbockers in similar style; a Stanley cork helmet with a silver club badge; black stockings; and white gloves.

The Stanley Club sponsored an annual exhibition of bicycles that became known as the Stanley Show. At the first, held at the Athenaeum in Camden Town, North London in March 1878, the club invited several bicycle manufacturers to show specimen machines. The show grew in size year by year, and by 1886 hundreds of bicycles were on view. Taking place at the formal opening of the riding season, the show proved to be of great interest to a public eager to see the novelties of the year. It was England's only cycle show until 1892, when the National Show also began to exhibit the year's new models.

As clubs spread during the 1870s—the Peterborough

Fig. 1. — Le tricycle de M. Terry, sur terre. (D'après une photographie de M. Hall.)

Fig. 2. — Le même converti en un bateau; représenté pendant la traversée du Pas-de-Calais, qui a été exécutée le 28 juillet 1883
(D'après une photographie de M. Hall.)

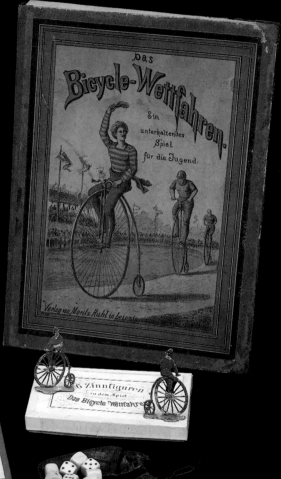

Amateur Bicycle Club, for example, founded in 1874, was a nationwide movement to unite amateur riders and organize local races, prizes and excursions—bicycling became linked to another cultural activity of the increasingly wealthy and leisured classes: tourism. The link between bicycling and tourism was quite natural: the bicycle offered the mobility and sense of adventure sought by those who traveled for the pleasure of traveling.

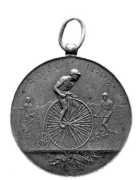

The Bicycle Touring Club (BTC) and the Bicycle Union were both founded in England 1878. The latter was renamed the Cyclists' Touring Club, then became, when tricycles were included, the National Cyclists' Union. The BTC had for its stated purpose, "To Promote Touring by Bicycle; to Help Tourists to Secure (when requisite) Companions, and (when needful) to Protect its Members" (Lightwood 52). Supported by some of the highest dignitaries in the church, it was composed not only of nobility and gentry from all parts of England, but also members of the legal, medical, military, and naval professions—anyone with sufficient credentials and social status to be of a respectable station in life. To symbolize their community, members of the BTC wore a uniform: a dark green Devonshire serge jacket, knickerbockers, a Stanley helmet with small peaks, and Cambridge gray stockings.

Members of the BTC were able to take advantage of the club when they toured, receiving guidance and advice from local representatives, called consuls,

listed in their handbook. The book also listed hotels around the country that gave special rates to members. By the 1880s, the club had become an international organization; in 1885 it had more than sixteen thousand members, about a tenth overseas. Citizens of the United States constituted the largest foreign group, followed by Germany, Austria-Hungary, Holland, France, Canada, Denmark, and Belgium. Joining was worthwhile for foreign members, even if only to receive the handbook and the *Gazette*, the club newsletter, which described tours and offered news stories.

While the Bicycle Touring Club developed into an association supporting the new leisure activity of tourism, the Bicycle Union became more concerned with the legal status and activities of cyclists in England. As the association governing cycling, the union framed definitions and recommended rules for racing, arranging annual races where the amateur champion was decided. During these races, union officials supervised the course and were responsible for the erection of danger boards to warn cyclists to ride with caution when approaching hills. The Bicycle Union also advocated cyclists' rights on public roads. As an interest group, it even put pressure on the English parliament in 1878 to block a proposed amendment to the 1835 Highway Act, which would have curbed the use of bicycles on highways. Parliament rejected the amendment, but authorized county justices to make bye-laws "for regulating

the use of bicycles." The union's victory gave it an even stronger position of advocacy. Soon it became concerned with tariff reduction for bicycles taken by rail and other issues concerning the rights and interests of cyclists in England.

The Highway Act of 1835 had been created at a time when two-wheelers could pass through turnpike gates unchallenged. When velocipedes became popular in the late 1860s, local justices had no systematic guidelines on how to regulate their use. In legal terms, the status of the bicycle was ambiguous. Was it a man or a vehicle? Was the cyclist riding, driving, or running? Who had right of way? Often the bicycle was not considered a carriage even though it carried a man or a woman. According to the Highway Act, drivers of carriages could be penalized for driving furiously. Could the rider (driver?) of the velocipede (carriage?) be treated likewise? These issues would not be resolved for decades.

In the United States, the first club was the Boston Bicycle Club, co-founded in 1878 by none other than Colonel Albert Pope of the Pope Manufacturing Company and Charles Pratt, the patent attorney for the firm, who became the club's captain. Pratt wrote the first American bicycle manual, which Pope published and distributed, and was editor of *Bicycling World* magazine. By 1880, there were over forty clubs in the northeast, and others in the Midwest, San Francisco, and Canada.

A proposal to unite these clubs in a Memorial Day parade at

Newport, Rhode Island, in 1880 gathered extensive support. Charles Pratt lost no time endorsing this initiative, for he was familiar with similar organizations in England and understood their importance in establishing the proper legal status for cyclists. He had, in fact, already examined the idea of an American cyclists' league. Pratt proceeded to rally the movement in his periodical with a letter to the secretaries of all bicycle clubs. The parade and festivities attracted over a hundred and fifty cyclists, along with spectators arriving by horse and buggy, carriage, farm wagon, and train. A conference was held to discuss the formation of a union "to promote the general interests of bicycling, to ascertain, defend, and protect the rights of wheelmen and to encourage, promote and facilitate touring" (*Wheelmen*, no. 110, 1980: 7). Shortly thereafter, the League of American Wheelmen (LAW) was founded. At their first meeting members discussed a constitution and elected officials. Charles Pratt was declared president, Kirk Munroe captain, and *Bicycle World* was named as the league's official publication. At the conclusion of the inaugural banquet, the members sung the following refrain to the tune of "The Boatswain" from Gilbert and Sullivan's operetta *H. M. S. Pinafore*:

For he himself has said it,
And it's greatly to his credit,
That he is a Bi-cy-cler !
That he is a Bi-cy-cler !
For he might have played at
base-ball,

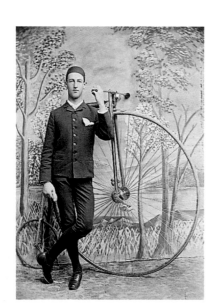

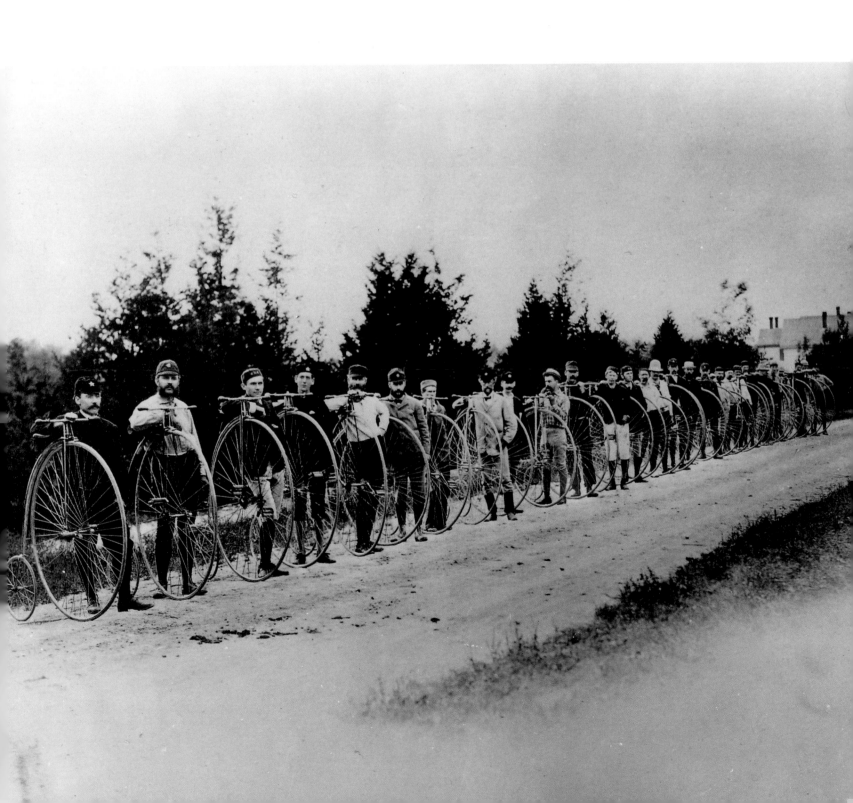

Or at ten-nis, or at foot-ball,
Or per-haps at po-lo !
Or per-haps at po-lo !
But, in spite of all temptations,
Towards other recreations,
He remains a Bi-cy-cler !
He remains a Bi-cy-cler !

The first clubs in Germany were not formed until 1881, a decade after victory in the Franco–Prussian War and the declaration of the Second German Empire in 1871. The impetus came from Thomas Walker, a young English Germanophile sent to Berlin in 1880 as branch manager of the Howe Machine Company, a Glasgow firm which made sewing machines. He immediately imported several bicycles for friends and the following year founded the Berlin Bicycle Club, later known as the First Berlin (Erster Berliner) Bicycle Club, the first of three cycling clubs in Berlin. In 1881, he wrote, edited, and published the first German cycling paper, called *Das Velociped*.

The paper was later adopted by the Norddeutscher Velocipedisten-Bund, a cycling union that Walker had helped to organize in 1882. Based in Hanover, the union represented sixteen northern clubs. After two years of factional rivalries with its sibling in Munich, the Deutscher und Deutsch–Oesterreichischer Velocipedisten-Bund (representing forty-nine clubs from southern Germany and Austria), the two unions merged to form the Deutscher Radfahrer-Bund (DRB), based in Leipzig. The DRB was a German cyclists' union similar in purpose to the CTC in England. Walker, who was the CTC chief

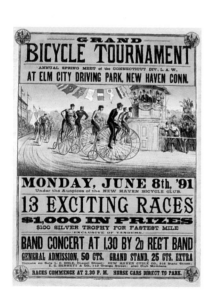

consul for Germany and Austria, also edited its official newsletter, *Der Radfahrer*.

During the 1880s, similar unions were formed in other countries of Europe: in Holland, the Nederlandsche, Velocipedisten Bund; in Belgium, the Fédération Vélocipédique Belge; in Switzerland, the Union Vélocipédique Suisse; in Spain, the Sociedad de Velocipedistas de Madrid; in Bohemia, the Czech Society of Cyclists; in Italy, the Unione Velocipedistica Italiana and the Veloce Club Torinese. Among the Spanish colonies, the Club Nacional Velocipedista was founded in Mexico City in 1883. In the British Empire, clubs included the New Zealand Cyclists' Alliance and the Australian Cyclists' Union, which eventually changed its name to the Victorian Cyclists' Union after other clubs were set up in the states of New South Wales, South Australia, and Tasmania.

One of the main functions of cycle clubs was to organize competitive tours and races. In France, Henri Pagis, who completed a record ride from Paris to Vienna in 1875, formed the Union Vélocipédique Parisienne on the last day of 1876. Years later one member, L. d'Iriart d'Etchepare, recalled that because the bicycle was not yet considered a practical vehicle, the UVP concerned itself mainly with racing. Out of deference to its English counterparts, it adopted amateur classification in its races, thereby excluding professionals. The result was disastrous, as there were too few amateurs, and the union had to fold in 1880. The following year, nine clubs

formed the Union Vélocipédique Française (UVF), which immediately organized championship races in the Place du Carrousel in Paris. To allow its members to race against the English, the UVF also adopted amateur classification, thus excluding the majority of their cyclists and igniting a campaign to abolish this caste-like division.

In 1889, writing in his magazine *Le Cycliste* under the nom de plume Vélocio, Paul de Vivie advocated that *cyclotouristes* should form an organisation similar to the CTC in England. Thanks to his efforts, the Touring Club de France was founded early the following year "pour favoriser le développement du tourisime" (*Revue du Touring Club de France*, no. 597, June 1950: 7). Vélocio also promoted

the formation of the Fédération Française des Sociétés de Cyclotourisme, and was later mythologized as the "Father of French Cyclotouristes."

Amateurs and Professionals

The development of cycling

as a competitive sport in the late nineteenth century provided manufacturers with an unparalleled marketing possibility. Unlike other organized professional sports, including baseball in the United States and soccer throughout Europe, the technology of bicycle racing was an important element in its popularity. Manufacturers, constantly trying to perfect their machines, received valuable publicity every time their bicycles won. The temptation to pay amateur riders to use particular machines was great, and such practices, although widely denounced, became increasingly common. Paying riders allowed them to train professionally, and thus disadvantaged true amateurs,

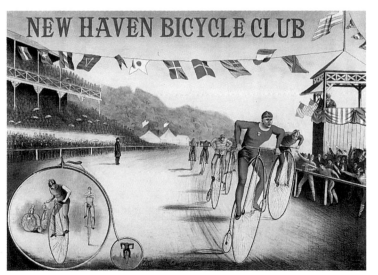

those who rode for the love of the sport but did not enjoy the benefits of full-time training.

The English National Cyclists' Union and the League of American Wheelmen responded to protests of professionals riding as amateurs by drafting the following definition: "An amateur is one who has never

engaged in, nor assisted in, nor taught any athletic exercise for money, or other remuneration; nor knowingly competed with or against a professional for a prize of any description" (Kron 629-31). The terms were strict: a cyclist could lose his amateur status by selling the race medal he had won. Nevertheless, the National Cyclists' Union exempted "makers' amateurs" from the definition until 1886. These riders were considered socially superior to those who raced for a living, despite the fact that they received remuneration from bicycle makers. The "maker's amateurs" were eventually barred in an attempt to abolish class barriers in the developing sport.

The debate over amateurs and professionals concerned issues of class as much as anything else. Professionals were men of the working classes who raced for a living, while true amateurs belonged to social groups who earned their living by other means. In his book *Ten Thousand Miles on a Bicycle* (1887), the tourer Karl Kron recognized the importance of social class when he wrote that, "There should not be any rule that impairs a racing-man's social recognition because he is poor. The logical line of demarkation [sic] which should be insisted on by those who favor a social separation between rich and poor in the cycling world (for that is all which their contention about, 'amateur' and, 'professional' really amounts to), is the line drawn between wheelmen who exhibit themselves on the race-track, and wheelmen who do not" (ibid.)

Kron was an early and outspoken advocate of professionalism in the cycling world. But professionalism and commercial sponsorship were far from antagonistic. Instead of detracting from professional cycling, bicycle manufacturers were considered to be necessary as backers. Kron argued that if "international tournaments" were to exist, they had to be sponsored and promoted by "the Trade" (ibid.) The public which attended races sought performance and, above all, speed. They wanted to see "fliers," as one journalist wrote in *Bicycling World*: "If bicycling wants to captivate the American people, it has got to parade the fliers. If the League wants to spread the glory of the wheel, it has got to beat the British records, and breed the fastest fliers in the world" (9 July 1886: 265). It was therefore imperative that industrial backing pay the costs of cultivating such a breed of riders.

One such "flyer" was John Keen, an English professional racer who built his own bicycles. He began racing in 1869, initially on a velocipede of his own making, and was soon entering and winning championship races. But as he made bicycles, he came to be considered a professional, and was kept from joining the CTC and racing against his friends, who were classed as amateurs. Keen then turned to other activities, including training. He coached H. P. Whiting, who won the 1871 Amateur Bicycling Championship riding a Spider. Whiting went on to win twenty-six of the thirty-two amateur races he entered.

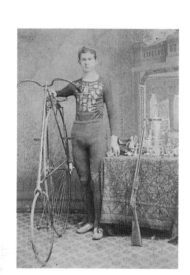

Unable to race against amateurs in the mid-1870s, Keen became something of a racing showman. In particular, he mounted spectacles in which he raced against trotting horses, winning frequently. Keen traveled to the United States in 1876 at the same time as another celebrated racer, David Stanton, who also rode one of Keen's Eclipse bicycles. One or both racers probably demonstrated their machines in the grounds of the 1876 Centennial Exhibition in Philadelphia. Returning to England, Keen was finally able to race in amateur events in 1878 and 1879 after receiving special exemptions from the National Cyclists' Union. In 1879, he raced against the great amateur riders Herbert Liddel Cortis and Ian Keith-Falconer. Cortis, who rode a sixty-inch wheel, held numerous national championships, and later, in 1882, became the first cyclist to achieve the speed of twenty miles an hour. Keith-Falconer also held many records, and in 1882 became the first to ride the "End-to-End" by himself against the clock.

The End-to-End is the ride from Land's End, the most westerly point of England, to John O'Groats, the northernmost tip of Scotland. The first cyclists to cover the distance were C. A. Harman and H. Blackwell, who completed the 896-mile ride in thirteen days in 1880. This challenging ride was considered one of the toughest races at the time, and many riders competed year after year. George Pinkington Mills rode the route throughout the 1880s and 1890s: his best time on an ordinary, completed in 1886, was 5 days 1 3/4 hours. Five weeks later he covered the distance on a tricycle in 5 days 10 hours, and in 1891 on a pneumatic safety in 4 days 11 hours 17 minutes, a convincing endorsement for pneumatic tires.

To authenticate riders' claims to these and other road trials, the Road Records Association was formed in London in 1888 to "verify and certify the genuineness of claims to best performances on record by male cyclists on the road and to prevent the publication of fictitious or uncertified records" (*Boneshaker* vol. 6, no. 54, 1969: 68-9). Reflecting Victorian morality, the association pronounced against riding on the Sabbath for any portion of a record-breaking ride.

The desire to ride marathon distances was evident in the United States as well, though not necessarily as a race against time. On a high wheel bicycle, the adventurous rider could transport himself on extended journeys through unfamiliar and exotic regions. The marathon ride was the logical extension of the sense of freedom and adventure embodied in the bicycle. Coinciding in the late nineteenth century with the image of the hero-explorer, the marathon riders became widely known, not simply through their numerous contacts with locals, but also by recording and publishing accounts of their journeys, so far beyond the conception of ordinary men and women. In their publications, these adventurers became unofficial publicists of the developing bicycle industry.

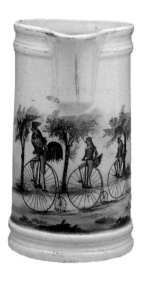

On 29 May 1879, Karl Kron began a ten-thousand-mile journey around the United States with an embarrassing moment, as he fell off his bicycle at the northeast corner of Washington Square Park in New York City. But there was nothing embarrassing in his accomplishment, a journey that lasted five years, during which time he solicited three thousand subscribers at a cost of one dollar each to ensure publication of his journal, *Ten Thousand Miles on a Bicycle*. The book was designed "for men who travel on the bicycle. Its ideal is that of a gazetteer, a dictionary, a cyclopaedia, a statistical guide, a thesaurus of facts" (Kron, preface).

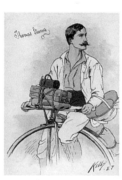

Kron's accomplishments were matched, if not surpassed, by Thomas Stevens, who gained the successive appellations of "Hero of the Wheel," "King of the Cycling World," and, "Knight of the Nineteenth Century." Stevens' unique and courageous feat lay in becoming the first cyclist to ride around the world. He began the journey in San Francisco on 22 April 1884, at age 29, riding a Columbia Standard high-wheeler. He arrived in Boston on 4 August of that year, where at a reception he received, in exchange for his old machine and as an encouragement for his trip, a nickel-plated Expert Columbia from Colonel Albert Pope.

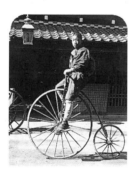

Stevens then rode to New York, where he had to spend eight months seeking the means to finance his travels. He began writing about his journey across America and, on the advice of Karl Kron, sold his account to *Outing* magazine. Sponsorship finally came when Pope, who subsidized the magazine, commissioned Stevens to write monthly reports to be serialized in *Outing*. Included with these reports were rough sketches of the incidents he described, which the illustrator William A. Rogers and others transformed into vivid adventures for a stay-at-home public. These reports were subsequently published in a two-volume book, *Around the World on a Bicycle*, over a thousand pages long and containing 178 illustrations. Stevens completed his journey in Yokohama, Japan on 17 December 1886, having cycled 13,500 miles.

Joining Kron and Stevens was another "Hero of the Wheel," Joseph Pennell, an artist, author, and pioneer of cycle touring in the 1880s and 1890s. Pennell was born in Philadelphia in 1860, and began his studies there. But like his friend and compatriot, the painter J. A. M. Whistler, he then went to Europe and made his home in London. He produced numerous books, but his chief distinction was as an original etcher and lithographer, and notably as an illustrator. Pennell was introduced to bicycles on a boneshaker in 1875. The following year he visited the Centennial Exhibition in Philadelphia, falling when he tried one of the English models. Pennell purchased an English high-wheeler the next year and eventually organized the Germantown Bicycle Club, which participated in the founding LAW meet in Newport. In 1881 he received

Left, top to bottom:
"Crossing the Sierra Nevadas". Print from Stevens' ride.

Thomas Stevens. 1887.

A privileged Japanese boy pictured on a high-wheeler. c. 1888. demonstrates the impact of Stevens' achievement.

Right: Lakin's Standard Cyclometer. 1885.

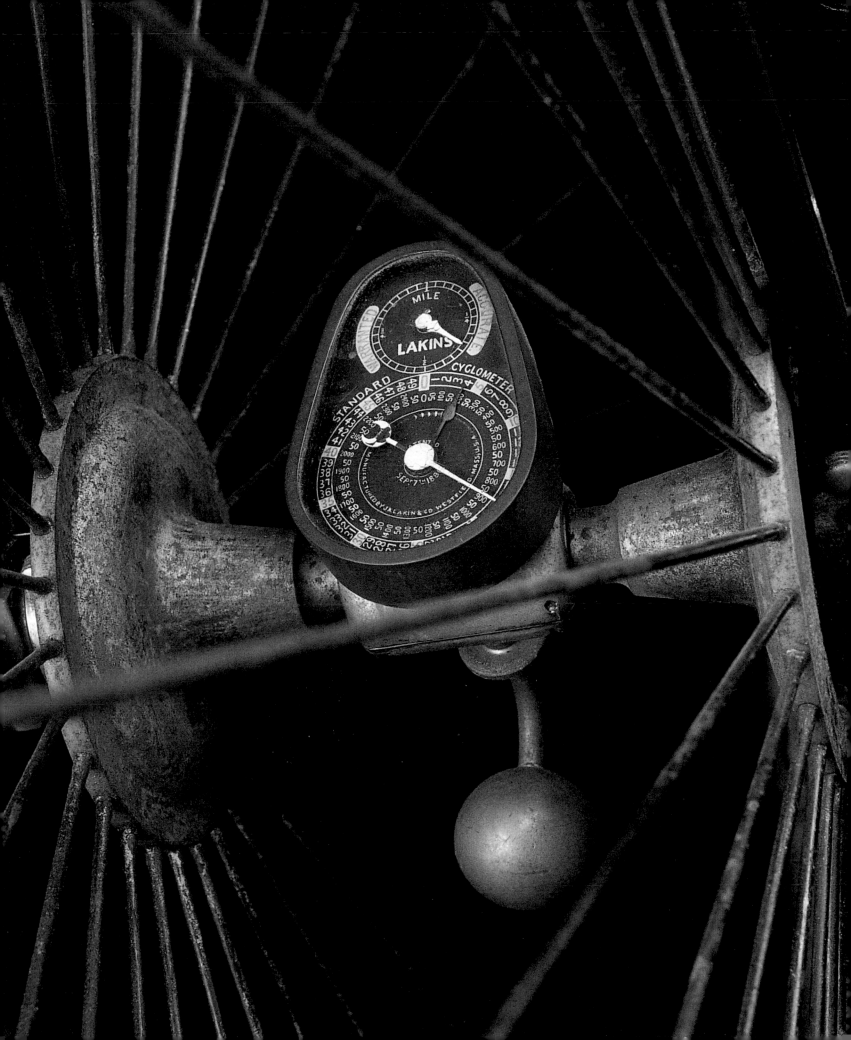

his first commission, to illustrate articles in *The Century Magazine*. This took him to Europe, where he stayed for the next thirty-three years. As the official London representative of the LAW, Pennell joined both the CTC and the Pickwick Bicycle Club.

Pennell's first tours in England and Italy, riding a Coventry Rotary tricycle, appeared as short articles in *Outing*. Like Kron and Stevens, his success was predicated on a growing reading public of books and magazines. But it was also made possible by his wife, Elizabeth Robins Pennell, who began to travel with him and write about all they saw. The pair soon became bicycling's most famous couple.

The Pennells' honeymoon was a bicycle tour which retraced the route of Chaucer's pilgrims; their experiences were published in an

Magazine, an idea they repeated in France. In 1891, their interest in gypsies took them on a tour (by this time on safeties) through Belgium, Prussia, Saxony, Bohemia, Bavaria, Austria, Hungary, and Transylvania. This trip, commissioned by *The London Illustrated News*, resulted in the book *To Gypsyland*, in which Mrs. Pennell wrote, "No more beautiful month in our life together can I recall" (*Wheelmen*, no. 11, 1977: 7). Their last work was *Over the Alps on a Bicycle*, published in 1898.

The Pennells have been described as "the most articulate couple alive, for all their reactions to art, life, and beauty, were given expression in the wife's poised and cultivated prose and the husband's eloquent graphic illustrations" (ibid).

illustrated book entitled *A Canterbury Pilgrimage*. They first toured together on a Coventry Tandem, then switched to a Humber Tandem for its improved design and appearance. Their next tour was in Italy. In 1886, they pedalled to all the cathedral towns in England to make etchings for *The Century*

Years after their last tour, they continued to convey vividly their passion for cycling: "To us of yesterday, the joy was and still is, in discovery of the unknown road and the untried inn. For the motorist of today, all is charted, certified, and known, and even if he camps out, he camps in a crowd!" (ibid.)

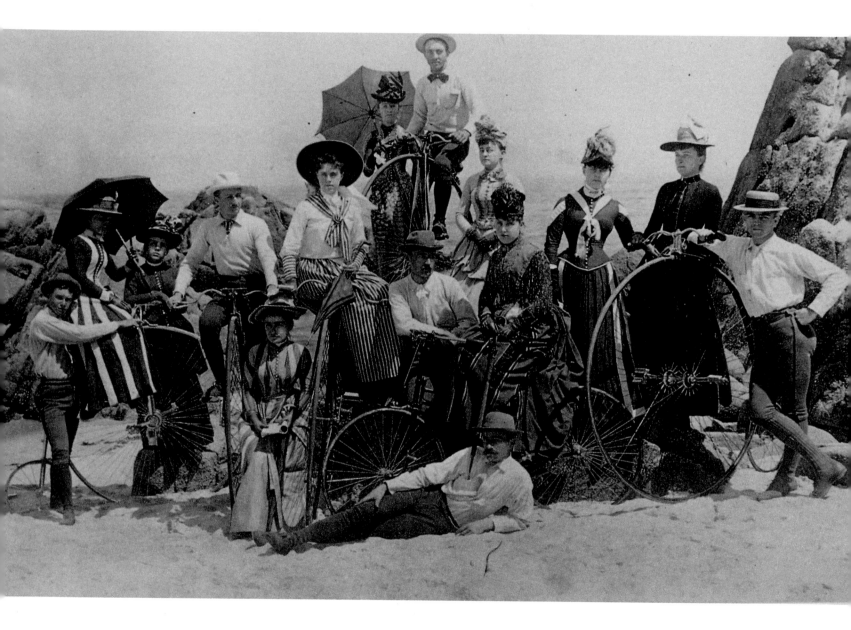

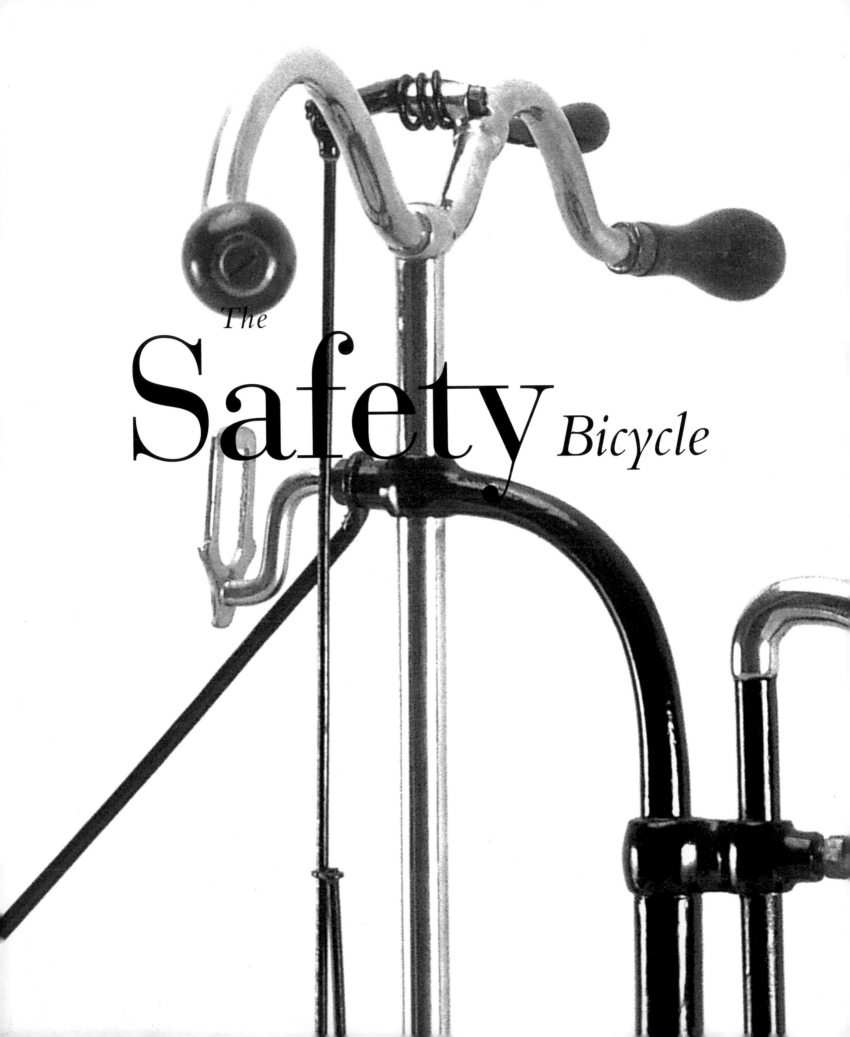

The Safety Bicycle

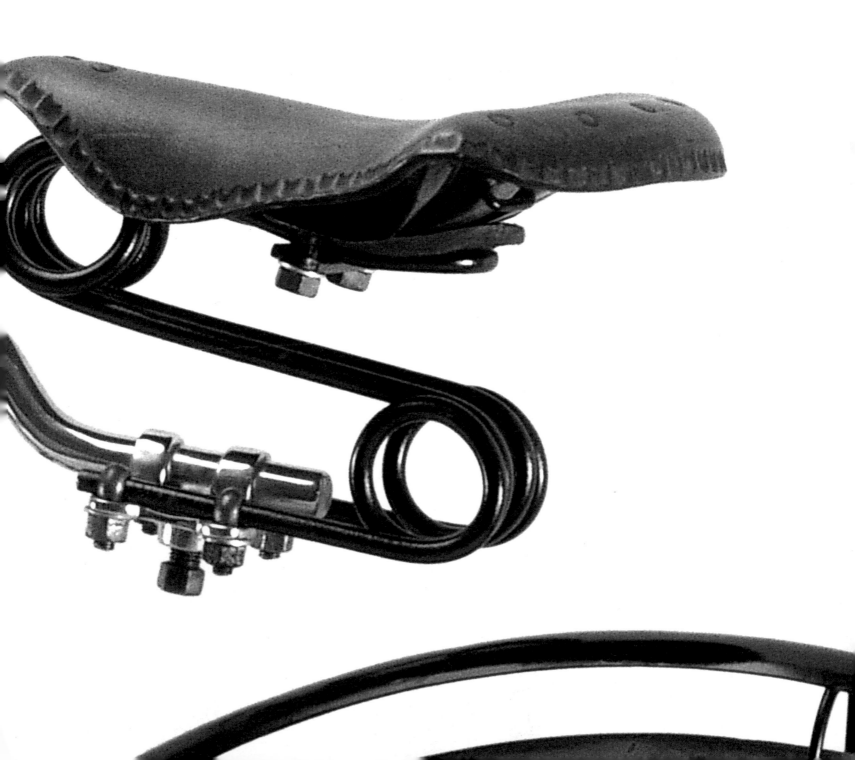

The inventor of the safety bicycle—the recognizable rear wheel chain-driven bicycle of today—remains contested among bicycle historians and enthusiasts, though not to the extent of the inventor of the pedal velocipede. One model, discovered in 1906 and presented that year at the Automobile and Cycle Exhibition in Paris, could have been made as early as 1869 by Meyer and Company from a design by the clockmaker André Guilmet. Known as the Meyer–Guilmet bicycle, it was donated in 1907 to the Conservatoire National des Arts et Métiers in Paris. As Meyer's name is only stamped on the hubs, the wheels alone can be definitely associated with him, especially as he is known to have supplied wheels to other makers. Some experts doubt that Meyer, highly regarded for his exquisite

workmanship, could have built such an ungainly frame and seat spring, or such an ill-fitting chain. Bicycle historians also dispute whether this bicycle was developed during the reign of the velocipede or in the high wheel bicycle era.

Another candidate for inventor of the safety bicycle is George

Shergold of Gloucester, England, who produced a bicycle with a chain drive to the rear wheel and bridle-rod steering sometime between 1876 and 1878. The original is now on show at the Science Museum in London. But as with the Meyer-Guilmet bicycle, the Shergold machine does not seem to have influenced subsequent bicycle design.

It was left to Henry J. Lawson of Coventry to produce a rear wheel chain-driven safety bicycle that inspired other manufacturers to improve their own. Lawson's quest for a safe bicycle may have been due to his own shortness of stature and subsequent inability to mount bicycles with large wheels. It seems more likely, though, that Lawson had a good sense of the growing market in bicycles, for the increasing criticism of the high-wheeler required a major

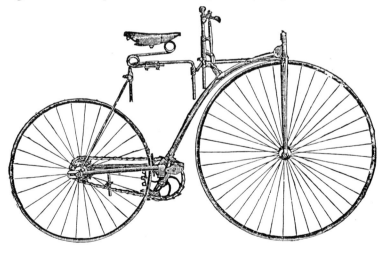

redesign of the bicycle's drive train. In 1876, Lawson built the Sussex Giant, named for its 84-inch lever-driven rear wheel. The same year, this unwieldy machine evolved into the Safety Bicycle, with a far more reasonable 50-inch wheel. Next Lawson produced the Bicyclette, a model he designed in 1879

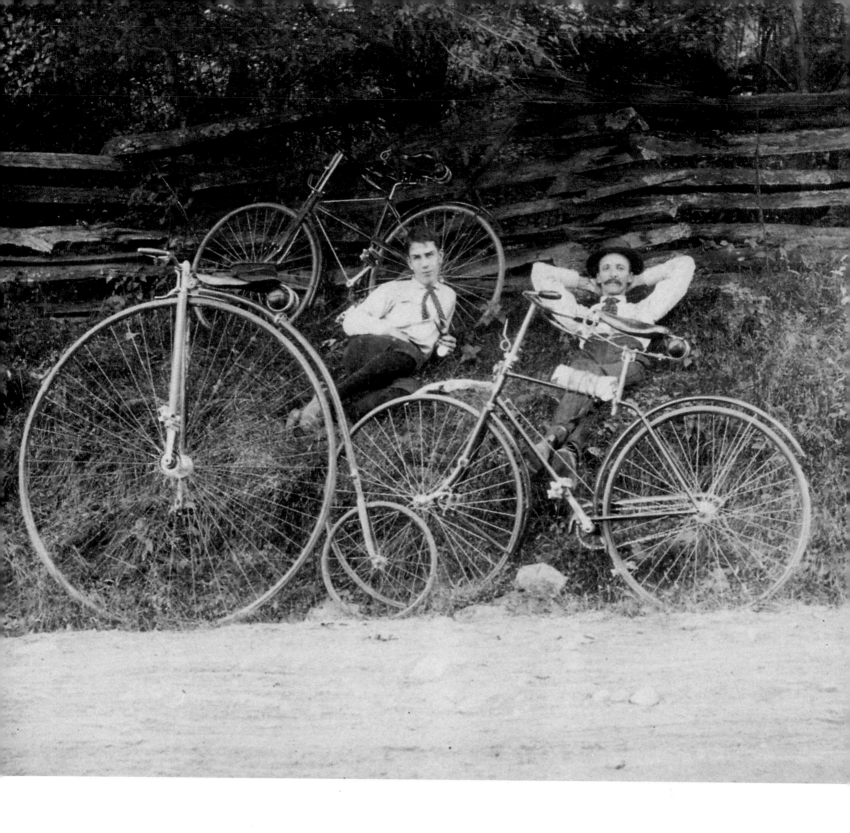

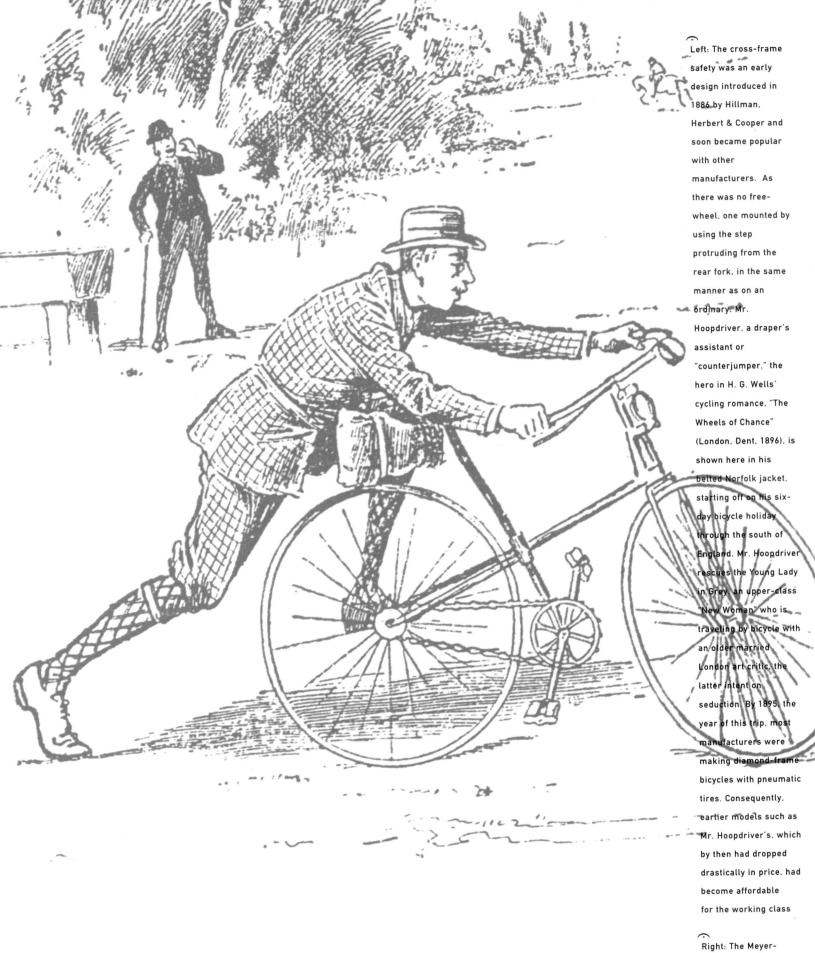

Left: The cross-frame safety was an early design introduced in 1886 by Hillman, Herbert & Cooper and soon became popular with other manufacturers. As there was no free-wheel, one mounted by using the step protruding from the rear fork, in the same manner as on an ordinary. Mr. Hoopdriver, a draper's assistant or "counterjumper," the hero in H. G. Wells' cycling romance, "The Wheels of Chance" (London, Dent, 1896), is shown here in his belted Norfolk jacket, starting off on his six-day bicycle holiday through the south of England. Mr. Hoopdriver rescues the Young Lady in Grey, an upper-class "New Woman" who is traveling by bicycle with an older married London art critic, the latter intent on seduction. By 1895, the year of this trip, most manufacturers were making diamond-frame bicycles with pneumatic tires. Consequently, earlier models such as Mr. Hoopdriver's, which by then had dropped drastically in price, had become affordable for the working class

Right: The Meyer-Guilmet.

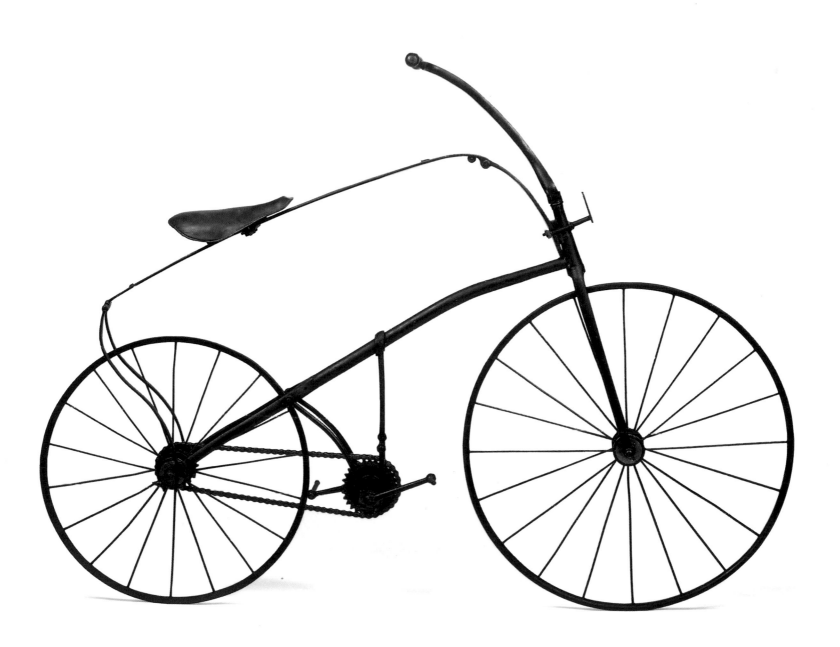

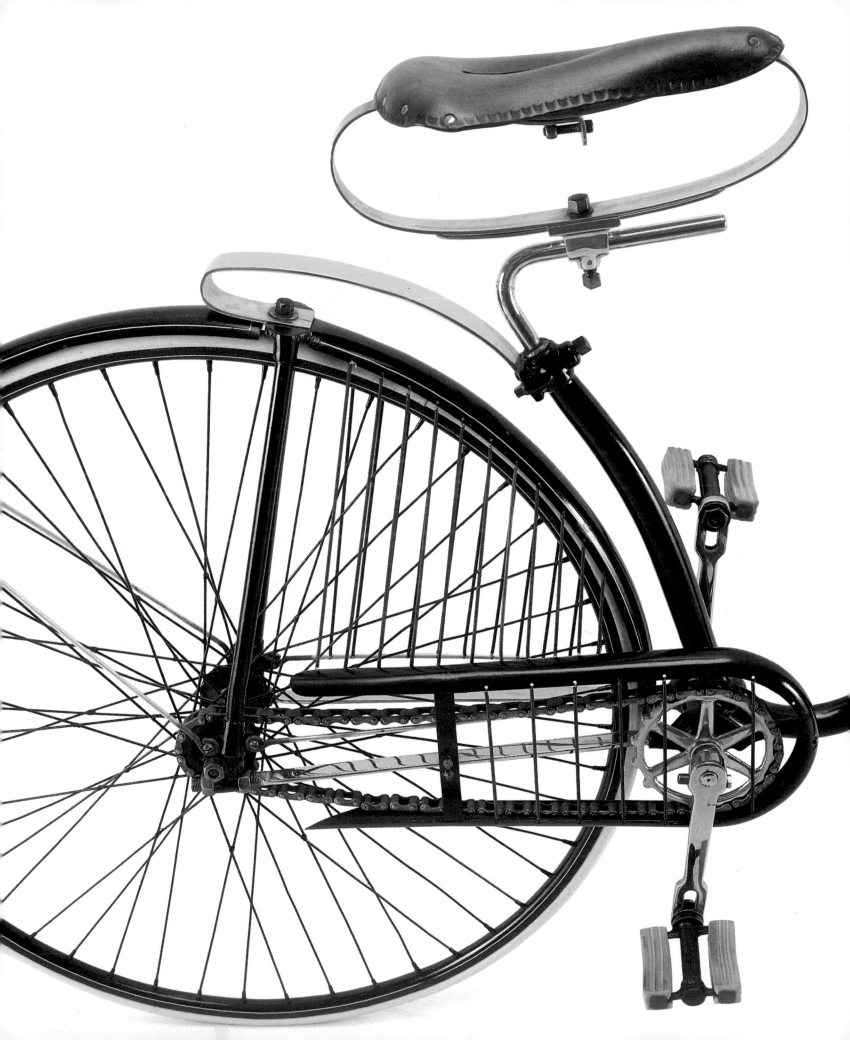

and presented at the Stanley Show the following year. The reaction was one of shock mixed with approval. One commentator reported how "by a peculiar arrangement you worked the hind wheel" (*Boneshaker* no. 18, 1959: 21), while a writer for *The Cyclist* exclaimed, "It's the queerest machine I ever set eyes on." The correspondent admitted, however, that "here, indeed, is safety guaranteed, and the cyclist may ride rough-shod over hedges, ditches and other similar obstacles without the fear of going over the handles. . . and he may even, if so inclined, charge with impunity. . . a brick wall" (ibid.)

The 1885 Stanley Show must have been one of the club's most exciting yearly exhibitions, for a new breed of rear-driven safeties was now added to the impressive variety of ordinaries, high wheel safeties, tricycles, quadricycles, tandems, and sociable tricycles. The CTC *Gazette* heralded its arrival: "Many novelties are again introduced, but the most observable speciality is the Safety Bicycle, which every maker worthy of the name now considers it a religious duty to add to his stock" (Ritchie 129).

The early safety still had a number of drawbacks, including the steering. Some bicycle makers put small front wheels on their machines and adopted a system of indirect steering by bridle-rods, as Lawson had done for his Bicyclette, and the Birmingham Small Arms Company (BSA) did for their safety. By contrast, Humber and Company's safety had direct steering, but still proved difficult to handle

because of its small front wheel. It was as if the early manufacturers of safeties sought to overcompensate for the high wheel by reducing the front wheel to an excessively small diameter. This practice was soon abandoned, and the front wheel recovered some of its original size. John Kemp Starley, the nephew of James Starley, introduced the Rover Safety in 1885. It had bridle-rods as its steering mechanism, but retained a large front wheel, which facilitated steering.

Starley's second version of the Rover Safety, introduced later that year with direct steering, was the first safety to have all the attributes of modern bicycle design. According to *The Cyclist*, the Rover "set the fashion to the world" (Roberts 50). As he explained years later in a letter from the company, safety had not been Starley's goal. Instead, his design was an attempt to improve the rider's mechanical advantage, especially in climbing hills:

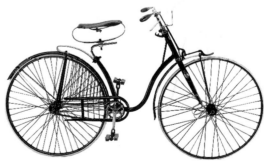

The "Rover" is absolutely the outcome of a determination to obtain advantage previously unknown in a bicycle. We felt confident that a large percentage of unused power could be utilised if the rider were properly placed, particularly with regard to hill-climbing. In this we were not mistaken, as the enormous success of the "Rover"

Far left: Worth Spring-Frame Safety, detail.

Left: Worth Spring-Frame Safety. The Chicago Bicycle Co., c. 1890. This model was noted for its spring suspension system, whereby a total of six springs separated the wheels from the frame. Springs also served to protect ladies' skirts on both the chain-guard and rear fender.

Left: The Whippet
Spring-Frame Dwarf
Safety Roadster.
Linley & Biggs.
London, c. 1887.
"As an anti-vibrator
the Whippet has
gained a reputation
second to none, and
it has now been
sufficiently long
before the public to
prove that our
original estimate of
its merits was well
deserved.
Not only is the
comfort of the rider
enormously
increased, but
the 'life' of the
machine is greatly
prolonged."
(H. H. Griffin,
"Bicycles and
Tricycles of the
Year 1889")
The frame was built
in two parts:
one carried the
saddle, pedals and
handlebar (their
relative position never
changed), which
was attached to the
main frame by a
strong coil spring,
adjustable to
different weights:
the front fork had
a ball-bearing shackle
(attached to the top
section of frame)
which gave a scissor-
like action when in
use. Note that the
color of this restored
example is not
in keeping with the
period.

undoubtedly proves (Boneshaker, vol. 6, no. 55, 1969: 106).

By optimizing the positions of the pedals, saddle, and handlebar in relation to the rider, the Rover managed to obtain the desired mechanical advantage.

When John Kemp Starley introduced the Rover in 1885, the Kangaroo was the most popular dwarf safety, and cyclists, who thought that the Rover was just another dwarf, sought it out because of its larger front wheel. Riders still believed in the convenience of riding high on ordinaries and their high wheel safety cousins. After all, road conditions had not improved, and rain turned dirt roads to mud which would fly up into the exposed chains and gears, eventually impeding all movement. But the dwarf safety caught on within a few years, and by 1889, dwarf safety roadsters made up ninety percent of the bicycles manufactured in England, with over one hundred different models.

Excessive vibration due to poor roads motivated manufacturers to incorporate springs into their bicycles. Various forms of springs had always been used to cushion saddles, but now they became an integral part of the frame, often found on the front fork, and in some cases the rear fork and the seat post. The Whippet, manufactured by Linley and Biggs of London, was one of the most effective models, incorporating springs into the frame itself. First conceived as a rear-drive tricycle in 1885, it was introduced as a safety in 1887. The machine received rave reviews. *Bicycling News*, having tested the machine, reported in 1887 that:

The Whippet is a safety which, we venture to predict will be among the machines of the year. The new "cry" is not speed, nor lightness, nor elegance, but, "anti-vibration", and having ridden the Whippet at 12 miles an hour over the nerve-destroying cobblestones, and up and down a kerb or two (this by way of variety), we can safely say that it has conquered the demon vibration (4 September).

The following year, *The British Quarterly Trade Review* said that the Whippet's "advantages are most apparent on rough roads and in hill-climbing. It has stood some remarkable tests, especially in riding over obstacles, a common and easy feat being to ride from the roadway on to the footpath and off again; over a kerbstone, six or eight inches high, without injuring the machine or inconveniencing the rider" (15 March 1888).

With the arrival of pneumatic tires, which absorbed road vibrations more efficiently than springs, came the demise of the Whippet and a decrease in other spring-framed safeties. Expensive spring-frames became less crucial for comfortable rides, though deluxe models were still available.

European Connections

What Coventry had become to the English cycling industry, Saint-Etienne was soon to be for the French. Located at the heart of a coalmining area, the town was well suited for bicycle manufacturing. It was already a center of heavy industry, with

Right, clockwise from top left: Rudge Cycles, by Frederick Dangerfield Lith., London, 1890.

The Coventry Machinist's Company Ltd. by Edward Ancourt & Cie., Paris, c. 1890, showing the models available in France.

Hillman, Herbert & Cooper Ltd., Coventry, by Frederick Dangerfield Lith., London, c. 1890.

Elliot Hickory bicycle, manufactured by the Elliot Hickory Cycle Co., Newton, Mass., c. 1889. A single piece of hickory served as the structural part of frame and fender.

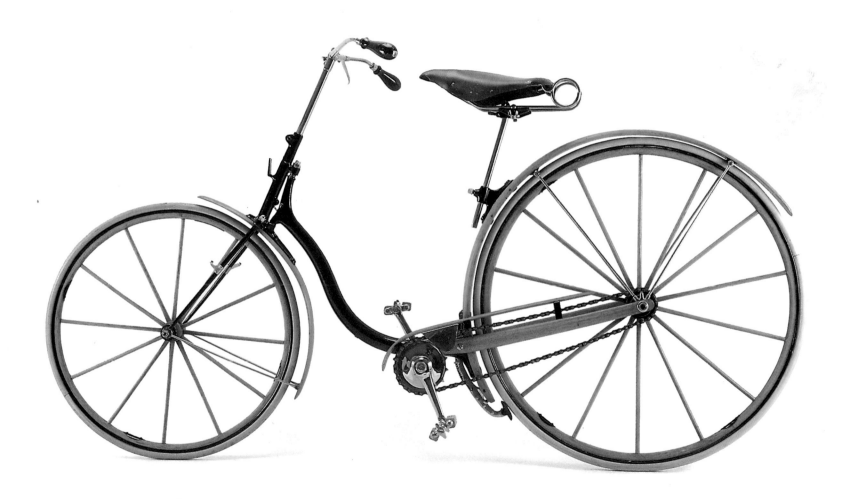

steel and weapons factories and a highly skilled labor force. No special adaptation of milling machinery or lathes was necessary for the fabrication of bicycles, nor was any intensive retraining of mechanics required. There were many examples of this close relationship between the steel industry and bicycle manufacturing, not only in Saint-Etienne, but also in Coventry and other centers of bicycle production.

In 1886, the Rudge Cycle Company of England sent a representative, H. O. Duncan, on a six-day trip by safety bicycle from Montpellier to Paris. The firm's purpose was to publicize its bicycles in France, and Duncan visited velocipede clubs along the way. Duncan himself was not unknown in France, for he had ridden in high wheel races, competing since the early 1880s against local champions such as Frédéric de Civry, Paul Médinger, and Charles Terront.

Arriving in Saint-Etienne, Duncan was received by the brothers Pierre and Claudius Gauthier, mechanics who built their own bicycles and had been members of the Club des Cyclistes Stéphanois since its inception in 1882. Duncan impressed the Gauthier brothers with his ease in climbing hills and, unnoticed by the Englishman, they secretly took measurements of his machine. Nine weeks later they had built a copy.

The following year, 1887, the Gauthier brothers produced a model called La Militaire in response to the French war minister's call for dispatch cyclists. The bicycle found a new role in the military, and most European

countries were to experiment with various forms of bicycle regiments through World War I. But the Gauthiers's fortune was destined to be made in the commercial marketplace. In 1889, they exhibited a machine at the Paris Exposition Universelle, the centennial celebration of the French Revolution. In keeping with the spirit of technological innovation and the use of steel (symbolized by the Eiffel Tower, one of the great engineering feats of the 1889 exposition), the Gauthier bicycle could be quickly transformed into three different vehicles: a tandem tricycle, a tricycle, and a bicycle.

The production of the Hirondelle bicycle is a good example of the symbiotic relationship between the steel and armaments industry and bicycle manufacturing in Saint-Etienne. In a commercial agreement of 1891, a major weapons company, the Manufacture Française d'Armes de Saint-Etienne, ordered three bicycle models to be designed by the Gauthiers. One was the famous Hirondelle ("swallow" in French), a bestseller for years to come. More generally, as workers in the weapons industry were highly skilled and trained, several set up their own workshops, eventually becoming founders, owners, or managers of bicycle companies. In times of peace, the manufacturers filled orders for hunting weapons from May through August, with sales from June through October; bicycle orders came in from January through April, with sales from February through August. If war threatened at any time, they

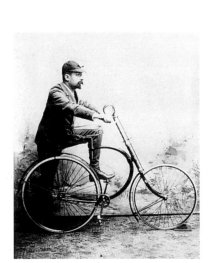

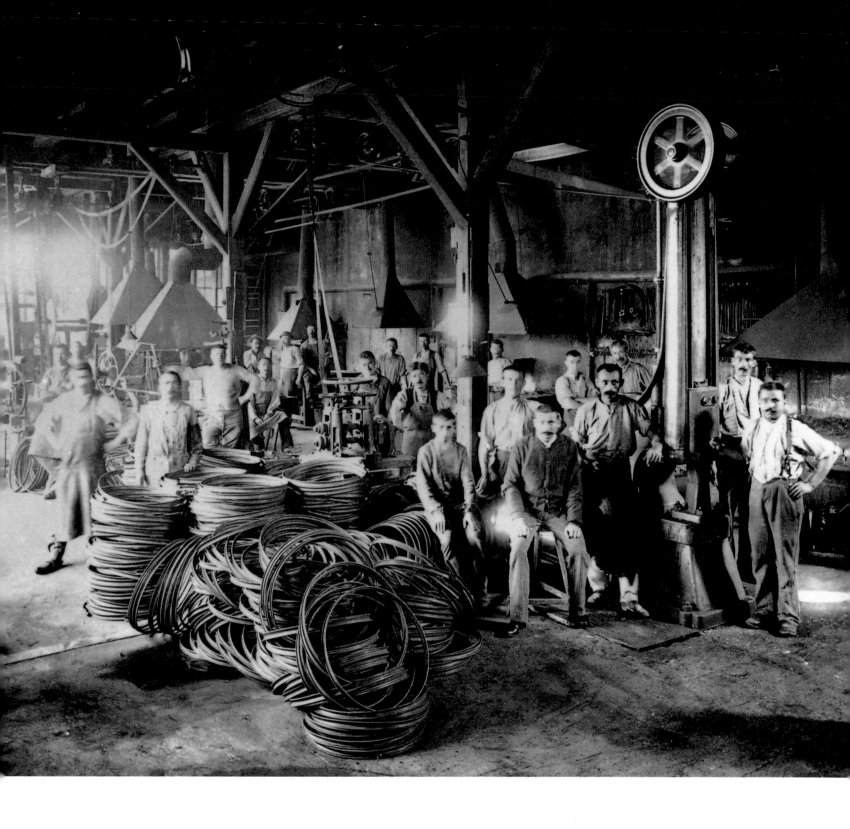

switched to arms manufacturing.

The close relationship between the two industries continued well into the twentieth century, with bicycle companies returning to arms manufacturing, and vice versa, whenever profits dictated. In the years leading up to the outbreak of World War I, manufacturers of bicycle parts were able to turn *en masse* to armaments with little investment in new tools or the adaptation of existing machinery.

As in England and the United States, sewing machine factories in Germany transformed their operations into the production of bicycles. In 1886, three sewing machine manufacturers began making bicycles: Dürkopp in Bielefeld, Opel (the future automobile manufacturer) in Rüsselsheim, and Seidel and Naumann in Dresden. Before 1870, bicycle production had taken place in major urban centers; in the 1880s, it shifted to towns with established manufacturing traditions. In industrial centers such as Nuremberg, Chemnitz, and Westphalia, the availability of raw materials, skilled workers, and machinery, enabled the bicycle industry to flourish.

In 1887, according to the first available statistics, Germany had a total of sixty-four factories with 1,150 workers producing 7,000 bicycles per year. Reflecting the state of German industry generally, most of these companies were small: only seven employed more than forty workers. The factories generally assembled prefabricated parts. After their relatively late start compared to both English and French bicycle makers, German

manufacturers tried to catch up, countering the annual Stanley Show in England with their first bicycle exhibition, the Great German Bicycle Exhibition held in the Crystal Palace in Leipzig in 1889. The show, combined with growing publicity for the new safety bicycles, boosted sales to a point at the beginning of the 1890s where demand began to exceed supply.

Starley's safety caught the attention of the young machinist, Ignaz Schwinn, who worked in bicycle factories in northern Germany. Well aware of its advantages over the high-wheeler, Schwinn spent his evenings designing improvements to Starley's model while he worked during the day in Frankfurt, producing high wheel bicycle parts for a supplier to the manufacturer Kleyer. Kleyer was impressed by Schwinn's ideas, and hired him as designer and shop manager at his factory. The result was the production of the first safety bicycles made in Germany.

Following the surge in demand for safeties, Kleyer's flourishing business required an expansion of production facilities. Schwinn was instrumental in this development, helping to plan and supervise the construction and equipping of a new factory in 1889. In spite of his success and good relations with Kleyer, whose company eventually became the renowned Adlerwerke, Schwinn looked to America for his fortune. In 1891 he emigrated to Chicago, attracted in part, like many other foreigners, by the World's Columbian Exposition of 1892. After working for several

different bicycle manufacturers, he joined with Adolf Arnold to form Arnold, Schwinn and Company in 1895, a firm soon to become one of the most important American bicycle companies.

In Italy, Costantino Vianzone of Turin built the first chain drive bicycle in 1884. It had a wooden frame and wheels of equal size equipped with tires made of rope. His sons developed the business into one of Italy's most important bicycle factories. The next year, following the design concepts of the early safeties in England, Edoardo Bianchi built a cross-frame model. His business also developed into an important brand.

Inventing the
Pneumatic Tire

With the development of the rear wheel chain-driven safety, the bicycle became a more accessible and safer means of transportation. Although close in form to today's cycles, it was still a rough ride. The shock and vibration generated by solid-tired bicycles and tricycles rendered the vehicles uncomfortable and thus undesirable to a large number of potential riders. By switching to rubber pneumatic tires, bicycle manufacturers jumped the final hurdle toward a mass market, for it was the development of the new tires, creating a lighter and more comfortable vehicle, that helped launch the Golden Age of the Bicycle in the 1890s.

John Boyd Dunlop, a Scottish veterinary surgeon with one of the largest practices in Belfast, often used rubber in his surgical procedures. In 1887, he

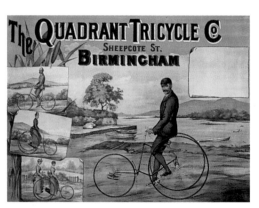

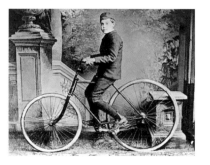

experimented by fabricating a tube out of 1/32-inch rubber and securing it with a thin strip of linen tacked to a wooden disk 16 inches in diameter. After inflating the tube with a football pump, he rolled the wheel across his stable yard and found that it traveled farther than the solid-tired wheel of his son's tricycle.

Satisfied with the result, Dunlop continued with his experiments. In early 1888, he ordered a Quadrant No. 8 tricycle without the rear wheels, which he proceeded to build himself. Unknown to Dunlop, a patent already existed for pneumatic tires, taken out by the Scottish engineer Robert Thomson in 1845. Dunlop patented his own invention in July 1888. In the fall of that year, he bought a new bicycle from Edlin and Company,

follow suit, as this meant re-tooling the machinery, leaving their stock of parts and bicycles obsolete. But though they were not originally conceived for speed, these bicycles performed so well in races that manufacturers soon had to reconsider. The first races took place in Belfast at Queen's College Sports Stadium on 18 May 1889. W. Hume won all four races he entered, riding an Edlin and Company racer with Dunlop pneumatics.

Hume was also the first racer to ride a pneumatic safety in England, winning several races at the Liverpool Police Sports event in July 1889. After the races, he placed the bicycle on display in a cycle shop. The tires were such an unusual site that swarms of people gathered, and the owner of the shop had to call the police to disperse the crowd. To the

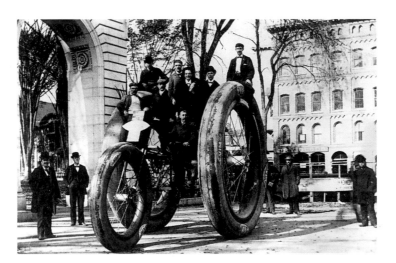

whose front fork and chain stay had been widened to fit his pneumatic tires, which were twice as wide as solid tires.

Sensing the market possibilities, Edlin and Company had new castings made up to accommodate Dunlop's two-inch air tires. At first the rest of the industry was reluctant to

public, pneumatics became something of a laughing matter, and were soon nicknamed "bladder-wheels," "windbags," "pudding wheels," and, in Germany, "liver sausage tires" (McGurn 89–90).

The pneumatic tire revolutionized the bicycle, making the recently introduced

Left: The VIM Tricycle advertised the Boston Woven Hose & Rubber Co.'s VIM tires. In 1896, it was ridden thirty-seven miles from Nashua to Concord, New Hampshire, by ten men in four days, to participate in the Merchants' Week bicycle parade. The tricycle's wheels were eleven and a half feet in diameter and in total it weighed 1,900 pounds. An advance guard was needed to place blankets over the heads of horses to keep them from running off to the next county.

Right: Pneu Michelin. M. de Brunoff & Cie., Paris. c. 1900.

solid-tire safety a lighter and more comfortable vehicle, practical and accessible to all. The invention was also crucial to the development of the automobile and the airplane.

In 1890, Charles Kingston Welch of Scotland and William Erskine Bartlett of the United States both patented a technique of securing tires to wheel rims. The Welch design had a detachable cover with hidden wired edges, the type still used today. In Bartlett's model, called a clincher, inflating the tire locked it into a groove against the rim. Dunlop purchased both patents, guaranteeing his company licensing fees from other firms producing tires of either design from 1894. Dozens of other inventions appeared in the 1890s in an attempt to circumvent Dunlop's monopoly: using laces, open wires, screws, bolts and levers, they included a number of first-rate designs. Nevertheless, Dunlop's company, the Pneumatic Tire Company, quickly dominated the market.

Dunlop's main competitor was the French rubber manufacturer Michelin, founded in Clermont-Ferrand in 1830. Edouard Michelin introduced the first detachable clincher pneumatic tire in 1891. That same year, Charles Terront rode Michelin's tires to victory in the Paris–Brest race, finishing eight hours ahead of his rivals even though a tire had been punctured (and repaired) during the course of the race. In 1892, Edouard and his elder brother André Michelin organized a race from Paris to Clermont-Ferrand to publicize their tires, preparing the route

with nails, arranged in tight rows. All riders were thus exposed to the possibility of flats, and the winner would be the rider with the easiest tires to repair. Henri Farman rode to victory on Michelin tires.

By the 1890s, the tourist industry in France had begun to flourish, as more and more members of the middle classes spent their disposable income on vacations. André Michelin, taking advantage of the growing trend and the arrival of the automobile, published the first Michelin Guide in 1900. The guide listed every city and town with a gas station and contained detailed information on automobile repair shops, food and lodging, and mail, telegraph, and telephone facilities. But the first Michelin Guides also paid considerable attention to bicycling. An advertisement in the first edition showed Peugeot's folding bicycle, a model designed to permit excursions on forest paths or in other remote areas inaccessible to the automobile. The guide also devoted twenty pages to the care of pneumatic tires.

By the 1890s, the bicycle had achieved its definitive modern form, with a rear wheel chain-driven transmission, diamond-shaped frame, and pneumatic tires, rendering the bicycle a comfortable, accessible, and increasingly affordable machine. Many bicycle manufacturers throughout England, Europe, and the United States were already producing tens of thousands of bicycles a year, and they were poised to expand their production during the following decade.

Left: Exterior wall of Bibendum Restaurant, London. The tiles depict Charles Terront the 100 km. Champion in 1888.

Right: Window in Bibendum Restaurant, London. Bibendum was introduced on Michelin posters by the cartoonist O'Galop in 1896. The Latin tag "Nunc est bibendum" promotes the claim that Michelin tires can "drink" nails or glass etc., without incurring a puncture. The window measures nine feet eight inches by seven feet eleven inches.

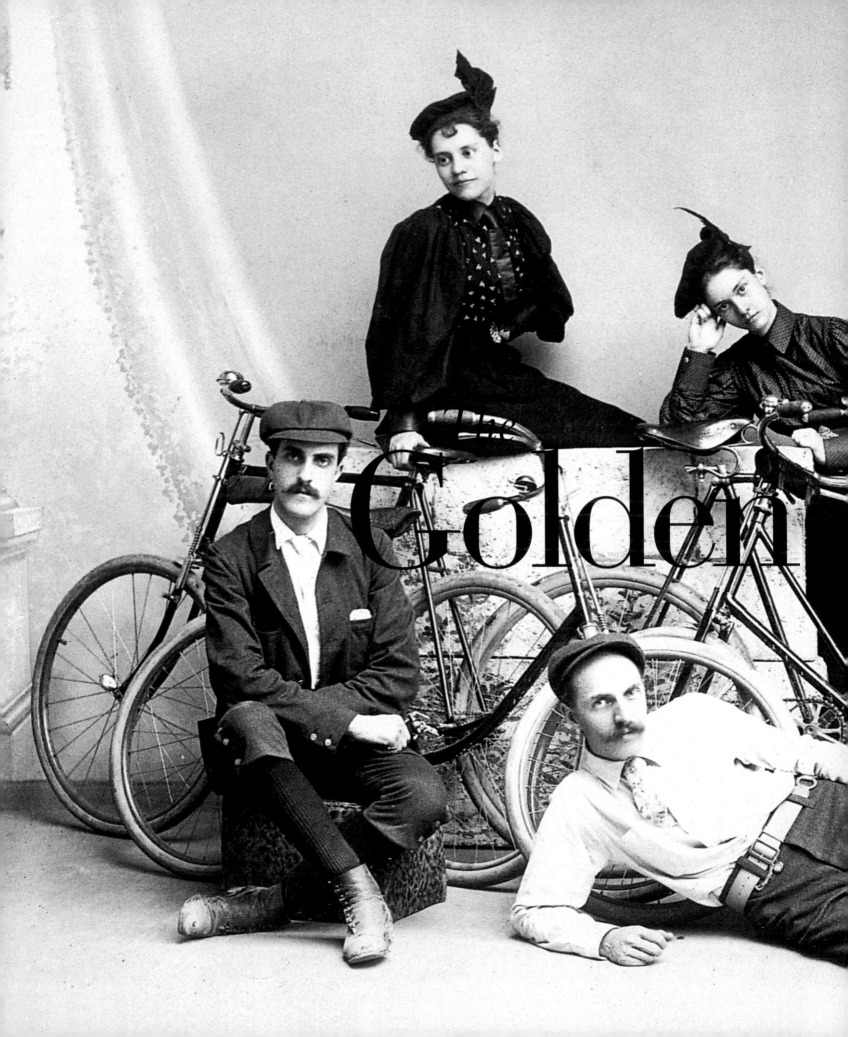

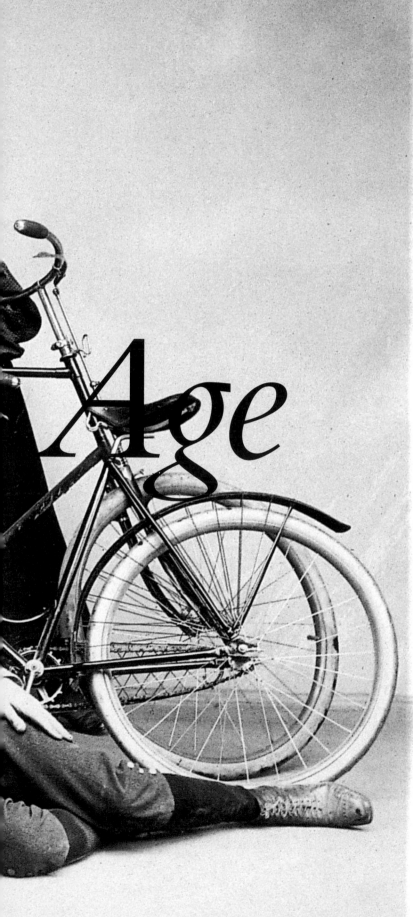

A*ge*

Around 1820, the Draisine and hobby-horse had produced a brief fascination among a highly select public; in the late 1860s, the pedal velocipede attracted a broader following, generating the first bicycle craze, particularly in Paris, London, and New York. In both cases, manufacturers and publicists, fuelled by visions of an increasingly mobile society where two-wheeled vehicles replaced horses, made predictions of universal acceptance. But despite such claims, both crazes were short-lived. Only with the emergence of the pneumatic-tired safety did a genuine swell of enthusiasm occur. The bicycle continued its democratic adventure as a middle-class and, increasingly, working-class public began to cycle. Women, first introduced to cycling in small numbers through velocipedes and in greater numbers with the tricycle, followed. All this led to the bicycle boom of the fin de siècle, a worldwide infatuation which only waned with the coming of the automobile at the start of the twentieth century.

The extent of the bicycle's popularity in Europe and America can be measured statistically by annual production figures, growing club memberships, and, thanks to the taxes imposed on bicycle riders in certain countries such as France, the total number of bicycles. In England, for example, membership of the Cyclists' Touring Club (CTC) rose from 16,343 in 1895 to over 60,000 in 1899. In the United States, where cycling was even more popular, membership of the League of American Wheelmen had grown gradually during the years of the high-

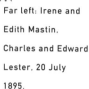

Far left: Irene and Edith Mastin, Charles and Edward Lester, 20 July 1895.

Left: E. Vauzelle, Morel & Cie., mail-order catalogue, 1906–7. From top to bottom: "The American" toe-clip; "Daisy" toe-clip; "Art nouveau" bell; "Butterfly" toe-clip; "Olga" bell; "Odette" bell; "The Cat" toe-clip. The toe-clips were made of steel and leather, and the bells of nickel-plated brass.

wheeler, from forty-four members in 1880 to 3,560 in 1890. By 1898, the club's membership had risen exponentially to 141,532.

Over the same period, the industry in the United States grew from twenty-seven bicycle makers employing 1,800 workers in 1890, to 312 manufacturers employing over 17,000 workers in 1900. Figures for 1896 indicate that there were approximately three million bicycles in the United States, one million each in England and France, and half a million in Germany. The German government resisted cycling, and restrictions varied according to the province and city. As one author has commented, "The freedom, mobility and privacy of the bicycle were more than the authorities would tolerate" (McGurn 94), though they found bicycles useful for policemen and local militia. Italy counted 605,000 bicycles in 1909, and more than

live piano music and protective padding on the walls. In Russia, there were five thousand cyclists in Saint Petersburg, and riders in Moscow even established a Society of Velocipede Enthusiasts.

As with any new technological advance, the bicycle generated its share of skeptics, and became the scapegoat for many of the problems generated by transformations taking place in an increasingly mobile industrial society. Municipal governments, chambers of commerce, and merchants of all kinds complained loudly about the disastrous effects of the bicycle craze on business. In the mid-1890s, bicycles were still costly, and consumers had to restrain themselves from other purchases. In 1896, *The New York Journal of Commerce* estimated that the craze for bicycles was resulting in an annual loss to other trades of approximately $112,500,000 (Smith 54). Jewellers and

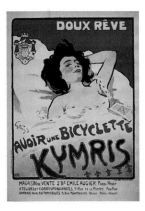

1,225,000 in 1914.

Although Paris and London set the standard and the fashion in new bicycles, the middle-class consumer market had spread throughout Europe by the mid-1890s. Copenhagen was swarming with bicycles, and Amsterdam had some of the best riding schools, complete with

watchmakers complained that people were no longer saving for their products. Piano dealers saw their sales cut in half, as one could buy two bicycles for the price of a single piano. Theater owners blamed bicycles for falling attendances, and tailors complained that men who wore cheap cycling suits were

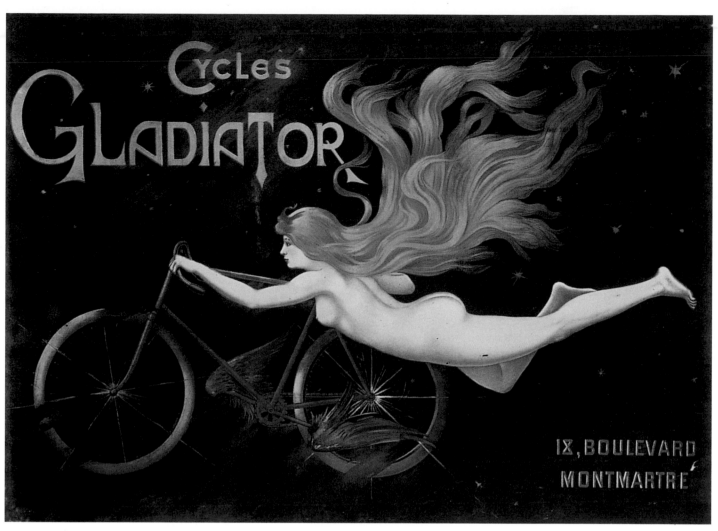

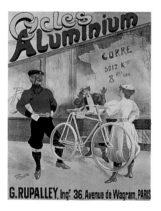

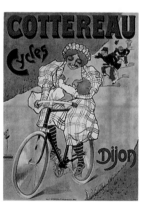

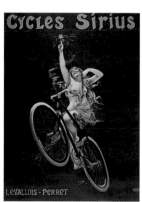

Dursley-Pedersen
bicycle. Contrary to
prevailing design
practice, Mikael
Pedersen, a Dane
living in Dursley,
England, conceived
his bicycle starting
with the saddle.
After making an
extremely
comfortable
hammock of woven
silk-covered cords,
he found that it
would not fit a
conventional frame
and so in 1893 he
developed what was
mistakenly called a
"cantilever" frame. It
proved to be quite
popular in England
with production
continuing until the
First World War.

not wearing out their good clothes. A bicycle, costing about the same price as a good suit, supposedly put forty percent of the twenty thousand tailors in New York out of work. Bicycling caps replaced hats, and hat sales fell. When men went out cycling and missed their regular Saturday shave, barbers could not sell them two shaves the following day. While on the wheel, men no longer smoked their Sunday cigars, causing consumption to fall at the rate of one million a day by 1896 (annual consumption had fallen by seven hundred million cigars since the beginning of the craze). According to newspaper and book publishers, cyclists were reading less—with the exception of *Harper's Weekly*, which often carried illustrations and articles on cycling and ran numerous ads for new models.

In the United States, one critic called the bicycle "the first big-scale assault of American technology on institutionalized religion" (Smith 72). The Sabbath, reserved for worship in the morning and a family gathering in the afternoon, had been corrupted by cycling. People were out riding when they should have been at mass. Bicycling might have been more acceptable if riders cycled to church, but they did not. The increasing numbers of races held on Sundays made things even worse. A clergyman in New Haven, Connecticut, warned that the road of the cyclist led "to a place where there is no mud on the streets because of the high temperatures" (Smith 72).

For one brief moment, it seemed as if the predictions made

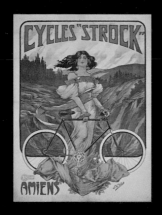
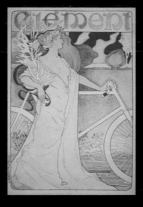

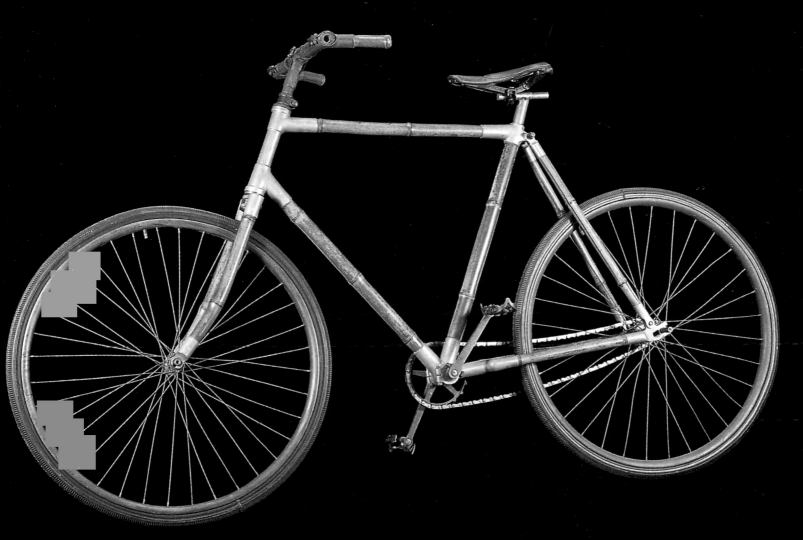

since the first appearance of the Draisine might come true: the bicycle would replace the horse. Indeed, in many American cities, the number of horses diminished significantly with the increased use of the bicycle and the development of electric trolleys. It was estimated in 1895 that about a quarter of a million fewer horses were needed in the United States, and Chicago alone made seventy-five thousand redundant. With horses costing about $125 each, the economic effect of bicycles and trolleys on the horse trade was enormous. Yet despite the cycling craze, it was the automobile, not the bicycle, which would replace the horse.

Bicycles and Bloomers

If the cycling craze of the 1890s restructured consumer demand

beauty—it redefined women's social and political roles as well.

The classical Victorian image of female beauty, shared by middle- and upper-class men and women throughout Europe and the United States, insistently exaggerated the shape of the female body, while covering up the flesh. Female curves were accentuated by tightening the waist with corsets that greatly restricted mobility, especially when coupled with long and heavy skirts. This aesthetic of the female body constituted a moral code backed by the medical opinion of the period. "Loose" women went uncorsetted, while "straight-laced" women followed normative aesthetic and moral codes. Doctors encouraged the use of the corset, claiming that it strengthened otherwise weak bodies. Women's

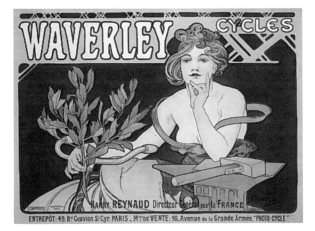

in subtle ways, it fundamentally transformed social relations, in particular relations between the sexes. The adjustment lay as much in the greater mobility gained by women as in their newly acquired freedom from the constraints of fashion. The bicycle did more than change the idea of female

reproductive functions, from puberty to menopause, were considered incapacitating experiences which, together with fainting spells (often caused by excessively tight corsets), required them to lead demure lives. Thus medical opinion rationalized the enclosure of women inside the home, setting up further

Left: Waverley Cycles by Alphonse Mucha. F. Champenois. Paris. 1898. Mucha came to prominence with his posters of Sarah Bernhardt. As with other artists of the Art Nouveau style. Mucha gave greater importance to the style and mood of his bicycle posters than to the details of the machine itself.

Right: Déesse. by PAL. Paul Dupont. Paris. c. 1898. Nike heralds the French brand of the Rudge Bicycle Co.

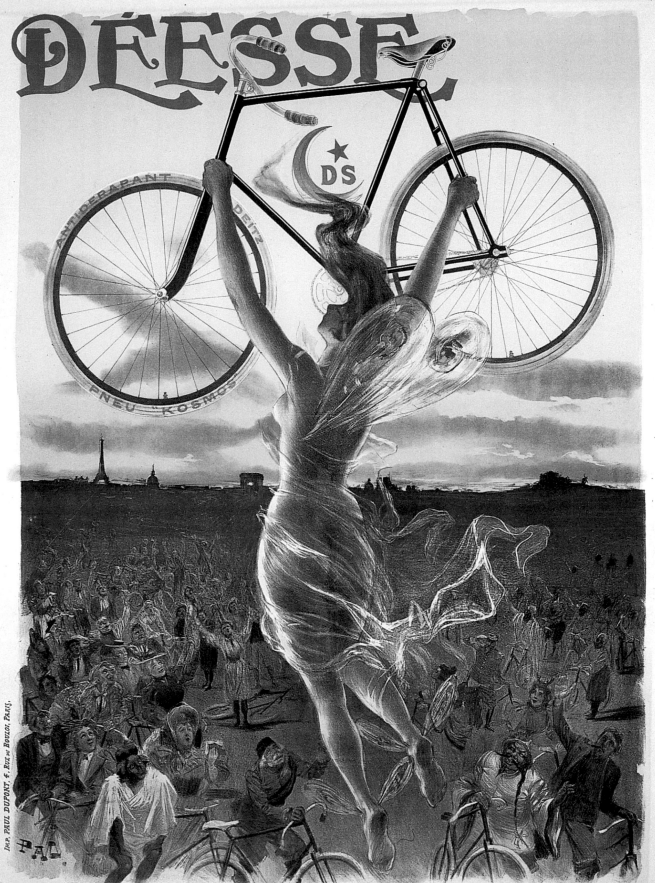

barriers to female participation in the predominantly male public sphere, including education, work, or politics.

In the late nineteenth century, as women began to gain access to such activities, male superiority became defined in increasingly physical terms. Charles Darwin's theories of natural evolution, especially his assessment of women's role in the evolutionary process expounded in such texts as *The Descent of Man* (1871), encouraged the male obsession with musculature and strength. City living and a less active lifestyle were widely perceived as a source of weakness and "effeminization" in men, thus encouraging the growth of sports—including bicycling—that improved physical fitness. Gymnasiums sprang up in cities and many colleges added sports to their curricula. Activities such as cycling, soccer, cricket, boxing, and baseball all helped to reinforce the image of male physical superiority, as did the re-establishment of the Olympic Games in 1896.

Although feminist reform movements had championed women's sartorial rights for decades, it was only in the 1880s that the bloomer became widely adopted—and fiercely contested. The garment itself dates from 1849, when the American feminist, Amelia Jenks Bloomer, advocated loose Turkish trousers gathered at the ankles and worn under a short skirt. Bloomer's cousin, Libby Miller, first fashioned the trousers from costumes she saw worn by women in Swiss sanatoriums to counteract the effects of tight-laced corsets and lack of exercise.

Far left: Before the bloomer.

Left: Ironstone plates by Henri Gray. Sareguemines, France. c. 1895. Gray was also a prolific poster artist.

Right: The Cygnet Cycle. Stoddard Manufacturing. Co., Dayton, Ohio. c. 1898. The 1897 catalogue noted: "As curved lines are more beautiful than straight lines or angles; as the Swann is more graceful than the Stork, so the 'Cygnet' Cycle is more artistic and graceful than the Diamond-frame wheel." The Cygnet's curved frame was designed to absorb all shocks, and a beautiful and rare feature was its celluloid fender.

Three decades later, the bloomer was at the center of the debate over "rational dress."

The Rational Dress Society was founded in England in 1888 with the purpose of encouraging women to abandon their corsets and cumbersome and weighty skirts. The association's newsletter was an important instrument in educating women about their condition and enabling them to make decisions about their dress. The society's secretary, Mrs. Carpenter-Fenton, declared in the opening statement of its first issue:

The Rational Dress Society protests against the introduction of any fashion in dress that either deforms the figure, impedes the movements of the body, or in any way tends to

deforming. The maximum weight of under-clothing (without shoes), approved of by the Rational Dress Society, does not exceed seven pounds (Rational Dress Society's Gazette no. 1, April 1888: 1).

The author went on to describe the dangers involved in women's dresses, as well as the premature aging engendered by "non-rational clothing." The newsletter ended with an article on "The Weight of Women's Clothes," stating that women's fatigue from walking was not the result of natural weakness, but was caused by exhaustion from wearing heavy clothes which swept the floor and gathered dust and dirt (ibid. 7).

In the 1880s, the bicycle entered into the debate about

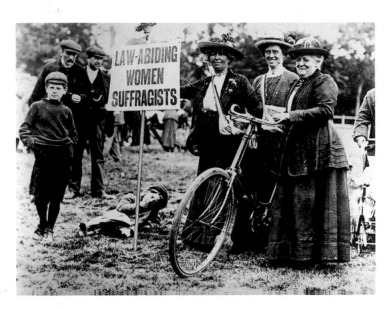

injure the health. It protests against the wearing of tightly-fitting corsets, of high-heeled or narrow-toed boots and shoes; of heavily-weighted skirts, as rendering healthy exercise almost impossible; and of all tie-down cloaks or other garments impeding the movements of the arms. It protests against crinolines or crinolettes of any kind as ugly and

rational dress. Indeed, the tricycle, and shortly thereafter the bicycle, became the vehicle upon which a more general argument for women's rational dress was mounted. In 1883, Mrs. E.M. King, secretary of the Rational Dress Association in England, wrote a letter to the CTC *Gazette* complaining that

Left: Women's suffrage. 1913. Cyclists came from all over England to attend a rally in support of a woman's right to vote.

Right: The Gentleman's Model Old Hickory, detail. Tonk Manufacturing. Co., Chicago. 1896. It was made from sixteen plys of laminated second growth hickory hollowed out and formed with no joints at the corners. Forks, stays, rims, handlebars, chain guard and fender are all made of wood.

Far right: Details of the Ladies' Model Old Hickory.

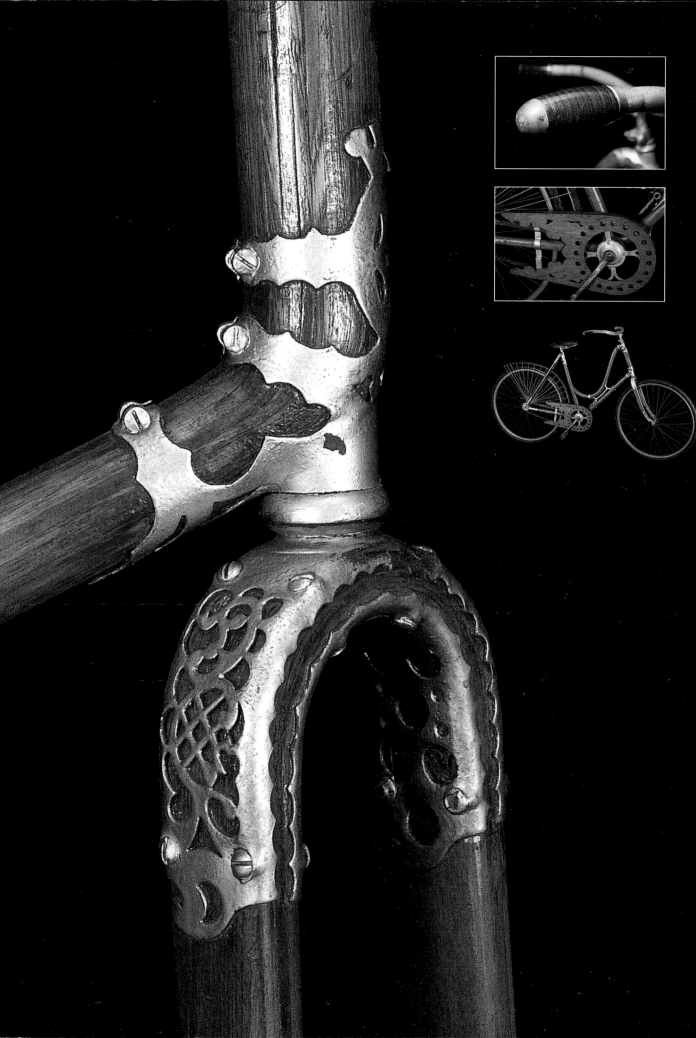

women who took up tricycling had not adopted rational dress. She went so far as to say that "the ladies and gentlemen who at present ride cycles are of that class who are so dreadfully afraid of not being thought ladies and gentlemen, that they cannot venture on any novelty in dress, or to appear to countenance it, until it has received the cachet of a superior class" (*Boneshaker*, vol. 5, no. 50, 1968: 189).

From a practical standpoint, women who rode needed more suitable clothing—either shorter skirts or bifurcated garments such as divided skirts or bloomers—to avoid entanglements in the wheels, chain, and pedals. In 1890, Lillian Campbell Davidson, who wrote the "Ladies' Column" in the *Gazette*, described a new French cycling outfit that resembled a "shooting dress," with a short dress worn over dark cloth leggings. This outfit had apparently been spotted in southern England, much to the terror of the local inhabitants. A month later Davidson wrote that the Parisian "shooting dress" had evolved, the skirt had been discarded and only knickerbockers were worn, allowing comfort for the rider at the expense of the observer. The horrified (male) editors of the *Gazette* fired Davidson in 1894 after she claimed that ladies in southern England were "all eagerly awaiting woman's emancipation from the bondage of the skirt" (ibid.)

Davidson's successor, Fanny Erskine, took a more conservative view, stating that because women foolishly wore rational dress, cycling was not

popular among the better classes. Besides, the "new woman" was the exception, not the rule, and was not to be an example to young ladies seeking employment. The review, *Cycling*, had a similar attitude, tending to avoid this contentious issue.

Fanny Erskine would have been alarmed by the women in Berlin who, in 1891, petitioned the city police for permission to wear the same silk tights in public parks that they had been accustomed to wearing in riding schools. And she would have been relieved, no doubt, to learn that the chief of police rejected the request on the grounds that it would create a public distraction. Only in the circus or the music hall could women on bicycles appear in silk tights.

But if silk tights crossed the boundary of acceptable appearance, women's cycling gear still offered a range of options, all carefully explicated in the numerous fashion columns attuned to the new phenomenon of cycling fashion. For those women hesitating between skirts and rationals, for example, columnists suggested an alternative: the divided skirt. The advantage of this style was that the division was virtually imperceptible when walking and even allowed the wearer to ride a man's frame bicycle. The divided skirt thus offered the advantages of the bloomer while avoiding the attendant controversy. A number of fashion writers who disapproved of the divided skirt suggested wearing a full skirt that was sufficiently ample to drape evenly on both sides of the saddle. One proponent of this voluminous skirt felt that

bloomers were either wide and baggy and therefore ungraceful, or of the "Parisian variety," tight and too conspicuous.

With the many available sartorial options, the fashion industry for women's cycling wear enjoyed a small boom. Manufacturers offered clothes with a range of practical features: reversible or waterproof cuffs and collars, veils for use in dusty weather, corsets knitted with elastic sides, and skirt clips for those embarrassing moments in gusty wind. Women seeking finer details could purchase matching outfits in tweeds and serges; knickerbockers of silk, satin, or brocade, to be worn beneath dresses instead of petticoats; or bloomers lined with chamois or fine merino wool. Designers were influenced by the Russian blouse, perfect for outdoor wear with its invisible front fasteners, braid trimming, and fur edging on matching cuffs and collars. Cravats were very popular as they could easily dress up any blouse. Milliners offered hats decorated with trimmings or bunched bows of taffeta scarves. Having an outfit that went with your bicycle could also be quite a fashion statement, as it was for Thomas Hardy's wife, Emma, who in 1895 was the first woman cyclist in Dorchester. Every day she went out riding at 7:45 A.M. wearing a green velvet dress to match her green bicycle.

The tricycle and the bicycle thus helped to liberate women from their clothes and, by extension, from their domesticity and isolation. There is a certain irony in the fact that the factories of the sewing machine industry which had burdened women with corsets and skirts eventually produced the machines that freed them from oppressive clothing.

Stephen Crane provides a vivid description of the contemporary female cyclist from the male perspective in an article on Broadway, "New York's Bicycle Speedway":

The girl in bloomers is, of course, upon her native heath when she steers her steel steed into the Boulevard. One becomes conscious of a bewildering variety in bloomers. There are some that fit and some that do not fit. There are some that were not made to fit and there are some that couldn't fit anyhow. As a matter of fact the bloomer costume is now in one of the primary stages of its evolution. Let us hope so at any rate . . . No man was ever found to defend bloomers. His farthest statement, as an individual, is to advocate them for all women he does not know and cares nothing about . . . We are about to enter an age of bloomers (New York Sun, 5 July 1896).

But the age of bloomers never really arrived. Across Europe and North America, voices were raised in opposition to women's rational dress, whether on or off bicycles. In England, some hotels denied access to women in rational dress as late as 1898. Lady Harberton, wife of Viscount Harberton and treasurer of the Rational Dress League, was refused admittance to the coffee room of the Hautboy Hotel in Surrey on account of her rationals. She had shown her CTC badge, expecting to be served in the same manner as other members, but was instead

shown the odorous bar parlor, with sawdust, spittoons, and a handful of working men smoking. She quickly rode off.

On her behalf, the CTC subsequently sued the hotel, but to no avail. The defense submitted a photograph of a room with a beautifully appointed table with flowers, and the jury decided in favor of the innkeeper, who admitted never serving a woman in rational dress unless she first put on a skirt. Much publicized, the case nonetheless had a positive effect in breaking down the opposition among hotel owners to rational dress. Aware of such opposition, the CTC handbook, in a section entitled "Hints on Touring," advised ladies to carry a skirt to wear over their rationals when not riding.

In the United States, it was not skirts that hid rationals, but, according to a satirical poem of 1896, bloomers that concealed activities—drinking, reading, firearms, politics, and business—considered forbidden to women:

Some observing man discovered
(How I've never thought to ask)
That Kentucky maidens' bloomers
Have a pocket for a flask;
That the cycling girl of Texas
As she rides is not afraid,
She provides a pistol pocket
When she has her bloomers made;
That the bloomer-girl of Boston
Always cool and wisely frowning,
Has a pocket in her bloomers
Where she carries Robert Browning;
That the Daisy Bell of Kansas,
Who has donned the cycling breeches,
Has a pocket in her bloomers
Full of women suffrage speeches;
That Chicago's wheeling woman
When her cycle makes rotations

Has a special bloomer pocket
Where she carries pork quotations
(Mackenzie 20-21).

Such caricatures and objections to women's cycling wear often masked a deeper concern: whether women should cycle at all. The example of Emma Eades, one of the first women to ride a bicycle in London, suggests the extent to which certain social classes resented female cyclists. Eades had cut her hair short, and wore divided skirts and a little straw hat when she went on Sunday rides with the men of her father's cycling club. Although accepted as a member of the club, she was ostracized and abused when she rode alone: men threw bricks at her in the street, used obscene language, called her a "fast woman," and shouted at her to go home where she belonged. Instead, Eades took up exhibition riding at the notorious Alhambra club, a behavior considered so scandalous that it was hushed up even in her own family.

Much of the problem stemmed from the association of bicycles with horses. According to conventional wisdom, women should only ride horses sidesaddle, for physiological reasons. But as they could not keep a safe grip on the horse with both legs in this position, women could not ride very fast or far. On bicycles, however, women were freed from such traditional handicaps and could enjoy an unprecedented liberty of movement and association. For a woman to defiantly vault the crossbar and ride a bicycle in public showed an alarming degree of independence and in many people's eyes threatened

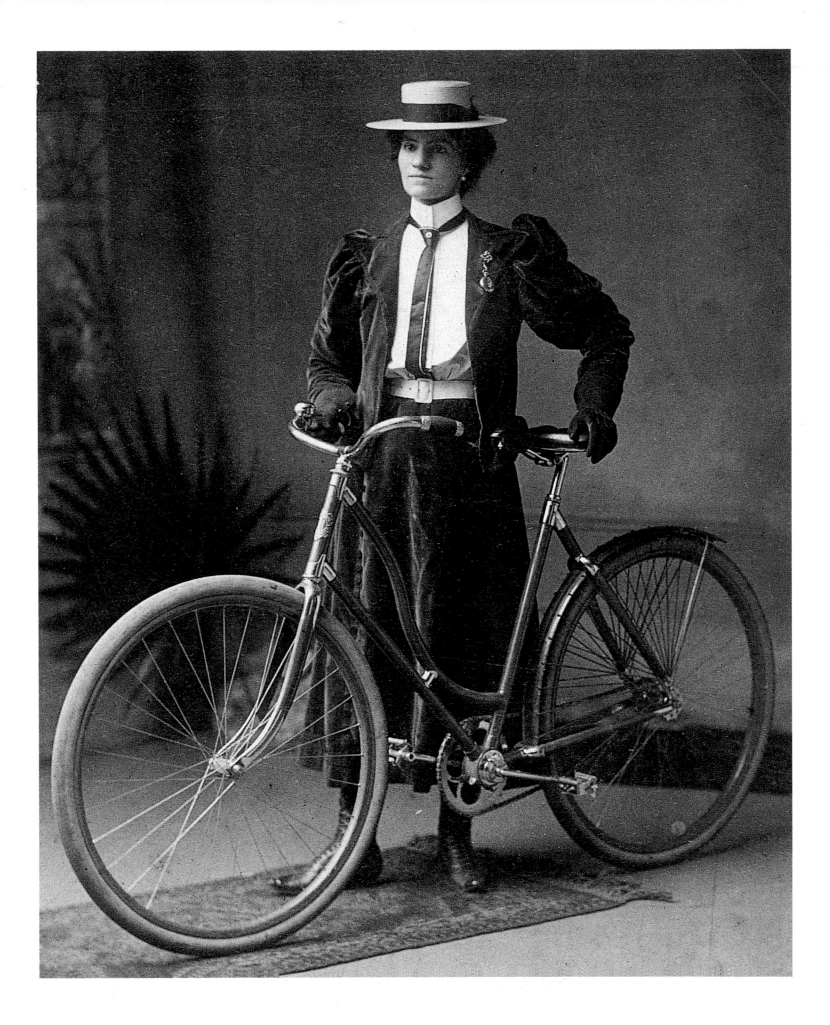

the norms of late nineteenth-century society.

To counter this image, cycling newspapers and magazines published numerous articles encouraging women to ride, but to do so in a manner different from men. Most people believed that they had to ride fast in order to keep their balance, and, perhaps modeling themselves on racers, riders tended to sprint when passed by another cyclist. As women were considered more delicate, they were advised to avoid violent exertion on their heart, lungs, and other vital organs, and not to "transform a health-giving, pleasurable pastime into a nerve-exciting muscle-tiring series of races" (*Wheel and Cycling Trade Review,* 22 May 1891). A speed of six to seven miles an hour was recommended, for it was not the destination but the activity itself that constituted the true pleasure of cycling.

recommended for those who could not ride with a closed mouth. Doctors reminded women that God did not intend them to be active during five days of the month. Most physicians had no objection to women cyclists, but some were concerned that this fascinating amusement would excessively infatuate emotional women, who could do themselves damage.

But most of the potential harm, it was commonly believed, was not to women's health but to their morals. The greatest threat came from riding without chaperons. According to the editor of the American magazine *The Wheel and Cycling Trade Review,* women had taken to the safety bicycle "with all the eagerness of a duck to water" (31 July 1891). The result was a dangerous practice involving a growing number of leisured women who gathered at hotels

Commentators recommended breathing with the mouth closed to avoid a parched throat, especially in cold weather. With perseverance, they argued, early experiences of suffocation would eventually pass, and with training the rider could even ride up steep hills with her lips shut. Chewing gum was

and inns. If allowed to escalate, the editor warned, such practices could deter self-respecting ladies from taking to the wheel for fear of being associated with these immoral women.

In England, the upper classes still considered chaperons important. In 1896, for example,

the newly formed Chaperon Cyclists' Association placed a notice in *The Queen, The Lady's Newspaper*, stating that the association could "provide gentlewomen of good social position to conduct ladies on bicycle excursions and tours," since "many ladies have a great objection to their daughters cycling without a proper and efficient escort. A chaperon will conduct a party of four or less, and excursions by the day or for longer periods might be made in the country by young ladies having a chaperon with them, which could not be attempted without." The association also solicited women to become chaperons, noting that candidates "must be either married ladies, widows, or unmarried ladies over thirty years of age. They must furnish three references, two to ladies of undoubted social position, and one to a clergyman of the Church

rights. Frances E. Willard's adventure with the bicycle typifies the causes which bicycles could serve. A suffragist and president of the Woman's Christian Temperance Union in the United States, Willard came to England as the guest of Lady Henry Somerset, head of the British Women's Temperance Association. Lady Somerset gave Willard a bicycle, nicknamed "Gladys," and at age 53, Willard learned to ride. She later wrote that she had persevered—it took her about three months, practicing fifteen minutes a day— because she wanted to show the women in her organisation what they were capable of. In conquering the bicycle, she had to overcome the same fears and uncertainties she faced in life. She came to the realization that "all failure was from a wobbling will rather than a wobbling wheel," the "will [being] the wheel of the mind" (Willard 31). At the time

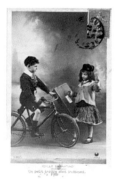 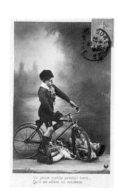 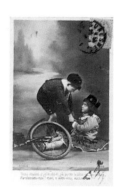 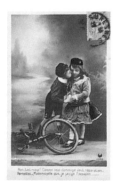

of England, or a justice of the peace" (16 May 1896).

Despite such elaborate restrictions, the bicycle still offered many women independence and freedom. More dramatically, it also served as the vehicle for specific political movements organized by and around the issue of women's

of her death in 1898, Frances Willard was hailed as the "Queen of Temperance." Inspired in part by her experiences on a bicycle, she had built the largest national women's organization of the nineteenth century.

We have seen that during the 1890s, women gained wider access to a sport and activity

Love on a Bicycle

Daisy Bell

There is a flower within my heart,
Daisy, Daisy,
Planted one day by a glancing dart,
Planted by Daisy Bell.
Whether she loves me or loves me not,
Sometimes it's hard to tell;
Yet I am longing to share the lot
Of beautiful Daisy Bell.

(refrain)

Daisy, Daisy, Give me your answer do!
I'm half crazy, All for the love of you!
It won't be a stylish marriage,
I can't afford a carriage,
But you'll look sweet, Upon the Seat,
Of a bicycle built for two!

We will go tandem as man and wife,
Daisy, Daisy,
Pedalling away down the road of life,
I and my Daisy Bell.
When the road's dark we can both despise
P'liceman and lamps as well.
There are bright lights in the dazzling eyes
Of beautiful Daisy Bell.
(refrain)

I will stand by you in wheel or woe,
Daisy, Daisy.
You'll be the bell which I'll ring, you know,
Sweet Little Daisy Bell.
You'll take the lead in each trip we take,
Then if I don't do well,
I'll permit you to use the brake,
My beautiful Daisy Bell.

(refrain)

Far left: Katie Lawrence. c. 1894.

Left, top to bottom: Seidel & Neumann. Poster by H. S. Hermann. Berlin, 1896.

Catalogue illustration for A. G. Spalding Co., New York. c. 1898.

Right: Cycles Peerless. Poster by Louis Galice. Paris. c. 1897.

Far right, top to bottom: Whitworth Cycles, anon., Camis. Paris. c. 1897.

Cycles Gladiator. C.B., G. Massias. Paris. c. 1900.

Love on a Bicycle

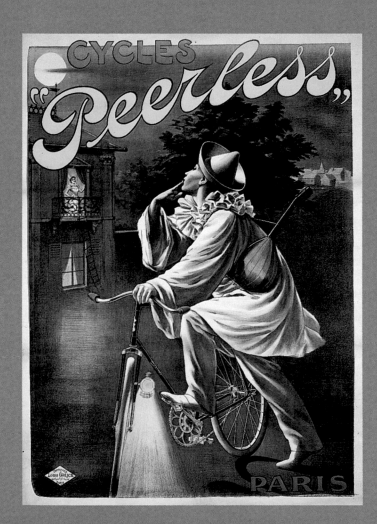

Frank Dean wrote the song *Daisy Bell* in 1892, under the pen name Harry Dacre. Katie Lawrence popularized the song in music halls, where the sheet music was sold after the concert, helping to spread its fame throughout the British Empire. On the cover of the song sheet, she is dressed in male attire, revealing her legs, an acceptable practice for performers. The song was such a success that Karl Kaps wrote a Waltz version the following year.

"Sweethearts Awheel"

When charming Clara bought a
 wheel
I begged that I might teach her
To ride the sinewy steed of steel
And guide the met'led creature.
And scarce 'tis needful I should tell
How cheerfully I taught her,
Nor to remark that when she fell
Most carefully I caught her.
And far and wide we'd often ride
When she had learned the art,
With one sweet rest where shade
 was best
Ere homeward we would start.
And once she said, while in the
 shade
We loitered ere returning,
"How nice to ride with you beside,
It's worth the toil of learning."
I said, and gazed on her fair young
 face,
"I wish you'd learn again;
I'd give the world for the right to
 place
My arm where I placed it then."
Answered my love with blushes
 bright
Her sweet voice trembling slightly,
"Who knows but that you'd have
 the right
If you should ask it rightly."

hitherto largely restricted to men. But the debates over women on bicycles were largely restricted to the upper classes, whose adoption of the bicycle lent it respectability and status in the first years of the 1890s. In New Orleans, women belonging to fashionable society organized a club and engaged a New York instructor to visit with an assortment of bicycles. Along the cities of the eastern seaboard, club facilities were being expanded, and often included amenities for women cyclists. In San Francisco, a new "cyclery" was planned near the Golden Gate Park in 1894, with a separate sitting room and quarters for women, including lockers, showers, and baths. The facility would include several pubs, and the wheel room was intended to house more than two hundred bicycles.

Cycle-Racing and Record-Breaking

Some of the most popular cycle events organized in Britain during the 1870s and 1880s were "six-day races." The first of these, held in 1875 at the Agricultural Hall in Newcastle, was won by Frank Waller, who rode eighteen hours a day. Until the late 1890s, these were "one-man" races, with each rider seeing how many miles he could cover in six days—a period limited only by observance of the Sabbath. Organized by bookmakers or pub owners, such events, often to the boisterous accompaniment of brass bands, took place either indoors or under huge tents on portable wooden tracks that could easily be moved to different locations.

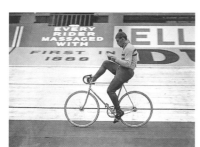

After a hiatus of several years, a "six" was held in Birmingham in 1889; the following year, the first "six" in London was run at the Agricultural Hall. The first indoor six-day race in the United States took place in Springfield, Illinois, in 1886, when Albert Schock, riding twelve hours a day, covered 1,401 miles. The following year, promoters organized a "six" with eighteen-hour riding days in Washington DC. At the first twenty-four-hour six-day race, held at Madison Square Garden in New York in 1891, "Plugger" Bill Martin rode 1,466 miles in 142 hours to win the $2,000 prize.

After 1896, public interest in "sixes" reached new heights, just as improved safeties allowed the distances covered to increase dramatically, reaching over 2,000 miles during 1897. Women cyclists had separate tournaments, but were only allowed to ride four-hour days, a major limit on the distances they could cover. Sixteen-year-old Monica Harwood rode 429 miles at the first women's "six" held in London, at the Olympia Velodrome in 1896. The American women's champion, Frankie Nelson, who won the New York "six" in 1895 and 1896, was rarely beaten in this specialty, earning the title "Queen of the Sixes."

In 1899, a new format, two-man team racing, was born. That same year Frank Waller and C. W. Miller, "King of the Single Sixes," rode a world record 2,754 miles in New York City. But "sixes" had begun to garner unfavorable publicity, with reports of riders hallucinating in their physical exhaustion. The

state of New York banned the sport in 1899, prompting the top racers to ride in states where "sixes" were still organized.

In Europe, six-day races became known as "Madisons," after Madison Square Garden, home to many famous performances. This name is still used for team races today. Madisons enjoyed continuous popularity until the outbreak of World War I, then experienced a revival, as did cycling generally, between the wars. In the Paris of the late twenties, Ernest Hemingway found himself caught up in the excitement of these races, even while he was reworking his latest book. He wrote: "I'll never forget the time I set up

in proof, trying to get it right" (Starrs 295)

If long-distance bicycle races were a spectacle for self-indulgence among spectators, for manufacturers of bicycles and tires, they were a means to test and perfect their products. In the wake of his successful Paris–Brest race of 1891, Charles Terront performed two other long-distance feats. In 1893 the North British Rubber Company paid him to ride their Clincher 93 tires from Saint Petersburg to Paris, a distance of approximately 1,800 miles. The following year Terront rode from Rome to Paris in a mere six days and fifteen hours.

During these boom years,

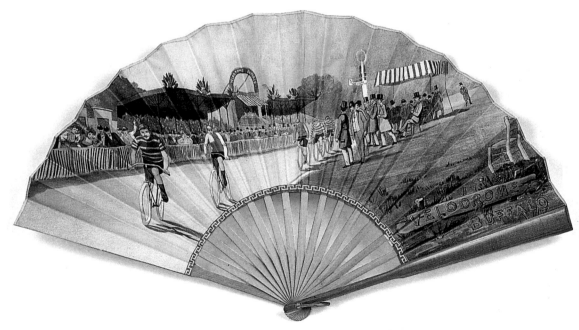

operations in a box at the finish line of the six-day bike races, to work on the proof of *A Farewell to Arms*. There was good inexpensive champagne and when I got hungry they sent over Crabe Mexicaine from Prunier. I had rewritten the ending thirty-nine times in manuscript and now I worked it over thirty times

French promoters organized many other long-distance races. One, sponsored by *Le Journal* in 1893, was like a miniature Tour de France, with a route that began in Nantes and passed through Bordeaux, Toulouse, Marseilles, Lyon, and Troyes before finishing in Paris. In 1895, Terront's plan to tour France on

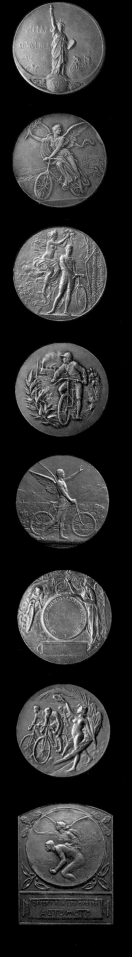

a motorized bicycle was dashed when two rivals, learning of his intentions, completed the tour by bicycle. Théophile Joyeux rode 2,746 miles in nineteen days, while Jean Corre covered 3,107 miles in twenty-five days.

The public enthusiasm for these and other shorter, inter-city races, could not match the passion aroused in velodromes, where spectators could focus more easily on the action. The Paris area alone had six velodromes, its fashionable and devoted public entranced by the spectacle of racers following directly behind their team of pacemakers, some sporting as many as five riders. Cyclists continuously broke records, becoming public heroes of their age. At a one-thousand-kilometer race held in 1893 between Terront and Corre at the Galerie des Machines, the first winter velodrome in Paris, Terront sold 3,000 copies of his recently published memoirs.

The Tour de France, the most celebrated and prestigious long-distance bicycle race of all time, developed out of a dispute over the Dreyfus affair. In 1894, Alfred Dreyfus, a Jewish army captain, was accused of espionage. The charges were eventually found to be false, but for over a decade the question of his guilt or innocence was hotly debated across France. Pierre Giffard, the organizer of the Paris–Brest race and then owner of the bicycling journal *Le Vélo*, supported Emile Zola and others who believed in Dreyfus's innocence, while the Marquis de Dion, a manufacturer of bicycles and automobiles and one of the most important advertisers to *Le Vélo*, was a staunch anti-

Dreyfusard. When Giffard refused de Dion's advertisements in 1900, the marquis began his own magazine. Called *L'Auto-Vélo*, the new review engaged Henri Desgrange, an ex-racer, as its editor. *Le Vélo* was printed on green pages, while, *L'Auto-Vélo* was yellow.

In the intense readership battle that followed, Giffard, who had organized the second decennial Paris–Brest (won by Maurice Garin in 1901) and the Bordeaux–Paris races, forced Desgrange to drop the word *Vélo* from his magazine's title. Desgrange, in desperate need of a publicity stunt, retaliated by creating the Marseilles–Paris race as well as his own Bordeaux–Paris contest. But his breakthrough came in 1903 when he organized the first Tour de France. With the cyclists passing through much of French territory, Desgranges claimed that he was "exposing a population to the most wonderful event in sport cycling, and offering the winner a reputation equal to Charles Terront, the winner of the Paris–Brest" (Laget 35). Later he was to write, not without reason, how the tour encouraged a sense of national identity, establishing the idea of France in geographic terms.

The first Tour de France began on 1 July 1903 in the town of Villeneuve-Saint-Georges, just outside Paris, with sixty racers starting off from in front of the café, Le Réveil Matin. The route before them was approximately 1,550 miles long, divided into six stages taking place over eighteen days, the finish line of each stage providing the excitement of the day. The overall winner, despite attempts by spectators to

Far left: In Greek mythology. Nike was the daughter of the River Styx. which led to Hades, and Pallas. a Titan. At first linked and confounded with Pallas Athena. goddess of victory. Nike later appears as an attribute of Athena. goddess of war and wisdom. Her depiction on racing medals symbolized the racers' great achievements. while on bicycle advertisements. Nike provided an elegant image which drew attention to the bicycle's design.

Center left: Bicycle Race board game. McLoughlin Bros.. New York. 1891.

Left: Paris–Brest trophy. c. 1893.

Marshal Walter "Major" Taylor

(1878–1932)

The "Black Wonder" from Indianapolis Indiana, began his astonishing cycling career in front of the bicycle shop where he worked. Every afternoon dressed in military uniform (hence the nickname "Major") he performed trick riding exhibitions. Taylor's first race was a ten-mile event sponsored by the store owners in 1891, and at the tender age of thirteen, Taylor won first place. In his sixteen-year career he went on to win 159 races and to establish a number of world speed records on the bicycle. Perhaps more importantly he was one of the first black cyclists to break into professional racing, traditionally an all-white sport.

Taylor's accomplishments were all the more astonishing as he had entered racing at a time of great resistance to the participation of black athletes in organized professional sports. Debates within the League of American Wheelmen became heated when black cyclists from the northern States attempted to join. Displeased with this prospect, white southern members reacted at the annual convention in 1892, questioning whether black cyclists who were admitted should be allowed to attend all the social functions. Bicycling World responded, taking an extremely open-minded and tolerant position on race, if not on the issue of class:
A black "gentleman" is infinitely superior to a white "hoodlum". Let us size up the applicant by his behavior, not by his color. ...For Heaven's sake let's draw the line only at respectability. If the colored man wants to come in, let us take him, not only willingly, but gladly. And after we have taken in the man, his money, and his vote, let us behave ourselves well enough so that he won't be ashamed of us.

Taylor's first professional race was perhaps his most difficult, the gruelling six-day at Madison Square Garden that winter. Even though he finished eighth, having ridden a total of 1,732 miles, his distance easily beat the previous record, and Major Taylor quickly became a celebrity. He went on to win a number of national and international championship races. In 1899 he won the world one-mile sprint title in Montreal, then traveled to Paris to beat Jacquelin and win the acclaim of France. In the same year Taylor used a powered pacing bicycle for track records in his attempt to ride one mile in less than a minute and a half. He had a Stearns bicycle powered by a steam engine that required two riders, one to steer and the other to operate the engine. His record ride in 1899 finished in 1:22 2/5 minutes.

Between 1901 and 1904, Taylor raced in France, Belgium, Holland, Germany, Denmark, Italy, Austria, England, Australia, New Zealand and the United States, earning the praise of one bicycling historian as "the earliest, most extraordinary pioneering black athlete in the history of American sports."

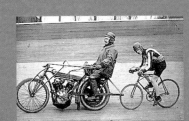

Left: Georges Sères, the motor pacing world champion in 1920.

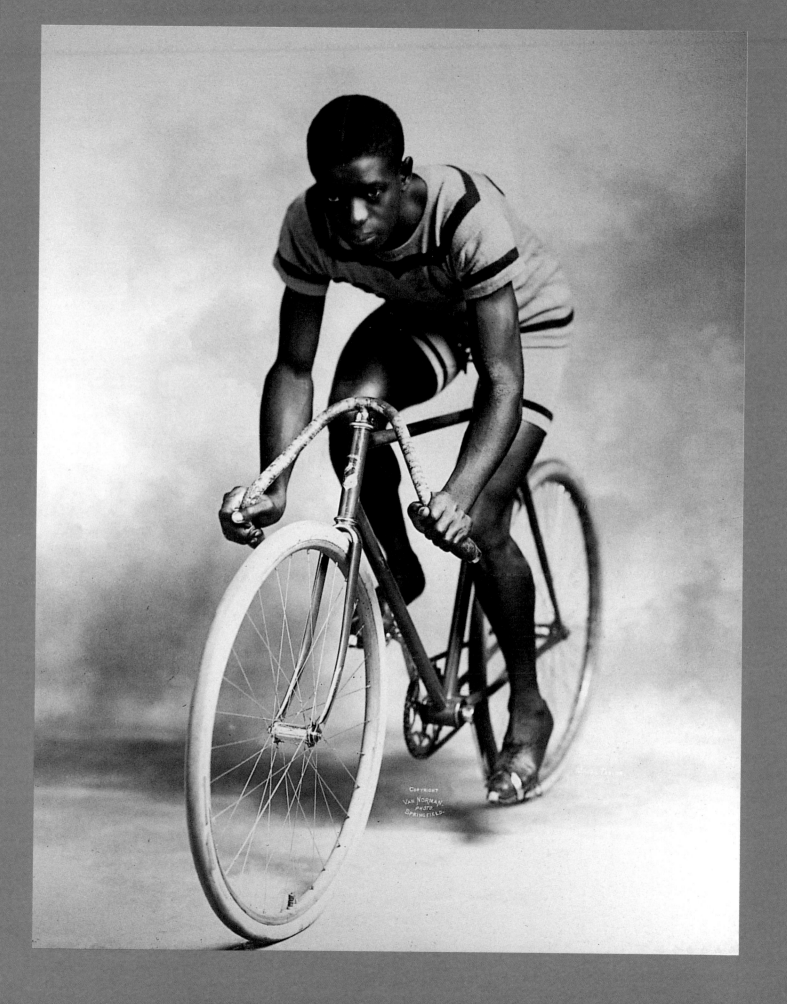

intimidate him, was Maurice Garin, who finished in ninety-four hours. Desgranges was showered with congratulatory telegrams and all the newspapers went wild, with the exception of *Le Vélo*, which did not print a word.

Thus began a tradition that was to be repeated every year, with the exception of the war years (1915–18 and 1940–46).

fact that derailleurs were only permitted from 1937. The Tour's route, which differs each year, frequently reflected political or cultural events. In 1919, the first Tour after World War I, there was a stop in Strasbourg, the capital of newly liberated Alsace; in 1994, the Tour crossed over to England to celebrate the opening of the Channel Tunnel.

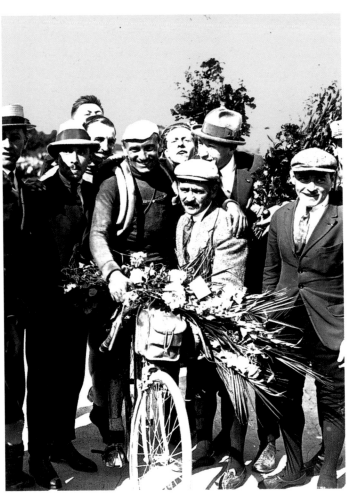

Left:
Philippe Thys,
the Belgian rider
winning the
Tour de France in
1914. He was
the first rider to
win three
Tours, his first in
1913 and his
third in 1920.

Distances varied from year to year, ranging between 1,500 and 3,000 miles. The Tour first reached the Pyrenees in 1910, and riders, lacking sufficient braking power, had to rent bundles of twigs on top of the mountain to slow their descents. These mountain courses were made even more arduous by the

The winners of each stage wore yellow armbands, denoting the yellow pages of Desgranges' newspaper, *L'Auto-Vélo*, whose circulation grew immensely; in 1919, the armbands were replaced with the famous yellow jerseys (*maillots jaunes*).

Commercialism permeated the Tour from the beginning, as did

scandals of sabotage, drug abuse, and collusion between teams. Bicycle manufacturers, and other commercial enterprises, lavished generous prizes on their teams, to the point where the Tour organizers replaced manufacturers' teams with national teams in 1930. After World War II the riders reverted to commercially sponsored teams, though the tension were disturbed by the great importance placed on winning. In an article entitled "The Finish Line of a Tour de France," which appeared in *Le Matin* in 1912, Colette wrote how "we are surrounded and possessed by a demonic taste for speed, and the idiotic and invincible urge to be 'the first'" (Laget 131). However, the playwright Eugène Ionesco, a twentieth-

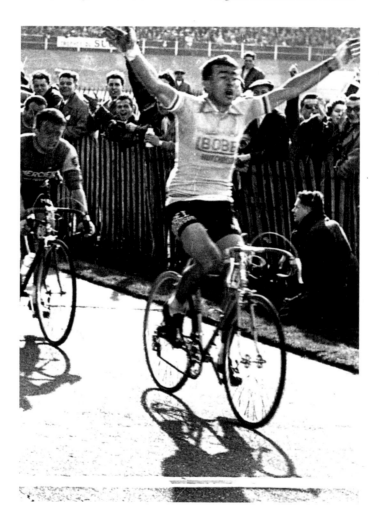

between national identities and commercial backers continues today.

Early in the history of the Tour, the public devoured stories of its scandals and were fascinated by the riders' heroic achievements. Many commentators admired the sheer physical effort involved, but century master of the absurd, was not able to appreciate "the passionate desire to arrive in Paris in front of the swarm of cyclists after having ridden throughout the country" (ibid. 121).

The magazine *La Bicicletta* organized Italy's first long-distance road race in May 1892. The course ran between Milan

Left: After winning the Tour de France in 1953, 1954 and 1955, Louison Bobet won the Paris–Roubaix race in 1956. Seconds after Bobet crossed the finish line, the Belgian racer Alfred de Bruyne caught up with him, but caused both to fall. This annual spring race, "La Reine des Classiques," was first organized in 1896 by the creators of Roubaix's race track in Parc Barbieux. The race became known as "l'Enfer du Nord" because of the obstacles and wretched riding conditions: the cold and wet spring weather made many competitors fall on the slippery cobbles, and both riders and machines would finish covered in mud. Since its inception, the challenge of Paris–Roubaix has continually attracted the greatest riders.

and Turin, and Enrico Sauli was the winner, covering the 329 miles in twenty-six and a half hours. In time, other road races were established, including a second Milan–Turin course in 1903, and a Milan–San Remo race in 1907. The first running of the great Giro d'Italia, organized by the paper *Gazzetta dello Sport*, took place in May 1909. Patterned after the Tour de France, it covered 1,518 miles, beginning in Milan, following seven stages as far south as Naples, then passing through Turin before ending in Milan. Many French riders competed in the first race, but the winner, Luigi Ganna, brought pride to his native land.

The World of Bicycles

By the beginning of the twentieth century, riding the crest of European imperialism and cultural influence, bicycles had literally reached the four corners of the earth.

In Argentina, horses were relatively inexpensive to purchase and maintain while bicycles remained costly, roughly the equivalent of three horses. Nevertheless, the fashionable set of Buenos Aires followed the trends set in Paris and London. A large proportion of riders were French women, who introduced bloomers to the country. Very few Argentine women participated, although their men rapidly took to the wheel. Their favorite cycling location was Palermo Park, built at the same time as Juan Manuel de Rosas' palace, adjoining the stables and racetrack of the jockey club.

In Australia and the Yukon Territory of northwest Canada, bicycles were put to the test during gold rushes. Between 1892 and 1897, imported Canadian and American bicycles proved very useful in the mining towns and rough Australian bush. A bicycle mail route was established between Coolgardie and Southern Cross in 1893, and extended later to other locations. A local postage stamp featuring an illustration of a bicycle was specially created for use on these routes.

During the Klondike gold rush in the Yukon, cyclists began riding the trails between mining sites in 1898, a practice that lasted about ten years. Bicycles were an alternative to dogs (pulling sleds) or horses (with stagecoaches), which had to be fed and often died on the trail. This was some of the most difficult riding terrain to be conquered by the bicycle, and only the hardiest of riders could survive. Freezing winds could carry cyclists over ice at speeds of thirty miles an hour, even with their coaster brakes engaged. More optimal conditions involved a trail where sleds had already passed and beaten down a firm path in the snow. The most-used trail for bicycles went from Dawson City to Whitehorse, a distance of four hundred miles. In the spring of 1901, over two hundred and fifty bicycles passed each other on this trail, stopping at roadhouses every twenty miles.

In 1900, a cyclist by the name of Edward Jesson achieved a very remarkable feat; he rode from Dawson City to Nome, Alaska, a distance of a thousand miles. There were many obstacles on

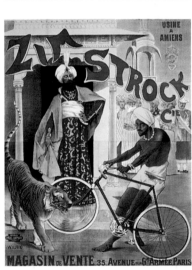

Left, top to bottom:
H. Chanon & Cie.
by H. Tichon.
G. Massias. Paris.
1894.

Zim Strock by Wilhio.
Dupont. Paris.
c. 1898.

Right: Selection from a set of 12 postcards sent at 6 p.m. on 1 April 1902 from Southport England to Belfast. Northern Ireland.

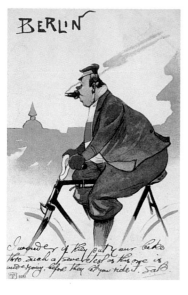

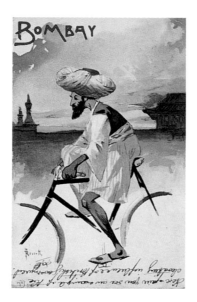

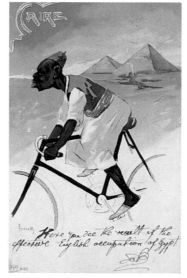

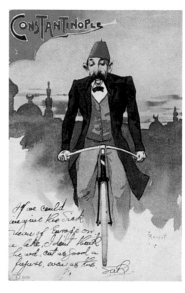

this torturous journey, including one which he later described with great vividness:

I was making good time, when all of a sudden I saw no sign of the many sled tracks I had been following, but very blue ice under me. I was going fast and began to pedal lightly as I had speed enough to carry me to the old tracks ahead. I drew a long breath when I got on old ice again and got off the wheel. Looking the situation over, I could see where a large section of ice had gone out to sea, and stepping to the edge of the old ice, I gave this blue ice a kick with my moccasin heel and up came the blue sea water. I am sure I could not have walked across it (Humber 47).

Steam, Speed and Flight

Inevitably, in an age of industrial development symbolized and propelled by the steam engine, inventors sought to harness the power of steam in the service of the bicycle. As early as the 1860s, mechanics and manufacturers began to experiment with motorized velocipedes, fitting steam engines to bicycles and tricycles in an attempt to bolster or replace the propulsion produced by human effort alone. In 1868, the Frenchman Louis Perreaux patented a "high speed velocipede designed to travel great distances without effort" (*Historia*, no. 511, July 1989: 97). Three years later Perreaux constructed an all-metal velocipede incorporating an alcohol-powered steam engine with a belt drive. This vehicle attained a speed of twenty-two miles an hour—far

greater than any human-powered velocipede. But it was dangerously unstable, which led Perreaux to improve the engine's design and place it on a more steadfast tricycle, reducing its speed to about eighteen miles an hour. Perreaux was not alone in attempting to motorize the velocipede. Around 1869, Sylvester H. Roper of Roxbury, Massachusetts, built a coal-powered steam velocipede with wooden wheels and an iron frame. The machine was a novelty, demonstrated to curious crowds at fairs and circuses along the eastern seaboard of the United States.

Seventy years after a German baron invented the running machine, a French marquis constructed a steam-powered quadricycle. In 1883, Marquis Albert de Dion built the vehicle with the assistance of mechanics Georges Bouton and Charles Trépardoux. By testing it on the Avenue de la Grande Armée in Paris, the heart of cycling retail activity in the city, they attracted an immediate crowd as well as a great deal of journalistic attention. A year later, the three men produced a steam tricycle with a much lighter frame. Public interest grew, and on 28 April 1887, Paul Faussier, publisher of the magazine *Le Vélocipède*, organized the first race of steam-powered vehicles, a round trip between Paris and Versailles. The only competitors, however, were de Dion, driving a quadricycle, and his mechanic Bouton, on a tricycle. Although Bouton reached Versailles first, the Marquis de Dion was allowed the honor of crossing the finish line at the Pont de Suresne first.

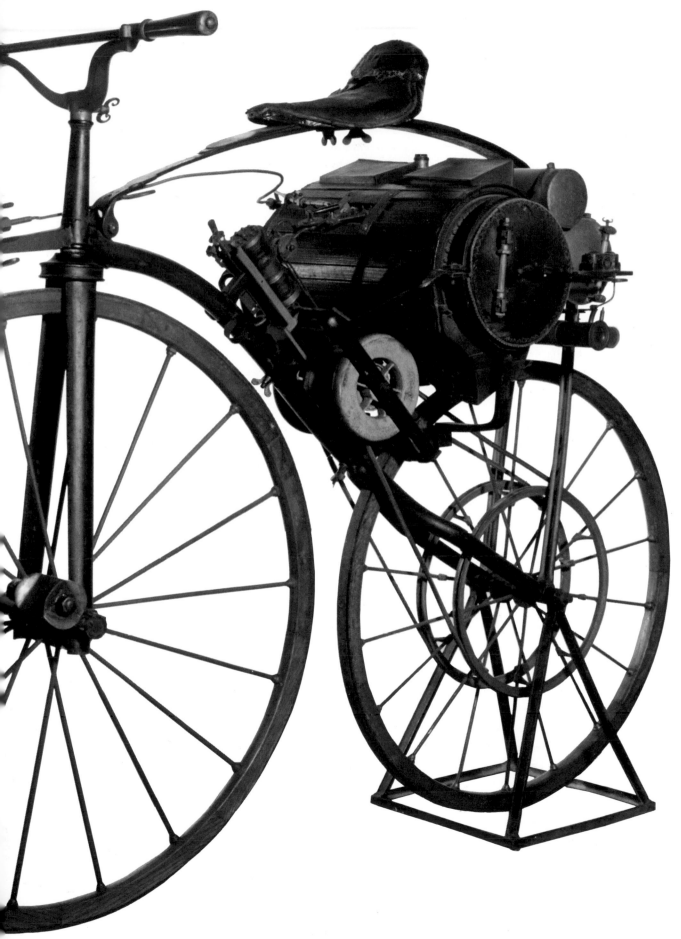

Left: Louis
Perreaux's steam-
powered
velocipede, 1871.

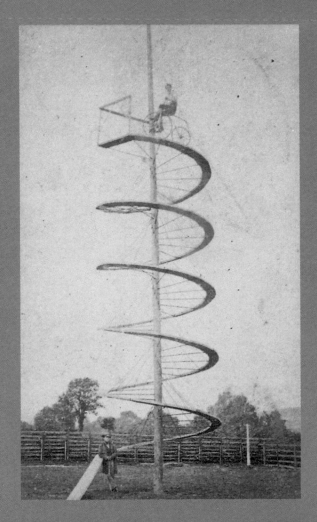

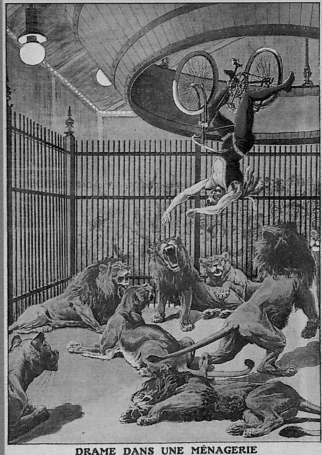

DRAME DANS UNE MÉNAGERIE

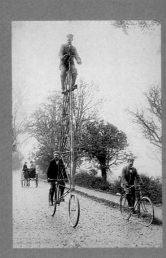

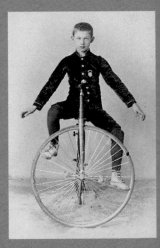

Performers on a Bicycle

Bicycle riders frequently entertained spectators with unusual acrobatics. Performances on wheels had fascinated audiences since the days of the Draisine. As riding a velocipede or high-wheeler depended on the rider's ability to maintain equilibrium, most performances involved balancing a bicycle when in motion or remaining still while performing some acrobatic feat. Highwire acts were thrilling and impressive, as Blondin and Jenkins proved by crossing Niagara Falls on specially designed velocipedes in 1869. Balancing acts took every form imaginable, as bicycles (or their parts) became novel appendages of the body that seemingly transformed the performer into half-person, half-bicycle.

Performances were not necessarily organized events, as they might take place wherever a rider could find a crowd—at fairs, gymnasiums, music halls, circuses, parades, races, or club meets. Soon after the introduction of the pneumatic safety, more daring performances with specially designed bicycles such as the Eiffel Tower model became common.

But the most impressive performances were those relying on centrifugal force to hold the cyclist in a banked aerial track, often called the "circle of death," or in loops that propeled the rider high into the air. These death-defying feats demanded courage, skill, and a daredevil disposition. Many performers traveled the world, some in self-contained circuses, assembling their massive loop-the-loop structures on location.

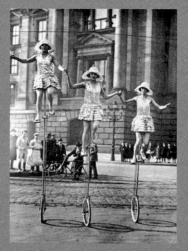

Far left, clockwise from top left:
The Wilmot Duo. Courier Litho. Co., Buffalo, New York. c. 1891.

Oscar Babcock performs the loop-the-loop at a fair in Trenton, New Jersey, 8 October 1925.

James Smithson. J. Blouin & Henry Paris. E. Delanchy, Paris. c. 1900.

Humber type Eiffel Tower tandem. c. 1900.

A Member of the Kauffmann Family, the internationally renowned American trick cyclists. c. 1900.

"Drame dans une ménagerie", from an illustrated supplement to "Le Petit Journal". 13 March 1912.

Early daredevil velocipedist. c. 1869.

Far left: The Rebras: Shop A.D., New York, c. 1900.

Left, top to bottom:
Female performer with velocipede, c. 1869.

Three French unicyclists photographed performing in Germany.

By the mid-1880s, mechanics and inventors on both continents were successfully experimenting with steam-powered three- and four-wheeled vehicles. In 1885, Lucius Copeland of Phoenix, Arizona, successfully added an eighteen-pound benzine-powered steam engine with a belt drive to a Star safety bicycle. The engine could be removed easily by unscrewing two bolts, allowing the Star to be ridden as a bicycle as well. Several years later Copeland contracted the Northrop Manufacturing Company in New Jersey to make an elaborate steam-powered tandem tricycle with a canopy. Northrop then formed the Moto-Cycle Manufacturing Company, which eventually produced about two hundred

first bicycle driven by an internal combustion engine, although problems of balance forced him to add two small stabilizing wheels. In 1886, another German engineer, Karl Benz, began his experiments in motorized transport with a large combustion-powered tricycle.

In England, motorized transport developed more slowly, in part because the British government had legislated a speed limit of four miles an hour. Nonetheless, Edward Butler constructed a motorized tricycle, called the Petrol-Cycle, in London in 1887. Although it was capable of moving at more than twelve miles an hour, the legal speed limit was not raised this high until 1896, a factor which discouraged the

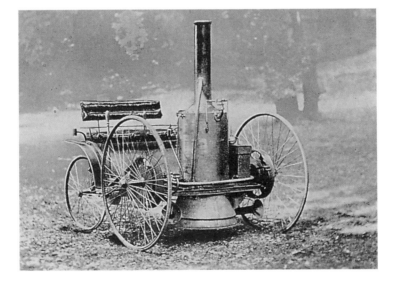

steam-powered tandem tricycles with protective canopies.

In search of an alternate form of power, the German engineer Gottlieb Daimler invented an internal combustion engine in 1885. He first attempted to mount it on a boat, then on a carriage. Finally, using a heavy wooden frame, Daimler built the

development of faster vehicles. The speed limit was increased to twenty miles per hour in 1903, and statistics for the following year show that England had over twenty-four thousand automobiles on the road.

By the end of the nineteenth century—at the precise moment when the mass market in bicycles

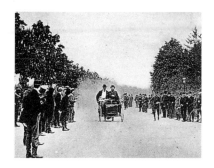
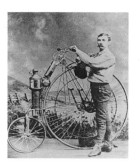

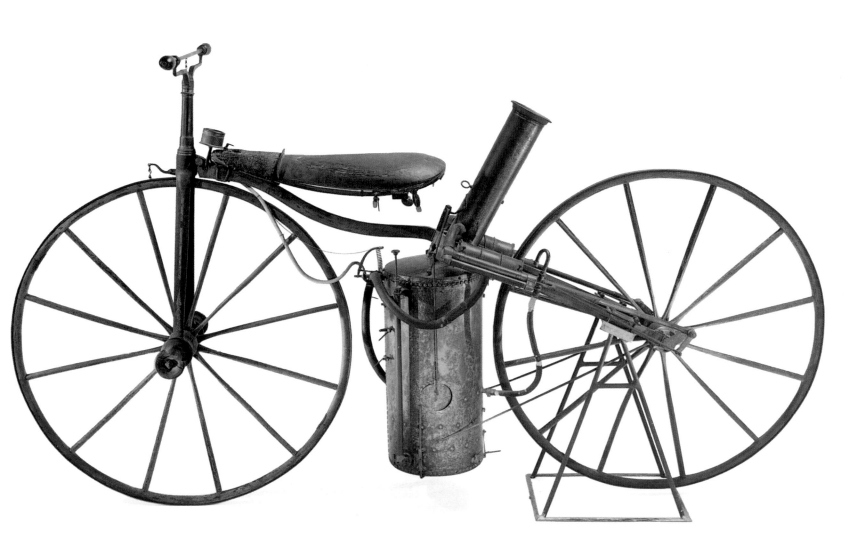

took shape—four-wheeled combustion-powered carriages were being produced in increasing numbers in both the United States and Europe. But it would be almost a decade before automobiles became a practical and widespread means of transport. Many early bicycle manufacturers began producing automobiles, as no industry was better placed to begin mass production. Over the decades, bicycle makers had developed a range of materials and technologies that were to become essential in the construction of automobiles. A simple listing of these technologies gives a sense of the overall importance of the bicycle in the development of the first automobiles: lightweight steel tubing, wire spokes, chain and shaft drives, drop forging, adjustable ball bearings and roller bearings, the free-wheel clutch, differential and variable gears, single tube pneumatic tires, reliable brakes, acetylene lamps and dynamos for electric lights, metal plating, Ackerman steering (originally developed for tandem quadricycles and tricycles with two front wheels, where separate wheel axles are controlled by a single pivoting steering gear enabling both front wheels to turn simultaneously), uniform interchangeable parts, and assembly line techniques for mass production.

Bicycle makers had also developed sales distribution networks and planned obsolescence to stimulate sales. Due to lobbying by high wheel clubs such as the LAW in America and the CTC in Britain, road conditions were constantly improved, facilitating at the same

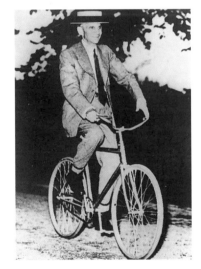

time the rise of the automobile. The success of the automobile was due in great part to road improvements that were the direct result of decades of effort by persistent cycling organizations. The gift of good roads literally paved the way for practical automobile transport.

As the bicycle was essential to the growth of the automobile industry, it also played an important role in the development of the first airplanes. The Wright brothers, universally recognized as the pioneers of powered flight, were originally in the bicycle trade. Wilbur and Orville Wright began repairing and selling bicycles in Dayton, Ohio, in 1892, at the beginning of the worldwide craze, and soon established the Wright Cycle Exchange. In 1896, they began manufacturing two of their own models, the Van Cleve and the Saint Clair, under the brand name of the Wright Cycle Company.

Around this time, the Wrights developed their interest in flying machines. In contrast to the bicycle companies which went on to develop automobiles, the Wrights were attracted to the challenge of creating a machine that would finally realize the age-old dream of flight. They were greatly inspired by the German Otto Lillienthal, who had made more than two thousand successful glider flights before falling to his death. Following Lillienthal's lead, the brothers began by experimenting with kites and gliders. But unlike other pioneers in the field, whose main concerns were wing and engine design, Wilbur Wright concentrated on the control of

Left: Henry Ford on a BSA Safety. c. 1940. Ford often rode his BSA in the grounds of Greenfield Village. the museum campus he created in Dearborn. Michigan.

flight. From his experience with bicycles, he realized that just as a bicycle's balance was maintained by steering adjustments relative to terrain, a flying craft's balance was also dependent on its response to air currents. By twisting an empty bicycle inner-tube box, he discovered the principle of wing warping, an elementary principle of flight which he applied to his first kite in 1899. With money saved from the bicycle business, Wilbur began experimenting with kites and gliders, and soon constructed a small wind tunnel in the shop. This led the brothers to construct their first manned glider in 1900.

As the glider required consistent winds of fifteen to twenty miles an hour to launch, as well as soft sand for safe landings, the

1902, they returned a third time to Kitty Hawk, this time with a glider incorporating their discovery of three-axis control, the three basic principles of flight control: pitch, yaw, and roll. All they needed now was an engine, a technology already developed to motorize the cycle industry, and propellers. The Wright brothers proceeded to design and supervise the construction of an engine in the bicycle shop; the propellers were a greater hurdle, since boat screws lacked the necessary efficiency for lift. After much experimentation, they designed propellers capable of higher pushing efficiency.

The brothers incorporated specially tailored bicycle parts in the construction of the first airplane: oversized bicycle chains and sprockets with ball bearings

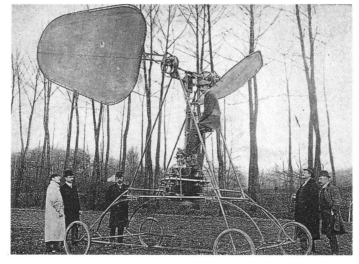

U.S. Weather Bureau suggested that the Wrights try the dunes near Kitty Hawk, North Carolina. Wilbur's first attempt to lift himself off the ground failed. A year later he and Orville returned with a larger improved glider, successfully making about a hundred flights of three to four hundred feet each. In

formed the transmission, bicycle spoke wire was used to brace the wings and other parts of the body, lightweight steel tubing was adapted to support the propeller shaft, while oversized bicycle hubs (later replaced by bicycle wheels) were deployed for the takeoff launching skid.

The Wright brothers completed

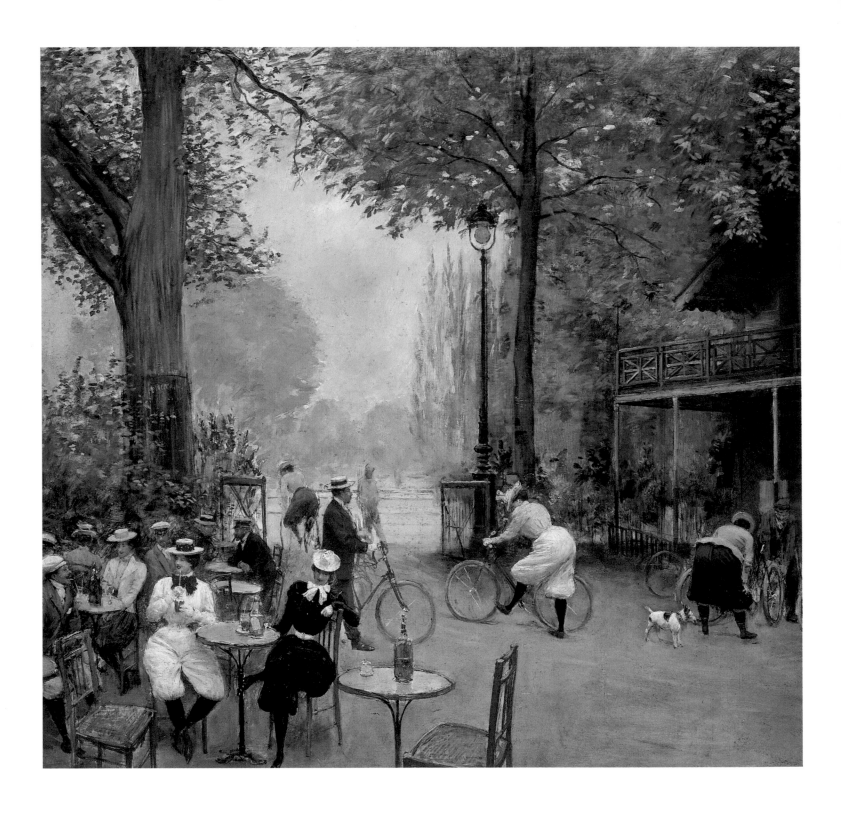

four powered flights on 17 December 1903. The first, by Orville, lasted all of twelve seconds and covered a distance of 120 feet. The fourth, by Wilbur, took fifty-nine seconds and covered 852 feet. The following year the brothers stopped producing bicycles and devoted their full attention to flying machines.

Classes and Clubs

During the summer of 1894, members of New York City's social elite, the "Four Hundred," amused themselves with bicycles at their estival residences in Newport, Rhode Island. Upon returning to New York City, they found the paved roads, boulevards, and park drives admirably suited to riding. A favorite trip began by taking the ferry from 129th Street in Manhattan to Fort Lee, New Jersey, then cycling along the Palisades through Englewood to Hackensack, where a train took them to Jersey City for the ferry ride back to Manhattan. The ride was so popular that one of the city's daily newspapers, *The New York Herald*, even warned of policemen in Hackensack who waited for unsuspecting cyclists who rode on the sidewalks to avoid mud puddles.

The following year, keen cyclists among the "Four Hundred," inspired by the dedication of a monument to Pierre and Ernest Michaux in Bar-le-Duc, France, organized the exclusive Michaux Cycle Club. Its headquarters was Bowman's Hall, a cycling academy on upper Broadway where members could even ride in winter.

Membership was limited to two hundred and fifty, and a long waiting list helped to assure the social cachet of the club.

In addition to riding instruction and afternoon rides for women, complete with orchestral accompaniment, the club scheduled special activities such as the Balaklava Melée, where four male cyclists wearing plumed fencing masks brandished canes at each others' plumage. Gymkhana rides, a spectacle newly imported from India, were also organized. In these, members attired in elaborate red and white costumes

performed intricate riding formations and relay races, before assembling for a climactic full-scale procession. The most complex of these rituals was the Virginia Reel, an elegant dance on bicycles which reproduced the same drills and movements executed by riders on horseback at White Sulphur Springs,

Virginia, a ceremonial gathering of the Southern landed aristocracy. Thus adopting and adapting a range of past and present aristocratic rituals, the Four Hundred Club symbolically defined its elite character.

In Paris, where titled aristocrats still dominated society, the Omnium club opened in fall 1895. An exclusive riding association frequented by many members of the aristocracy, the Omnium occupied a luxurious mansion with a restaurant, a grill, a covered garden, rooms for massage, hydrotherapy, and showers, and toilets of white marble. It became closely allied with another club, the Union Vélocipédique Française, and, as a sign of the Omnium's cultural prestige, the Union eventually adopted the elements of the elite club's own racing code.

principal bicycle manufacturers on the Avenue de la Grande Armée. From there, riders could cross the Bois to the Chalet du Cycle, as described in *Vanity Fair* in the summer of 1897:

The fashion—which is now become a habit—of cycling took the world of Paris before that of London; and there it has yet lost none of its frequency. Without doubt the bicyclette is more in use this year than ever before. From Princess to ouvrier they all ride—if they can—in Paris. Quite early the Bois de Boulogne is daily charged with wheels and "bloomers." By the thousand the cyclists ride forth along the avenues to the Châlet du Cycle by Suresne: with a smiling gaiety that is unknown in Hyde Park. You can sip from your glass and watch the grandest lady of the biggest world, the

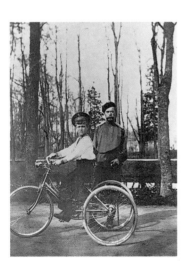

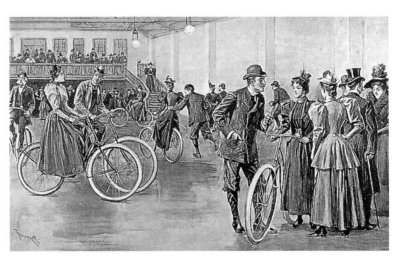

The Omnium was on the rue Spontini, conveniently located near the Bois de Boulogne, an expansive park of 2,200 acres on the western perimeter of Paris. Cyclists from all walks of life would meet at the Brasserie de L'Espérance, near the park entrance at the Porte Maillot and the main stores of the

most fashionable demi-mondaine, the prettiest waitress, the staidest bonne, and the smallest child: each lady with a cavalier in attendance. Here is a rider whose bicyclette is enamelled to match the colour of her dress (3 June 1897).

In London, members of the upper classes began cycling in

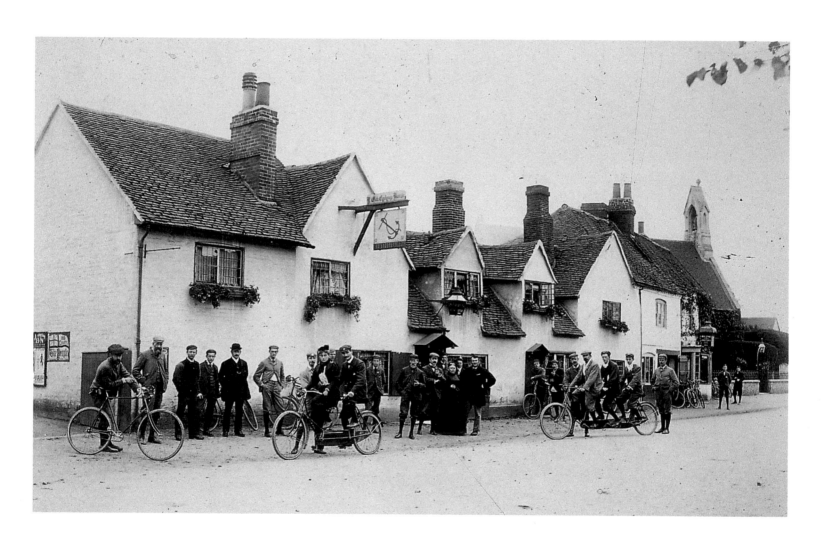

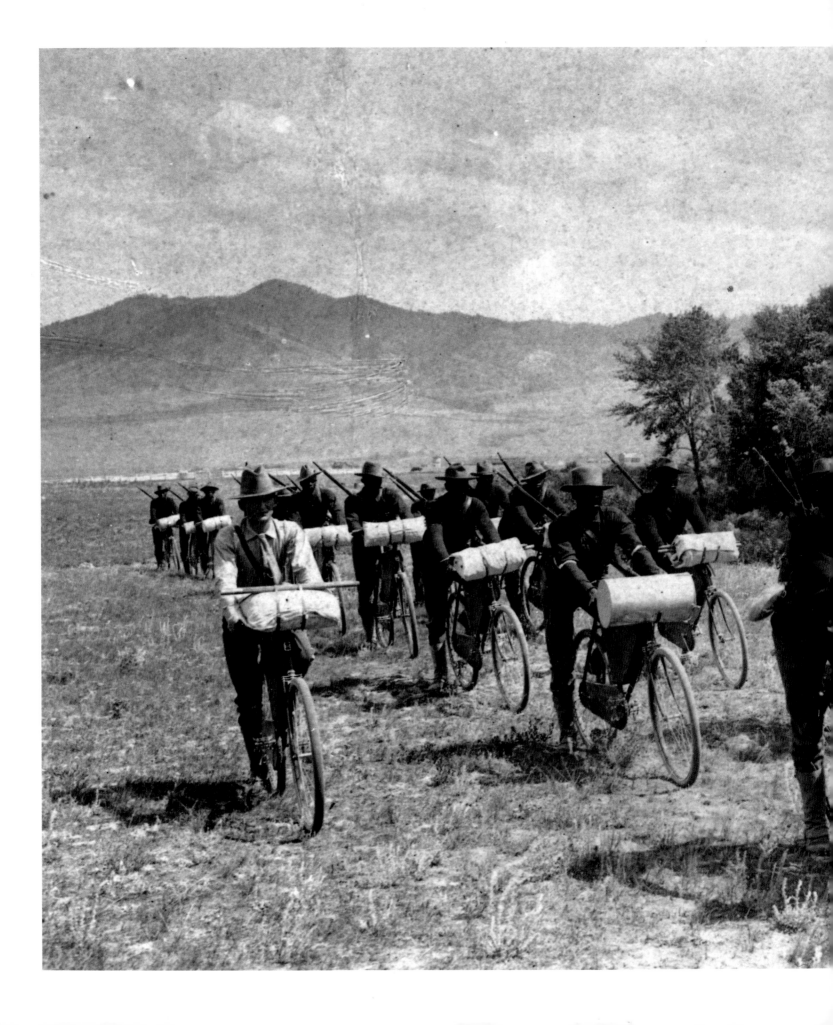

Lieutenant Moss with the 25th US Infantry Bicycle Corps. Moss, who organized the Bicycle Corps in 1896 at Fort Missoula, Montana, was determined to prove the viability of bicycles for use in the army. He ordered specially designed bicycles made by A. G. Spalding to carry his troops on a twenty-eight hundred mile round-trip to St. Louis, leaving Fort Missoula on 14 June 1897. On the way, the sight of black soldiers in uniform disturbed residents of Missouri as they were reminded of the black members of the Union Army during the Civil War. Though the arrival of the corps in St. Louis on 24 July should have demonstrated the bicycle to be a desirable addition to the Army, Moss and his men were ordered to return by rail as the bicycle was considered to be a handicap. Moss's experiment encouraged the establishment of similar troops in Europe, especially in France, where military cyclists had already served as messengers and scouts. Other military commanders who used bicycles include the Japanese General Yamashita, who used the bicycle to transport men and supplies through the jungle and forced the British to evacuate Singapore in 1942. In the Vietnam War, specially designed bicycles transported up to 500 pounds of supplies down the Ho Chi Minh Trail, posing a very difficult target. "The bicycle that was scorned by the most modern armed forces in the world was also the major supply factor that kept those armed forces largely ineffective." (Starrs 66)

Battersea Park during the spring of 1895. Their influence in the CTC enabled them to open Hyde Park to bicycling the following year, where crowds gathered each morning just to watch between two and three thousand cyclists. The fashion of cycling among the affluent classes reached such heights that women, displaying the latest fashion in cycling dress, would arrive with their bicycles by horse drawn carriage, to be returned home the same way.

Outside London, country clubs known for their equestrian gymkhanas also began to offer bicycle versions of these gatherings. Competitions, modeled directly on equestrian events, included bicycles decorated with flowers, tilting at rings, and even cavalry charges.

But while the cultural and political elites of Europe and North America created elaborate rituals for the bicycle, the middle classes and working classes had also taken to the wheel. The Golden Age of the Bicycle was marked by a significant democratization of cycling. Unlike the running machine and the velocipede, both adopted and made fashionable by the upper classes, the safety bicycle was affordable to an increasingly large consumer public. At the height of craze of the late 1890s, the bicycle had captured the imagination of all social classes. As Stephen Crane remarked in *New York's Bicycle Speedway*, "Everything is bicycle":

[Broadway] has vaulted to a startling prominence and is now one

Far left: American Crescent Cycles. Frederick Ramsdel. Chaix. Paris. 1869.

Left: Canadian Cycles Massey Harris. E. Célos. Camille Sohet et Cie. Imp.. Paris. c. 1900.

Right: This photograph illustrates the section on the development of gearing. The Crypto-geared Ordinary (right) was introduced in 1891 in an effort to continue the tradition of front-wheel drive through the use of gears in the front hub. It provided a 60-inch gear. as did a version called the Crypto Bantam. introduced in 1893. which had an even smaller front wheel to enable the rider to place his feet on the ground. These last examples of front-wheel drive were known as front-drivers to differentiate them from the rear-drive safeties.
The earliest of these bicycles is the Facile (center). invented by Beale and Shaw in 1878. and first manufactured in 1881 by Ellis & Co. of Coventry. Its lever action allowed the rider to sit further back. thus offering greater safety from headers.
The Premier (left) made by Hillman. Herbert and Cooper. c. 1892. although the model with the most promising future. still had solid tires while the later models Facile and Crypto both had pneumatic tires.

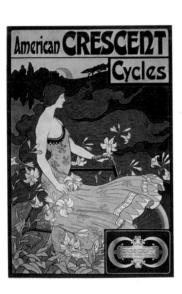

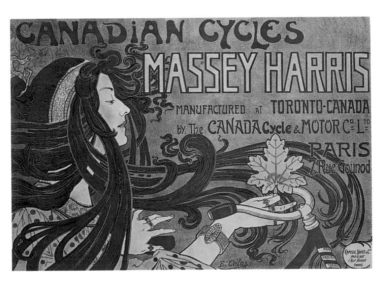

Accompanied by music, women in white costumes wove intricate figures with military precision; all week long they rehearsed at open practice sessions at the Albert Hall in London. Among the upper classes, the bicycle was so completely interchangeable with the horse that fox hunts even included contingents of cyclists.

of the sights of New York. This is caused by the bicycle. Once the boulevard was a quiet avenue whose particular distinctions were its shade trees and its third foot-walk which extended in Parisian fashion down the middle of the street . . . Now, however, it is the great thoroughfare for bicycles. On these gorgeous spring days they appear in

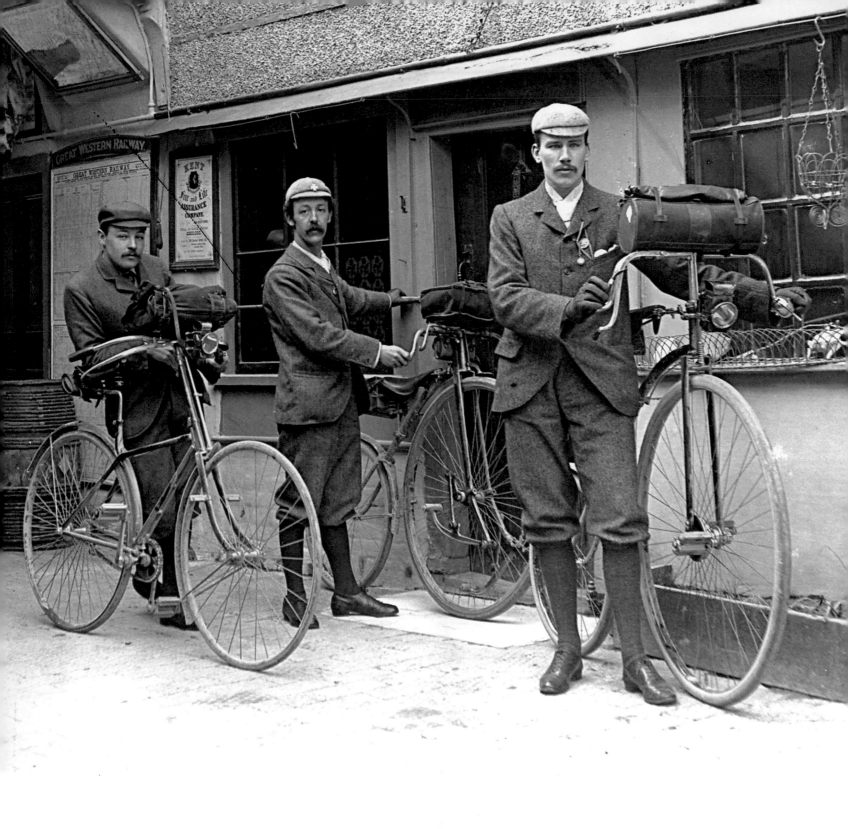

thousands. All mankind is a-wheel apparently and a person on nothing but legs feels like a strange animal . . . The bicycle crowd has completely subjugated the street. The glittering wheels dominate it from end to end. The cafes and dining rooms or the apartment hotels are occupied mainly by people in bicycle clothes. Even the billboards have surrendered. They advertise wheels and lamps and tires and patent saddles with all the flaming vehemence of circus art . . . Down at the Circle where stands the patient Columbus, the stores are crowded with bicycle goods. There are innumerable repair shops. Everything is bicycle (New York Sun, 5 July 1896).

The bicycle became a great equalizer among social classes, especially when prices broke in the late 1890s, a fact which may help to account for the end of the fashion of bicycling among European and American elites. For as the bicycle's popularity spread among working-class riders, members of elite society began to return to their horses, and eventually the upper classes took to the automobile.

The bicycle industry, especially in the United States, had flourished at a time of general economic depression. Assuming that sales of higher priced models to the wealthy would continue to grow, the industry became overcapitalized, resulting in overproduction at a time when demand was dropping. Companies began to merge, competition became more intense, and prices started to fall. Albert Pope introduced mass production, where parts made separately were combined on an

assembly line to lower manufacturing costs. At about the same time, benefiting from the introduction of such advanced machinery as the hydraulic press, Western Wheel Works of Chicago pioneered the cost-saving technology of stamping out parts such as hubs, sprockets, chain guards, fenders, and rims. These innovations enabled the American bicycle

industry to compete successfully with manufacturers in Europe; but overall, sales were dropping precipitously.

In 1899, Albert Spalding, a professional baseball player turned bicycle maker, formed the American Bicycle Company, also known as the Bicycle Trust, with Colonel Albert Pope as

chairman. This affiliation of forty-two manufacturers attempted to save the industry by raising capital and controlling competition. The Bicycle Trust advertised widely and appreciably augmented their sales force. When it attempted to start a similar organization in Canada, the major Canadian firms formed the Canada Cycle and Motor Company. But by 1901,

experienced similar difficulties, and had to contend with the added problem of cheap American imports. In an effort to lower costs, several English companies began to use female labor. Some believed that such practices lowered the quality of bicycles; the Triumph Cycle Company of Coventry proclaimed in its catalogues of the late 1890s that no female labor was used in the

production in the United States had fallen by ninety percent, and in Canada, by two-thirds. The Bicycle Trust dissolved, cycling magazines folded, and newspapers covered fewer cycling events, only adding to the impression that interest in bicycles was on the wane.

The European bicycle industry

construction of its machines. But all such efforts went unrewarded: as American imports flooded a shrinking European market, manufacturers in England and the Continent suffered.

Many bicycle makers reacted to foreign imports by shifting toward mass production, making cycles substantially cheaper. Prices

broke in 1897, when Rudge-Whitworth offered a bicycle at ten guineas, a drop of almost fifty percent. The company also devised an installment plan whereby a bicycle could be purchased with a down payment of one guinea, followed by eleven monthly payments. By 1900, most European manufacturers had adopted American methods of mass production. This enabled them to lower prices and recapture their home market, further compounding problems for American firms dependent on exports. The end result was that bicycles increasingly came into the hands of those who most needed a cheap means of transport: the working classes.

As the bicycle became more affordable and widespread—France had four million bicycles by 1914—working-class groups began to set up their own cycling clubs. The earliest examples in France include the Societé des Cyclistes Coiffeurs-Parfumeurs, founded in 1896, and the Union des Cyclistes des Postes et Telegraphes, organized in 1897 (by which date the French postal industry relied heavily on the bicycle). Such clubs provided new forms of sociability for the working classes, in imitation of middle- and upper-class organizations; but they also helped to organize laborers politically.

The political uses of bicycles were especially evident in Germany. In 1896, skilled workers organized the Workers' Cycling Federation: Solidarity (*Arbeiterradfahrbund: Solidarität*), whose members called themselves the "Enlightenment Patrols of Social Democracy." At a time when governments were banning working-class organizations, including unions, the Workers' Cycling Federation distributed political pamphlets and engaged in primitive political campaigning. For example, the federation organized parades apparently for the sole purpose of distributing political materials, throwing propaganda at crowds while riding at full speed. By 1913, its membership had grown to over 150,000. It had a chain of bicycle shops, a bicycle factory, and a bi-weekly newspaper called *The Worker-Cyclists*, all owned collectively and run co-operatively. Although leading figures of the German Social Democratic Party did not take the worker–cyclists seriously, the federation nonetheless played an important role in politicizing members of the laboring classes in Germany.

In Britain, the Clarion Club, founded in 1895, fulfilled a similar purpose, although it was substantially smaller and less politicized: in 1914, it counted 8,000 members. Nationwide, however, there were over 230 other local clubs, almost all based in the north of England, the region of highest industrialization. In addition to promoting amateur racing and arranging touring activities for their members, these clubs often became involved in political activities and election campaigns. Although its members included wealthy and middle-class cyclists, the Clarion Club remained working-class in character.

Between 1899 and 1910, the CTC in England lost more than 42,000 members, due partly to

the appearance of the automobile, but mainly to the fact that touring had become less central to cycling, replaced by the spectacle of watching bicyclists compete professionally. Cyclists became public performers, media heroes. As such, they were constantly manipulated by event promoters, track owners, cycle manufacturers, and newspaper publishers. For bicycle racing, like equestrian competition before it, soon became riddled with corruption.

The Development of Gearing

It had incorporated the rear wheel chain drive and pneumatic tires, but the safety bicycle still differed in one important respect from the modern bicycle. It was only with the addition of variable gears that the bicycle became easier and more comfortable to ride—especially up hills. The measurement of gearing still bears the imprint of the high-wheeler, for it has always been measured in inches corresponding to the diameter of the front wheel of an ordinary. For example, if a safety was geared to 56 inches, it would cover the same distance with one revolution of the pedals as an ordinary with a 56-inch wheel.

Variable gears fall into three categories: bracket, hub, and derailleur. The development of bracket gears, located at the crank axle, began in 1869. In that year, inventors patented eleven separate mechanisms using meshed gears to gear up the front wheel of the velocipede and thus increase speed. The French

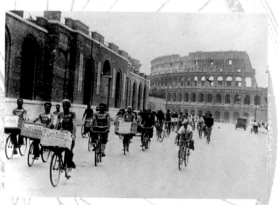

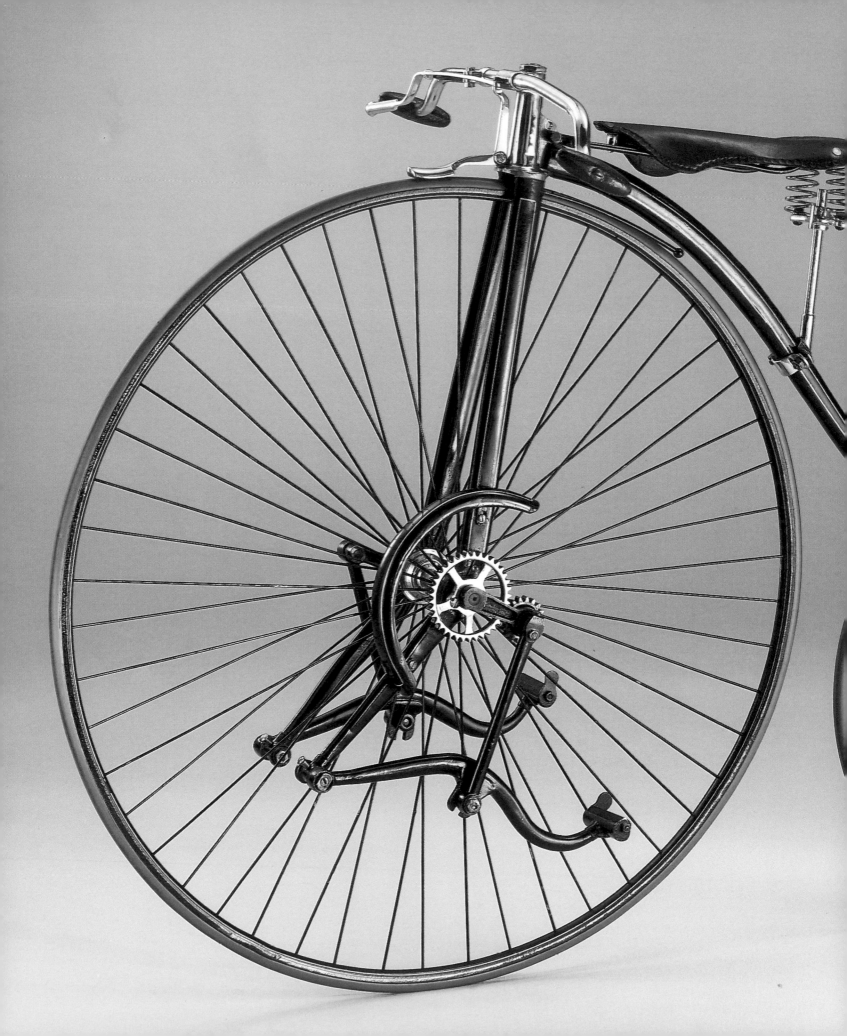

firm Barberon and Meunier produced the design with the greatest influence in the industry: it provided two-speed gearing, initially operated by pedalling backward. Their second version, with forward pedalling for both gears, served as a model to manufacturers such as Starley and Hillman striving to ease the strains of uphill riding.

In 1878, Scott and Phillott invented a two-speed gear based on the epicyclical or sun-and-planet principle. This design was to become the model for many bracket gears and, more importantly, the basis for a successful hub gear design still in use on three-speeds today. Further advances developed out of this principle. One, the Crypto Dynamic two-speed produced by Shaw and Sydenham in 1882, became significant when the Crypto Cycle Company of London applied it to tricycles.

Ordinaries such as the Geared Facile of 1887 and the Crypto-geared Ordinary of 1891 used bracket gears in an attempt to continue the tradition of front-driving bicycles amidst the growing popularity of rear-drive safeties. But the use of bracket gears on safeties was inevitable. In 1889, Collicr introduced a design for a two-speed bracket gear for safeties that was to last for fourteen years. Other manufacturers followed with a wide variety of bracket designs.

After epicycle gearing principles in bracket gears had been tested and refined, manufacturers began to apply them in a more compact form to rear hubs, where space was restricted. In 1895, Seward

Geared Facile. This new faster model, introduced by Ellis & Co. in January 1887 at the Stanley Show, supplanted the Facile which had lost its market due to the introduction of rear-drive safeties in 1885. In the sun-and-planet gear configuration, the sun gear, which is attached directly to the wheel, is driven faster by the smaller rotating planetary gear, thus offering greater speed to the front wheel. This became the preferred model until it was supplanted by the Crypto-geared Ordinary.

Thomas Johnson, an American machinist later heralded as the "Father of the Modern Speed-gear," patented his two-speed "bicycle wheel hub with driving mechanism" in England. Johnson's design influenced the Englishman William Reilly, who patented a practical two-speed hub in 1896. Reilly also introduced the toggle chain with a flared nut for changing gears, still in use today. Having lost control of current and future inventions to the company which produced the hubs, Reilly engaged a colleague, James Archer, to sign all subsequent patent applications.

In 1901, shortly after Reilly filed a patent in Archer's name for a three-speed hub, Henry Sturmey, well known in the cycling world for his handbooks and magazine articles, patented a similar design. Reilly, Archer, and Sturmey soon began to collaborate, and the Raleigh Cycle Company manufactured a hub based on Reilly's design under the name of both patentees, "Sturmey-Archer." Due to great demand, Raleigh licensed Birmingham Small Arms (BSA) to manufacture the three-speed hub in 1907. The success of hub gears at the time can be measured by the fact that there were 30 models on the market in 1909. It was the "Sturmey-Archer" model that evolved and Which has survived to this day.

The third category of variable gear was the derailleur. It differed from bracket and hub gears in that a mechanism moved the chain itself from one gear sprocket to another. In 1895, Jean Loubeyre in Paris patented the earliest design for a derailleur,

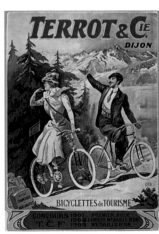

called the Polycelère. The following year, Edmund Hugh Hodgkinson took out the first of several patents for a three-speed derailleur gear called the Gradient. To keep the chain in line and avoid undue bending and wear, Hodgkinson designed the sprocket cluster to slide sideways and placed the smaller sprocket on the inside, so that it could slide inside the hub when either of the two larger sprockets were in use.

In 1894, Linley and Biggs, manufacturer of the Whippet bicycle, patented the Protean Gear, an unusual gearing system located on the chainwheel, and therefore formally neither a bracket nor a derailleur gear. The Protean was named for the varied shapes the expanding chainwheel assumed to achieve its four speeds. In 1897, Linley and Biggs attached it to the Whippet, naming the resulting bicycle the New Whippet. As the rider had to pedal backwards to change gears, the manufacturers incorporated a freewheel, thus necessitating the development of a rim brake (since backpedalling no longer stopped the machine). The same was true for later models of the Gradient. In 1899, Linley patented a veritable two-speed derailleur, called the New Protean gear, though it was generally known as the Whippet, after the bicycle on which it was sold. In this design, the chain bent slightly to engage a sprocket.

English riders generally preferred hub gears, and both the Gradient and Whippet fell out of favor around 1903. But French manufacturers soon

adopted them and went on to develop and perfect the derailleur. Although the Gradient, bought by Terrot and Compagnie of Dijon in 1904, influenced a number of manufacturers over many years, it was the Whippet that led directly to today's derailleur.

Gearing was particularly important to cyclists in the mountainous regions around Saint-Etienne, the center of France's cycling industry. Vélocio, the cycling tourist and editor of *Le Cycliste*, followed developments in the field closely. In 1908, not long after he purchased a Whippet bicycle and modified the derailleur, he reported on several makers of derailleurs with similar designs. One of these was Charles Boizot of Puteaux, near Paris, who

company, calling it Le Chemineau (The Vagabond), also the name of his derailleur. The internationally recognized manufacturers Simplex and Huret eventually adopted and improved upon Panel's design, selling one of the most popular derailleurs until the early 1970s.

Another gearing arrangement, the chainless or shaft-driven design, became quite popular in the late 1890s. Chainless bicycles had the advantage of sealed transmissions that were securely oiled and protected from dust and dirt. Gear shaft casings offered a sleek appearance, were easy to keep clean, and protected the rider's clothes. Some models had two speeds and coaster brakes. Although manufacturers claimed that it offered a smoother ride, the chainless drive

Right: L'Acatène-Metropole. France. c. 1895. The bevel gear chainless mechanism.

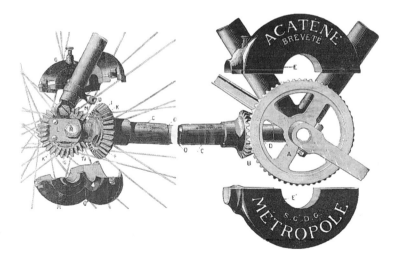

employed the term *dérailleur* for the first time in a patent application of 1910. Joanny Panel, another cycling tourist working at Rivolier, a manufacturer of cycles and arms in Saint-Etienne, patented an improved version of Vélocio's design in 1911. He later left the firm to establish his own

was less efficient on hills than chain drive bicycles.

There were three varieties of chainless safeties: spur gear, roller gear, and bevel gear. The most popular, the bevel gear chainless, was first produced by the Belgian company FN (Fabrique Nationale) in 1889. Five years later the League Cycle Company

Left: Simpson lever
chain. The tops
of the triangles had
cross-bars that
engaged the
perimeter of the
rear chain wheel's
flange.

Below: Detail
of the Simpson rear
chain wheel.

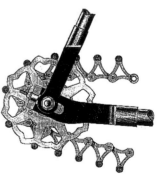

of Hartford, Connecticut, patented and produced the first bevel gear chainless in the United States. Lacking the high degree of precision needed for such a design and the finances to promote it, the firm ended production in 1897, selling its patent rights to the Pope Manufacturing Company. Meanwhile, in France, the Acatène Chainless had already been winning world long-distance records.

Other leading manufacturers joined Pope in promoting the chainless at a time when bicycle sales in general began to slacken. It was seen as a technological novelty to retain the public's attention, and manufacturers and enthusiasts predicted the complete demise of chain drives. But chainless bicycles had certain disadvantages. They cost more and were heavier than chain drive models. Shaft drive transmissions had no flexibility, so that if the rear wheel was seriously shocked by a bump, the bevel gears could be thrown out of alignment, or, worse, a gear tooth might break. The greatest inconvenience of the chainless, however, was the difficulty of removing the rear wheel when changing a tire. By 1903 the fashion for chainless bicycles had passed, although some manufacturers continued making them into the 1920s.

In the meantime, technological experiments continued as manufacturers and inventors sought ways to reduce the power necessary to pedal. Such was the object of William Speirs Simpson's invention of 1895, the Simpson Lever Chain. The main

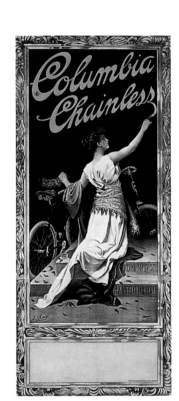

"La Chaîne Simpson," by Henri Toulouse-Lautrec. Imp. Chaix, Paris 1896. Toulouse-Lautrec was an avid sports fan who attended weekly races at either the Vélodrôme Buffalo or the Vélodrôme de la Seine. As he was friendly with Tristan Bernard, the sports director of both velodromes, and with several of the racers, Toulouse-Lautrec traveled with the French team to London to witness the Chain Matches. He returned to Paris with sketches used for "La Chaîne Simpson" (1896). This poster shows Huret

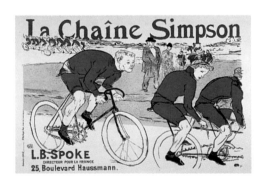

riding behind the Gladiator pacing team, viewed from the center of the track by Bernard and Louis Bouglé (known as "Spoke"), the French agent for Simpson chains.

feature of the chain was its method of engaging the rear chain wheel. The tops of the triangles had cross bars that engaged the perimeter of the rear chain wheel's flange at a much greater distance from the wheel's axis than would an ordinary chain and chain wheel. Thus Simpson could claim that his chain provided more power through greater leverage.

not only included the top racers—Tom Linton, Jimmy Michael, and Constant Huret—but also the Gladiator pacing team brought over from Paris. Pacers enabled a racer to ride faster by shielding him from air resistance. Although Simpson won the Chain Matches, they only proved that the Gladiator pacers were superior to their English rivals.

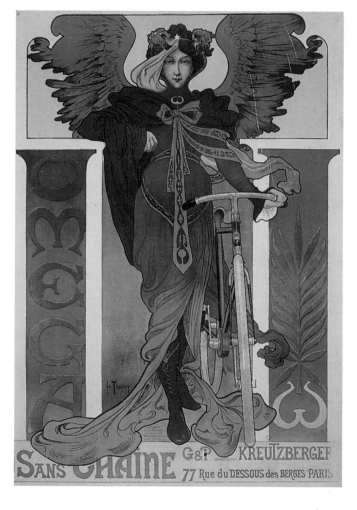

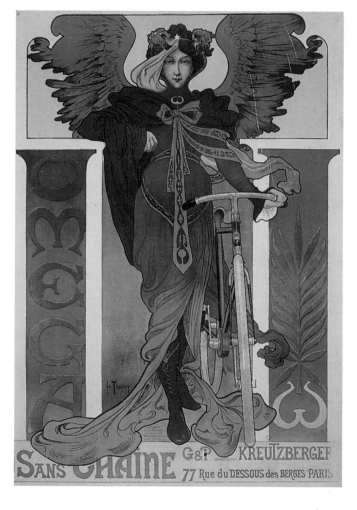

Far left : "Columbia Chainless." Poster by A. Romes. J. Ottman, litho., New York, c. 1898.

Clockwise from left: "Le Gyroscope Humain." Poster by Faria, France, c. 1900, a novel indeed spectacular application of the bevel gear drive.

"Omega Sans Chaîne." Poster by Henri Thiriet, France c. 1897.

Bicycle Brand Playing Cards, no. 808, by the United States Playing Card Company, 1891–1908.

In the fall of 1895, Simpson offered ten-to-one odds that riders with his chain would beat bicyclists with regular chains. Later known as the Chain Matches, these races at the Catford track in London attracted huge crowds estimated between twelve and twenty thousand in the June of 1896. Simpson's team

Through such advances, created in an atmosphere of intense competition between rival companies, the bicycle and its technologies acquired a high degree of sophistication, developments which would be crucial to the bicycle's future as it prepared for the motorized challenges to come.

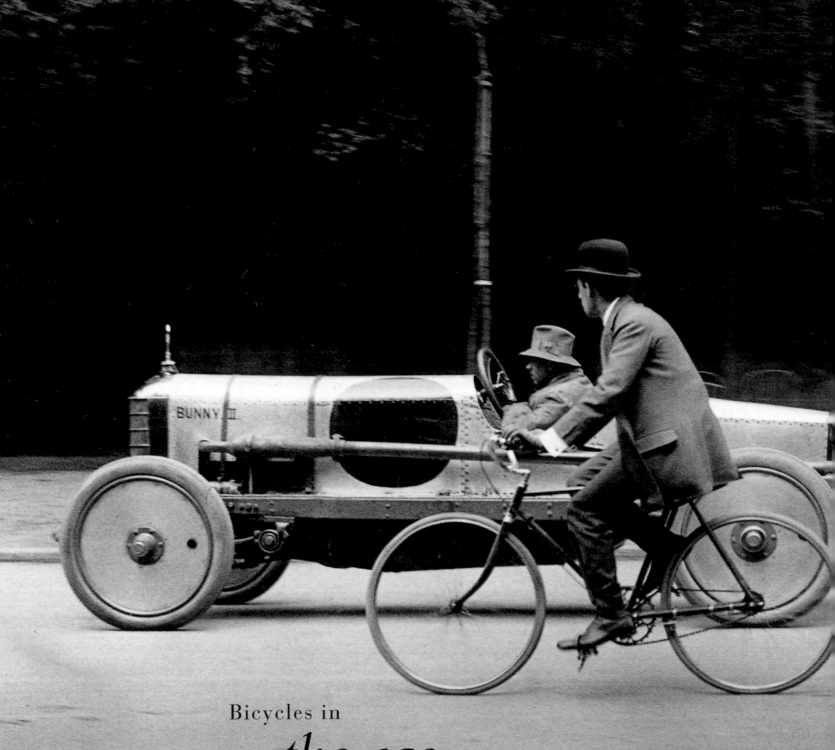

Bicycles in

the age of the

Automobile

During the years leading up to and immediately following World War I, motorized transportation grew enormously in popularity in Europe and North America, as did an increasing standardization and uniformity of design among bicycle manufacturers. As the public's fascination with the bicycle wavered, a novel design made its appearance in the United States around 1920: the "motorbike." Although not motorized, this new bicycle was designed to resemble early models of the motorcycle. The deluxe models had "tanks" (built-in or bolted-on tool boxes imitating early motorcycle gas tanks), headlights, full mudguards, and occasionally front fork spring suspension. With the addition of balloon tires, adapted to bicycles by Goodyear, the motorized look was complete; all that separated the "motorbike" from the motorcycle was the engine.

Balloon tires were oversized pneumatic tires so named for their high volume and low air pressure. The Goodyear company introduced and promoted them for use on automobiles around 1923, when most bicycle tires in the United States were of the single tube variety. Single tube tires were difficult to patch, and cyclists had to replace them often. This raised the cost of bicycle use and discouraged sales, especially for serious transportation purposes. Goodyear adapted their technology to bicycles to producing reliable, easily reparable double-tube balloon tires in 1927. Later popularized by Schwinn, the balloon tire caused bicycle sales to surge again.

Strangely enough, however,

Left: A Singer automobile overtakes a bicycle, on the Avenue des Acacias. Paris. 5 June 1912.

Below: Automobiles and Cycles Hurtu. Poster by Geo. Dorival. Ste. Gle. Imp.. Paris. 1911.

the adoption of balloon tires in the United States was a regressive technological evolution. Bicycles equipped with them weighed ten to twelve pounds more than their predecessors, and their relatively low tire pressure made them slower and less responsive. In fact, for most American city dwellers in the era between the two wars, bicycles became less functional vehicles for urban and inter-urban transport. In the era of the automobile, the motorcycle, and the perfection of mass transit systems (trolleys and subways), bicycle manufacturers focused more on form than function, paying careful attention to the new aesthetics of art deco. This led to a fascination with streamlining, a style influenced in part by the aerodynamic designs of zeppelin and airplane design, and present throughout the art deco movement. Most material culture between the wars was influenced by streamlining— makers of automobiles, trains, and even household appliances, gave their products a sleek, aerodynamic look, as did bicycle manufacturers beginning in the mid-1930s.

Schwinn introduced the Streamline Aerocycle in 1934. Advertising its "new welded frame—built like an aeroplane fuselage," the company promoted the model as "a greater sales stimulator" (Arnold 58) than earlier ones. Subsequent models incorporated elements of the latest motorcycle design. The Elgin Bluebird, another streamlined model designed in 1934 and released as the "bicycle of the century" the following year, had a speedometer that lit up at night built into the tank.

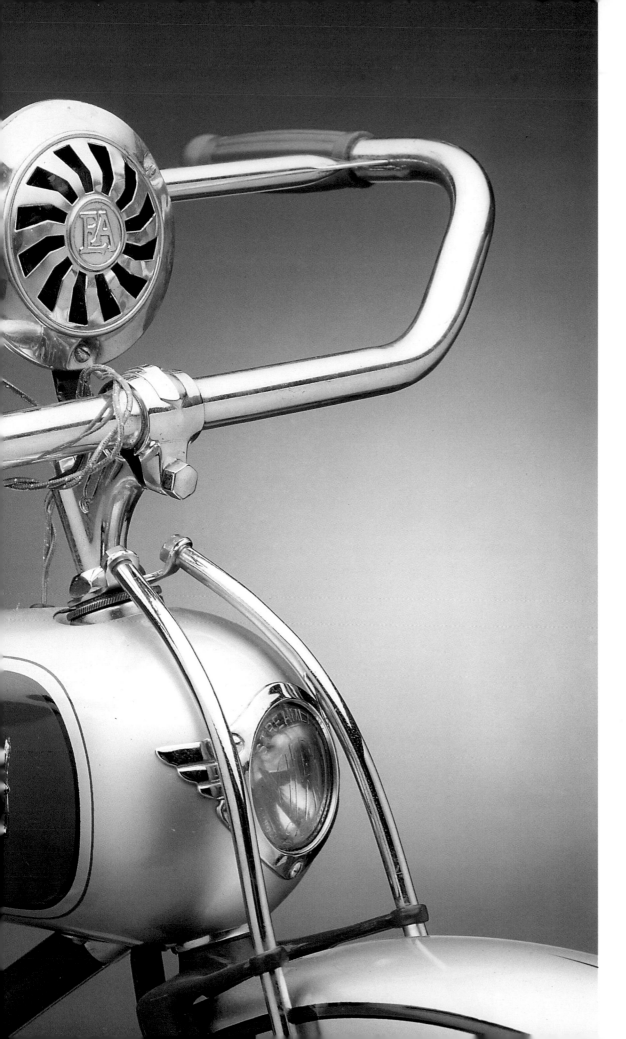

Far left, top to
bottom: Norman
Rockwell, poster
for Fisk Bicycle Club,
1917.

Schwinn Streamline
Aerocycle.
Introduced by
Schwinn in 1934, it
was advertised as
having a "new
welded frame—built
like an aeroplane
fuselage."

Left, Schwinn
Streamline
Aerocycle, detail.

Elgin was produced by Sears, Roebuck and Company, a national chain store that at one point sold a quarter of all bicycles in the United States.

This innovative styling popularized bicycles enormously among a younger generation: teenagers saw streamlined bicycles as the first step toward motorcycles and automobiles, the preferred modes of transport. Manufacturers believed that the main appeal of these deluxe bicycles was the "equipment": tanks, used to hold tools and the battery; built-in electric lamps that were later streamlined in the fender; tail lights; reflectors; knee-action spring forks; men's chain guards; and front wheel drum brakes. Retailers were trained to "step up" their customers and coax them into buying these "dolled-up" bicycles.

Although deluxe bikes did not sell well during the world economic depression of the 1930s, they nonetheless helped promote the less expensive models. As during the 1890s, despite (or perhaps, because of) economic depression, overall sales were brisk: many adults temporarily returned to bikes when they could not afford cars. In 1938, in an effort to create a new market and capture the adults seeking a higher quality and more efficient machine, Schwinn introduced adult lightweight touring and racing models, similar in concept to the bicycles of the 1890s. There were three models, the Paramount, Superior, and New World. The American cycle industry also promoted payment by installments. This had the

added benefit of raising the quality of bicycles and their parts so that they would "stay sold," as unhappy customers could always return their purchases. Business was also helped by newspaper cover photos of Hollywood stars out for a ride, adding glamour to the bicycle's image.

In the United States, balloon-tired bicycles continued to be manufactured until 1965. Known, in retrospect, as "Clunkers" and "Bombers" because of their heavy weight and sluggish handling, these bikes later gained a cachet and reputation of their own. In an effort to lend respectability to these machines and differentiate them from antiques, an article by collector Leon Dixon in *Bicycle Dealer Showcase Magazine* in 1979 described them as "Classic Bicycles," a term since used widely. "Character Bikes," a term coined by the same author a year later, described a range of bicycles inspired directly by the American film and television industries. Buck Rogers, Hopalong Cassidy, Gene Autrey, and Disney cartoon characters such as Mickey Mouse and Donald Duck, all inspired specific bicycle models.

In Europe, with fewer automobiles and paved roads, the bicycle tended to function before and after World War II as a utility vehicle, used by a wide variety of merchants for deliveries. In France, however, the bicycle came to symbolize the greater leisure and paid holidays introduced by the Popular Front government (1936–38) and immortalized by the paintings of Fernand Léger. Later, with the war-time restrictions of occupied Paris, a new means of transport—

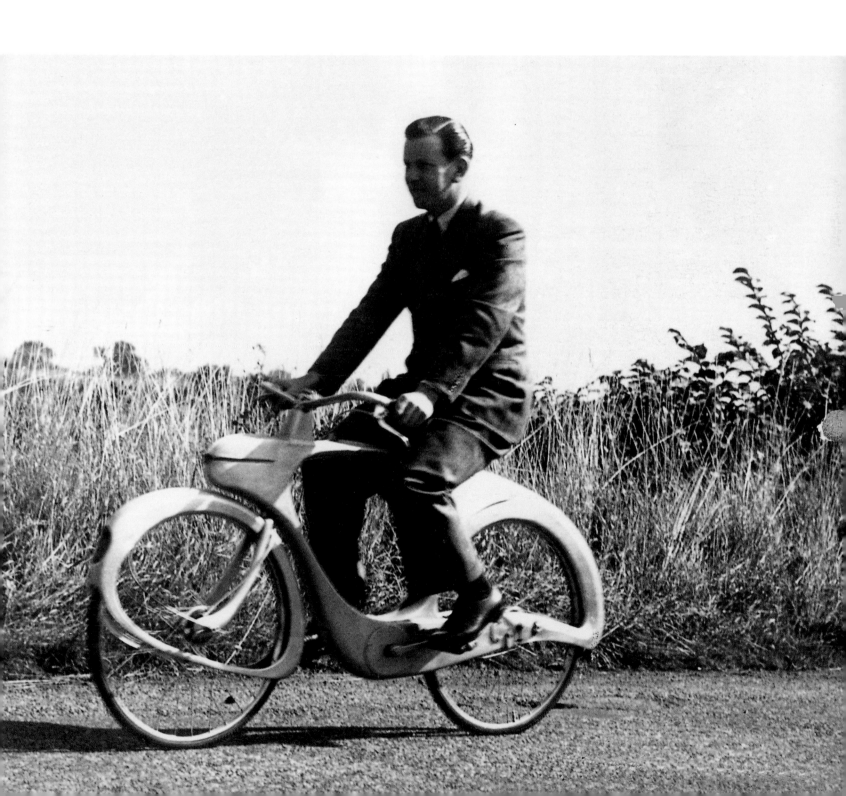

the taxi-vélo—developed.

Postal services throughout Europe adopted bicycles to expedite mail delivery, and police departments relied on them for greater speed and mobility in congested cities. An essential means of transport, the bicycle widened the horizons of the rural world and helped transform the cultural landscape of rural Europe, allowing peasants a degree of mobility they had never before known. Sociologists and historians have even shown how the bicycle contributed to lowering rates of endogamy, with greater numbers of rural inhabitants marrying farther and farther from their home villages. In the Netherlands and parts of Germany, governments built bicycle paths with the specific project of integrating outlying areas into national economic and cultural life. An anonymous author of 1923 described their usefulness in a jubilee publication of the United Netherlanders Riders Club (Algemeen Nederlandsche Wierlrijders-Bond):

Just how useful cycle paths have been in the intellectual development of country people is beyond calculation, but together with the bicycle and the acetylene lantern, which made it possible to take lessons and to attend courses and meetings, they fulfilled a leading role in the intellectual development of the farming population. (McGurn 132)

Western Europeans, especially the working classes, continued to enjoy bicycling as a spectator sport, and bicycle racing remained an important leisure activity. While America quickly took to

the wheel of the automobile, Europe maintained its fascination with the bicycle long after the Golden Age had passed.

Since the perfection of the safety bicycle, the use of bicycles has oscillated between two poles: as a practical means of transport, and as a leisure activity. After World War II, these two functions became more marked geographically.

In the United States, the development of a transportation system based on the automobile turned bicycling almost exclusively into a leisure activity for individual consumers, largely unsupported by bicycling as an organized sport. The increasing power of the big automakers cast the bicycle into this role as early as the 1920s, as buses and automobiles replaced trains, streetcars, and trolleybuses.

The automobile became the symbol and ideal of American identity, even before the postwar boom in economic prosperity. As we have seen, the Classic Bicycles of the 1930s, with their imitation of motorized vehicles, were already forming the desire to possess an automobile within the younger generation. As a 1974 Senate subcommittee on Antitrust and Monopoly claimed in its report to the Judiciary Committee, the automobile dominated ground transport in the United States, largely due to the monopoly established by the "big three" manufacturers— Ford, General Motors, and Chrysler—which "eliminated competition among themselves, secured control over rival bus and rail industries, and then maximized profits by substituting cars and trucks for trains,

Left, top to bottom: Sale of used cycle parts. Used bicycle parts were a precious commodity during the war, especially since production at cycle companies was directed towards the war effort and supply of new cycle parts was scarce.

On the routes du Nord.

Right: Cycling in the snow at the Opéra, Paris during the Occupation.

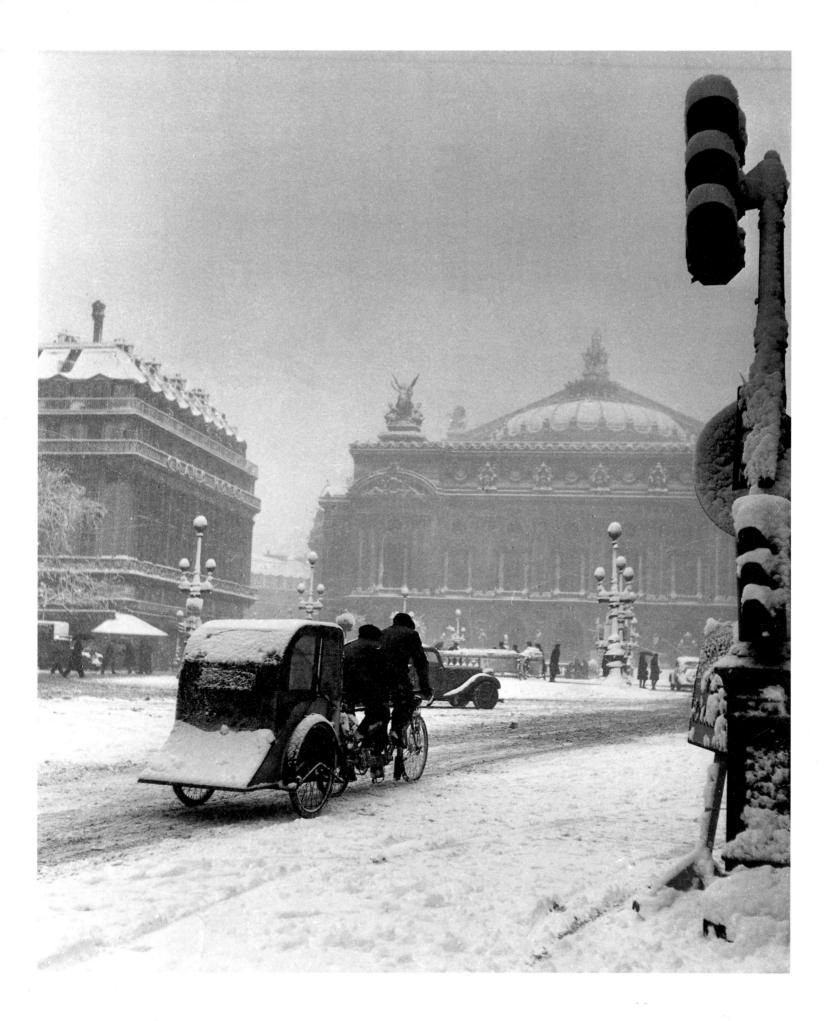

streetcars, subways, and buses" (Snell 1).

In Europe, where a vast web of local railroads continued to meet the needs of public and commercial transportation, bicycles still served utilitarian ends, and cycling thrived as an organized spectator and club sport long after the Golden Age. By the late 1950s, improved economic conditions in Europe allowed consumers to follow the American fascination with the automobile, and the bicycling industry experienced a distinct decline. Yet although the bicycle began to be displaced by an increasingly dense automobile population, bicycle culture remained more deeply embedded in Western Europe, especially in the northern countries, where

problem posed by increasing automobile ownership. In what might seem a throwback to the era of nineteenth-century individualism and entrepreneurial capitalism, an independent inventor, Alex Moulton, challenged TI-Raleigh in 1962 by introducing a small-wheeled bicycle with a rubber suspension system. The bicycle, named after its inventor, became an icon of 1960s design. As one author wrote succinctly, it was "a mini-bike for the era of mini-skirts and mini-cars" (McGurn 165). Such small bikes, with sixteen- or twenty-inch wheels, were designed as urban vehicles, at once fashionable and useful. Realising this, Raleigh joined in the entrepreneurial spirit by buying out their rival in

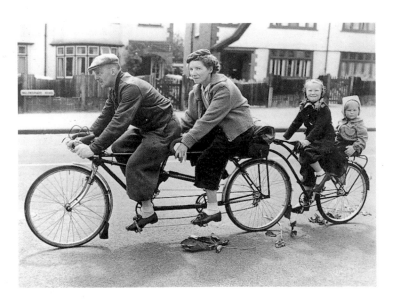

governments became actively involved in planning for what one author has called the "vehicle for a small planet" (Lowe).

In postwar Britain, it was left to private enterprise, in the form of TI-Raleigh (a company formed from the 1960 merger of Tube Investments and Raleigh Industries), to address the

1967 and producing about a quarter of a million Moultons over the next seven years.

After the world oil crisis of 1973–4, bicycling experienced a notable revival, both as a sport and as an alternative to the automobile. But it was only with the financial assistance and cooperation of national

Left: Daisy Bell continued—the Bicycle Built for Four. Mr and Mrs Leonard Howe and family of Streatham, London, show just how the problem of transporting the family can be resolved. The additional tailpiece to the tandem accommodates 6-year-old Jacqueline and 2-year-old baby Margaret. Further wheel and handlebar units can be added "as required." 1 August 1952.

Right: Katherine Hepburn takes a break from filming her latest MGM movie "Pat and Mike" by taking a spin on a bicycle. 25 May 1952.

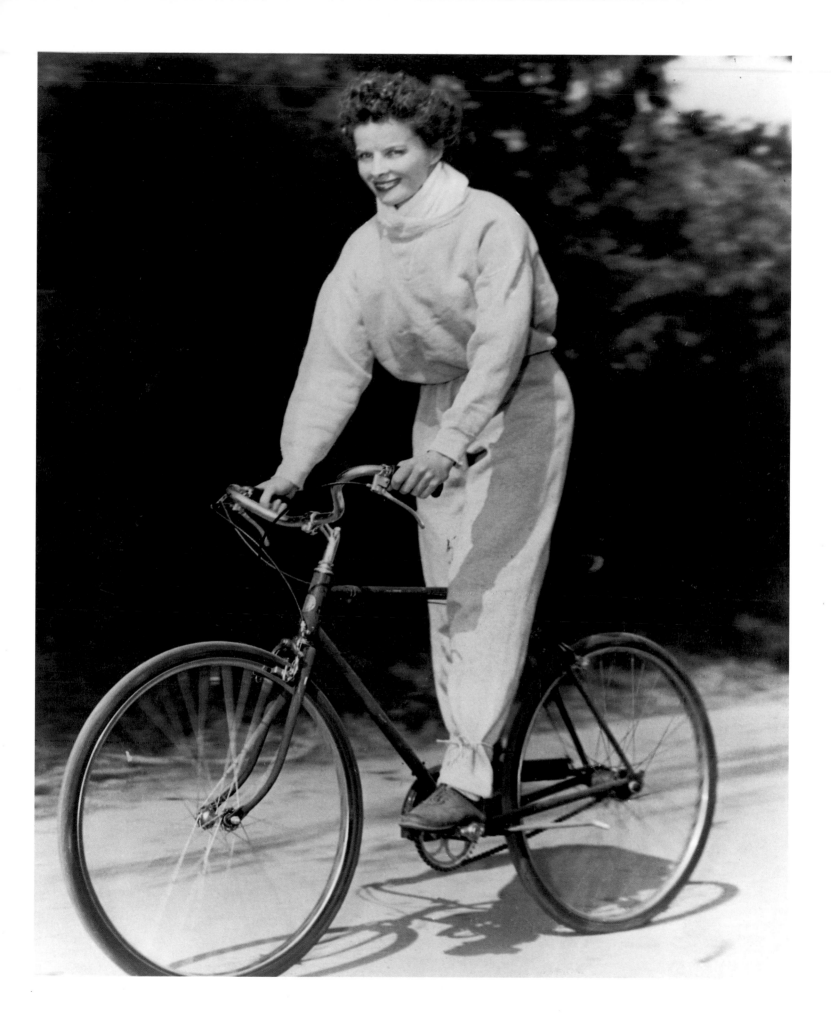

governments that bicycles came to rival automobiles with any degree of credibility. In the late 1960s, the Dutch government began to create a vast network of cycle lanes on a landscape practically designed for the mass use of bicycles; by the late 1980s, over eight thousand miles of bicycle paths criss-crossed the country. In the city of Delft, these lanes included bicycle-sensitive traffic signals, and underpasses and overpasses at dangerous intersections. By the mid-1980s, bicycle use as a percentage of transport preference averaged between twenty and fifty percent in the cities and towns of the Netherlands: here, cycling had become a practical alternative to the automobile. Denmark also embarked on an ambitious program to build bicycle lanes. By the late 1980s, cycle paths ran

and Sacramento voted plans in the 1980s—it was only in smaller towns with colleges and universities that bicycles served such utilitarian functions. After all, bicycles were a perfect transport mode for a population not yet able to afford a car, in an environment with few parking facilities where distances were not too great. But even if advocates of alternatives to the automobile could be heard in great numbers, neither local, state, nor federal government undertook any systematic attempt to wean America from its fascination with the automobile.

The bicycle industry did enjoy a minor boom in the United States beginning in the mid-1970s, but it developed as much along recreational as functional lines. By the late 1960s, commercial versions of racing

alongside seventy-five percent of main roads, and bicycles made up twenty percent of the traffic in urban areas.

In the United States, while a number of municipal governments belatedly began to propose bicycling paths as a means to relieve traffic congestion—Denver, Tuscon,

machines were arriving in large numbers from Europe. Soon American companies began to produce domestic models comparable to these imports. Originally designed for professionals, these mechanically sophisticated bicycles far exceeded the needs of recreational cyclists. Once again,

Far left: Cycles in the snow outside a downtown Copenhagen office illustrate the Danish commitment to the bicycle culture.

Left: In this Dutch cycle lane. the raised island that separates the bicycle path from the automobile lanes is a critical component in the safe and successful promotion of bicycles in Holland.

bicycles became status symbols, with name brands—such as superior quality components from the Italian company Campagnolo—fetching high prices. In the late 1970s, the Japanese (led by the parts company Shimano) entered the international bicycle market, introducing racing technology such as aerodynamic tubing to commercial bicycles. The market for new technologies continues to grow, with each year witnessing exotic advances in equipment—including ultra-light carbon fiber and titanium frames; clipless pedals; tri-spoke and solid aerowheels; cyclocomputers for measuring distance, cadence, and altitude; index shifting; and brake lever index shifting. Electronic index shifting, pioneered by Mavic and used by a few professionals in 1993, was even introduced commercially, though without success. At the same time, the cycling fashion industry grew into a multi-million dollar business, all in imitation of professional bicycle racing.

The popularity of cycling in the United States—a 1985 survey showed the existence of more than seventy-five million riders, half over the age of sixteen—has not, however, had a noticeable impact on the use of automobiles. Cycling continues to be practised as a recreational sport, not an alternative form of transportation, and for good reason, since no infrastructure exists for bicycles in large cities. Indeed, the only useful adoption of bicycling in large North American cities has been the bicycle messenger business, which created a new kind of urban hero,

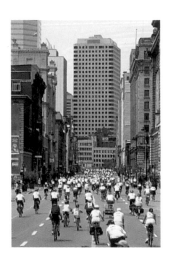

darting through traffic and traffic lights, endangering himself and pedestrians in the process. This daredevil riding style is due in part to the use of single-speed track bikes, which discourage stopping. Not even the fax machine or the information superhighway has put an end to this "cult" profession, whose members often serve as advocates for the improvement of bicycling conditions in urban centers.

As the environmental movement took shape in the late 1960s—the first Earth Day was celebrated in 1970, the same year that the United States Congress passed its first Clean Air Act— the bicycle became a symbol both of an energy ethos and an antagonism to the powerful interests of the automobile and oil industries. Once again, the bicycle entered the stage as a means of liberation—this time, the liberation of environmentally conscious men and women who sought a political and practical response to a pervasive environmental crisis, especially after the 1973 oil embargo. Activists formed associations and groups, occasionally using the organizational lessons learned from the political activism of the late 1960s and early 1970s.

Drawing on his experience as chief liaison officer for the United States to China in 1975, George Bush wrote to John Dowlin, who established the Bicycle Network in the mid-1970s: "The more I think about our U.S. domestic transportation problems from this vantage point of halfway around the world, the more I see an increased role for the bicycle in American life. Obviously some

Left top and bottom: The Tour de l'Ile in Montreal.

Right: Cyclist on the Brooklyn Bridge. New York. c. 1990.

terrains make it more difficult, obviously, some climates make it more difficult; but I am convinced after riding bikes an enormous amount here in China, that it is a sensible, economical, and clean form of transportation and makes enormous good sense" (*Network News*, no. 48, 1990: 10). As president of the United States from 1988 to 1992, Bush was not, however, a particularly vocal advocate of bicycle transportation. In part, he was limited by a landscape already designed for the automobile, and by a vast set of vested interests which only proposed building more roads and parking lots, thereby increasing traffic congestion.

Beginning in the late 1970s, bicycle advocacy groups began to take shape in cities which suffered from heavy traffic congestion. While small in membership, they occasionally made their voices heard. In general, such groups consisted of commuting cyclists concerned for their own safety and aggravated by motorists who paid them little respect. Only on such occasions as public transportation strikes in major cities (such as the 1980 strike in New York City) did these groups gain converts who temporarily reconfigured their daily commuting habits. The *vélorution* in Canada began in 1975 with the founding of Le Monde à Bicyclette (MAB) in Montreal by "Bicycle Bob" Silverman. Since its inception, the group has employed imaginative theatrical tactics to convey its message. In 1975, MAB organized the first mass parade demonstration, an event that has evolved into the yearly Tour de l'Ile, organized now by Vélo Québec. In another event, the Manif Spatial (Spatial Demonstration) of 1981, each bicycle was outfitted with a wooden frame so the cyclist occupied the same space as a car. The cyclists then rode to the city center and joined in the daily traffic jam, causing one of the many angry motorists to drive on the sidewalk. The point they wanted to make was that if they had been riding in noisy polluting steel boxes like the rest of the traffic, their presence would have been deemed respectable. Since 1977, when the one bridge accessible to cyclists collapsed, MAB has been leading the fight for bridge access, an issue which was only partly resolved with limited seasonal use of a bridge.

More recently, bicyclists have organized mass rides, demonstrations on bicycles, beginning in San Francisco in 1992 and now common in many North American cities. Known as Critical Mass rides, these political actions are intended to bring the issue of unsafe streets to public awareness. In New York, these rides are backed by Transportation Alternatives, an environmental advocacy organization which has succeeded in gaining bridge access and limiting the use of automobiles in Central Park.

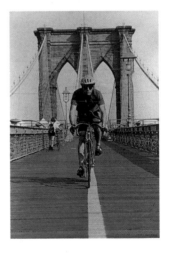

In an effort to create a more acceptable city life with lower pollution levels, urban and environmental activists sometimes work alongside bicycle advocacy groups. Their aim is to reduce or even completely eliminate automobile dependency through improvements in cycleways and mass transit. Perhaps the greatest advances began in Holland,

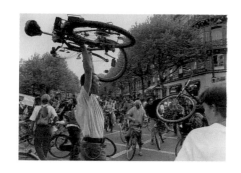

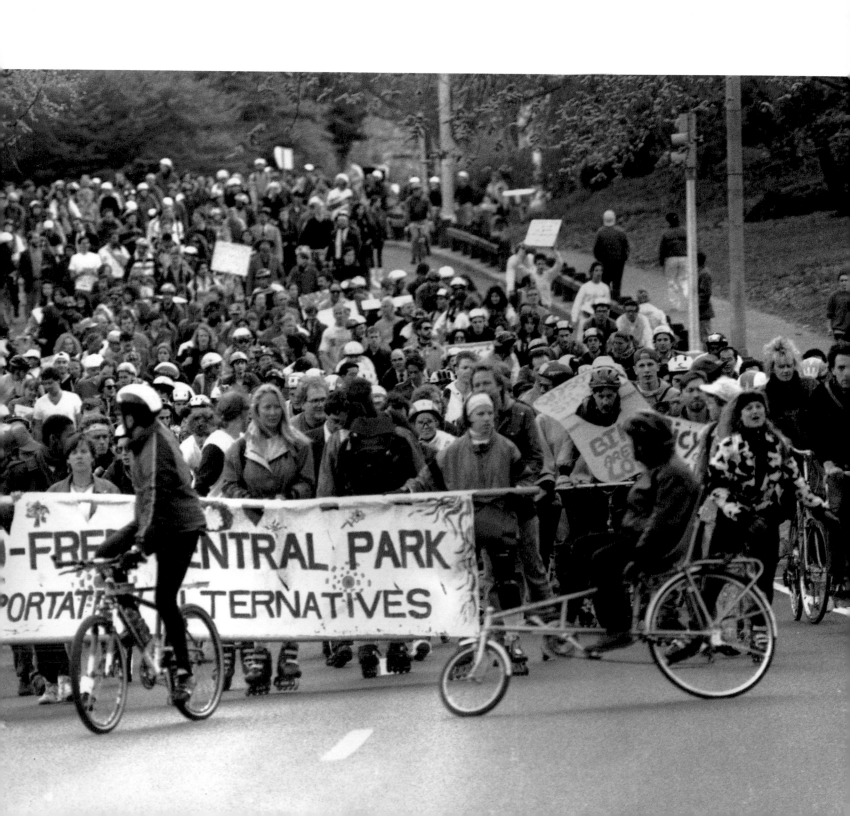

Denmark, and Japan in the 1970s, spreading to Germany in the 1980s. People living in these crowded countries were encouraged to bicycle to rail, bus, and ferry stations, where they could park their bicycles safely and take public transport to their final destination. The creation of bicycle parking at suburban stations encouraged such trends, at a relatively low cost to municipal and state governments. Today, the Dutch National Railway alone has close to 200,000 guarded bicycle parking spaces, and about eight percent of passengers have two bicycles—one ridden to the station, and the second waiting at their destination. In Japan, one of the most densely populated industrial countries, the daily number of bicycles parked at train stations rose from half a million in 1975 to over three million in 1987. The Japanese have multi-level above- and below-ground state-of-the-art bicycle storage facilities, some with automated cranes to park the bikes. Fifty-five of these facilities can hold two thousand bicycles each.

The European Cyclists' Federation (ECF) was founded in Copenhagen in 1983 to "achieve a shift from motorised modes to an increased use of the bicycle for daily travel as well as recreational purposes." Believing that "the bicycle is the means of transport for the future" (*Handbook of the ECF*, 16 September 1994: 3), the federation serves as an umbrella group for lobbying organizations in over twenty countries. As a non-governmental representative at the European Conference of Ministers of Transport, the ECF lobbies the European Parliament and the European Commission. It recently applied for consultative status with the United Nations, in order to participate in the Economic Commission of Europe, an agency involved in the standardization of traffic regulations and signs.

In Japan, as in Europe, one of the major obstacles to traveling with a bicycle is the lack of train access. Bicycles are not allowed on certain trains, and riders are frequently charged high fees when they bring their bicycles aboard. An apparently increasing number of long-distance international trains do not have room for bicycles. A case in point is the newly inaugurated Chunnel train between London and Paris. Due to pressure by the ECF, the CTC, and other English, French, and Belgian groups, the operator, Eurotunnel, will be obliged to provide bicycle access on both Le Shuttle (the service for motorists) and Eurostar (the passenger service). In an effort to inform cyclists of "bicycle-friendly" trains throughout Europe, the ECF has produced the report *Bikes and Trains*.

The ECF also sponsors the international Velo-City conferences, a program founded in Bremen, Germany, in 1980. Eight conferences have taken place so far, each in a different country. As well as attracting city planners, politicians, engineers, representatives of the cycle trade, and cyclists themselves to discuss the latest developments, these conferences have become an opportunity for the host city to improve its own cycling facilities. The Velo-City Falco Lecture Prize, a competition

Left, top to bottom: Cyclists protest against polllution, 1 October 1994. Hundreds of riders crossed Paris asking for more space to be set aside for pedestrians, cyclists, more public transport, and fewer cars.

Auto-Free Central Park demonstration, Spring 1991. The author is riding on the far right of the picture.

sponsored since 1991 by Falco, a Dutch company that fabricates cycle parking and street furniture, encourages the development of new ideas on cycling use and policy. Topics for the competition are established at each conference, and winners presented the following year. The topic for the first paper was "How can cycle use be extended to all sections of society?" The first prize, announced at the Velo-City conference in Montreal in 1992, went to Howard Boyd of England for his paper "The Missing Chapter." Boyd was responding to the 1986 World Bank report "Urban Transport—A Policy Study," which did not include discussion of the bicycle in any meaningful capacity. In Boyd's own words, his paper "presents an economic justification for positive policy action by national governments in favour of cycling as a mode of transport." Using case studies as disparate as Beijing, Groningen (Netherlands), and Harare (Zimbabwe), it describes "the type of investment a government could make to encourage cycling" (ibid.)

On another level, the creation of auto-free zones in many of Europe's dense city centers, begun in the 1970s, brought relief to pedestrians and cyclists alike. Again, political activists of the 1960s were frequently key players in this transformation of urban space, and, once again, the Dutch led the way. Luud Schimmelpenninck, a member of the Provo anarchist group in Amsterdam, promoted as early as 1967 the First White Bicycle Plan, a project that proposed replacing motorized traffic in the inner city with public transport and the free use of several thousand white bicycles. The first experiments were less than successful in practice—the approximately one hundred white bicycles in Amsterdam quickly broke down or simply disappeared. But this inspiring movement did manage to capture the public's attention, especially when Queen Beatrix was seen leading bike rides. In 1995, the city of Portland, Oregon attempted a similar project, getting unemployed youths to repair bicycles and paint them bright yellow.

The Dutch also pioneered the development of street closing. Their success in Delft, Groningen, and Amsterdam led many other European cities to create pedestrian and bicycle areas in central sections of older towns—many of which were built, after all, centuries before the appearance of the automobile. In most cases local merchants, initially hostile to the idea in the belief that their business would suffer if customers could not drive or park close to their stores, came to support the plans as public life was revived in pedestrian and bicycle-friendly areas.

Such solutions are becoming increasingly necessary. The problems posed by the automobile and excessive motorization in the cities of the world have not only deepened the dependence on oil imports and created serious environmental hazards; they have also produced serious obstacles to free circulation. Traffic in many North American and European cities now moves at an average

pace slower than bicycles: at peak hours, automobiles in London and Los Angeles average five miles an hour. Police departments in those cities, and smaller ones such as Seattle, Washington, have increasingly turned to bicycles rather than automobiles for patrolling their congested urban centers.

In the United States, progress has been much slower than in Europe. An American organization similar in many respect to the ECF is the Bicycle Federation of America (BFA). It was founded in 1977 to increase the safe use of bicycles, and since 1989 has expanded to include pedestrian safety in its Pedestrian Federation of America division. The BFA is the only national organization devoted to the needs of urban walkers, and is the main source of information on bicycle and pedestrian advocacy. Every two years since 1988 it has hosted the Pro Bike Conference, as a way to spread ideas. The conference in Montreal in 1992 was international in scope as its co-hosts were the ECF and Vélo Québec.

American municipal governments have shown a much greater resistance to street closing and the provision of cycling lanes and parking amenities. Transportation planners often dismiss the need for lanes and bicycle parking by citing a lack of riders; yet according to opinion surveys, the number of cycles would rise substantially if such amenities were provided.

Nevertheless several cities, mostly in California, have become exemplary models of progressive planning. Palo Alto and Davis, California, are both college communities, housing respectively Stanford University and the University of California, Davis; both have an extensive network of cycling paths. In Palo Alto, an affluent, highly educated community of 56,000 near San Francisco, businesses and local government have taken innovative steps to encourage bicycle commuting. A city zoning ordinance of 1983 requires that showers and secure indoor bicycle parking for employees be included in new buildings above a certain size. The Xerox Corporation, based in Palo Alto, went a step further by offering a towel service in its shower room, a persuasive amenity, since a fifth of its employees cycle to work. The Alza Corporation has taken a different approach, paying its employees one dollar for each day they cycle to work, after finding that bicycle commuting employees were more alert on the job and took fewer days off because of illness.

More recently, federal laws designed to solve pollution problems in the United States have served as incentives to turn to the bicycle. The Clean Air Act Amendments of 1990 forced regions with the worst air quality to diversify transportation choices, specifying that if automobile pollution was not reduced by fifteen percent by 1996, highway funding would be curtailed. The Intermodal Surface Transportation Efficiency Act (ISTEA) of 1991 allowed more federal transportation funds to be allocated throughout the nation for transit, pedestrian, and bicycle travel, and required each

Below: Bicycle messenger. New York. c. 1990.

state's department of transportation to have a bicycle and pedestrian coordinator to advocate for better facilities in communities suffering from air quality and congestion problems.

The British government took a more assertive stand in 1994 when the Royal Commission on Environmental Pollution announced a comprehensive plan to divert half the road budget to rails, buses, and trains; raise the price of gasoline; and reduce automobile use in London by favoring bicycles. The following year, another report by the commission unveiled a plan to reduce automobile use and augment mass transit and non-motorized modes of transportation, including walking. Measures call for a doubling of the price of gasoline and a fifty percent reduction of the government's $12 billion roads program, with the savings to be spent on mass transit.

As pollution concerns have only had a mild effect on transport policy in the United States, a recent effort to build a greater argument for change includes studies that quantify a broad spectrum of the costs of the automobile to society. These include the cost of accidents, land use, loss of productivity due to noise, loss of time due to congestion, damage to buildings and infrastructure from vibration, and the military costs to guarantee foreign oil, all of which are in effect subsidies borne by the taxpaying public at large. Added to this is the effect imported oil and cars have on the United States' trade deficit. A menu of disincentives to auto use would need to be instituted.

These could take the form of higher gas taxes, road tolls, and other fees that could then be directed towards improvements in public transit and bicycle facilities.

In our world market economy, a nation's competitive edge is greatly affected by production costs which are themselves dependent on the cost of transportation. The fact that the United States spends approximately eighteen percent of its GNP on transportation, while Japan, an economic giant dependent more on bicycles and public transit, spends just nine percent, would seem to illustrate the bicycle's value in reducing these costs. But despite all the facts and figures available on this subject, the bicycle is still faced with many hurdles in its effort to be recognized as a legitimate form of transportation rather than simply an article of leisure.

Bicycles in the Developing World

The preceding pages have shown how the early implantation of automobile culture in the United States and large parts of Western Europe has made the switch to the bicycle as a legitimate form of transportation a slow and difficult process. Yet in countries that industrialized later, or are only now beginning to do so, the bicycle has served an essential role in transportation. Indeed, in many regions of the world, the idea of bicycling as a leisure activity is almost entirely absent.

Although it was invented by European entrepreneurs for a Western market, the bicycle no longer belongs to Europe.

Right: Shanghai, China.

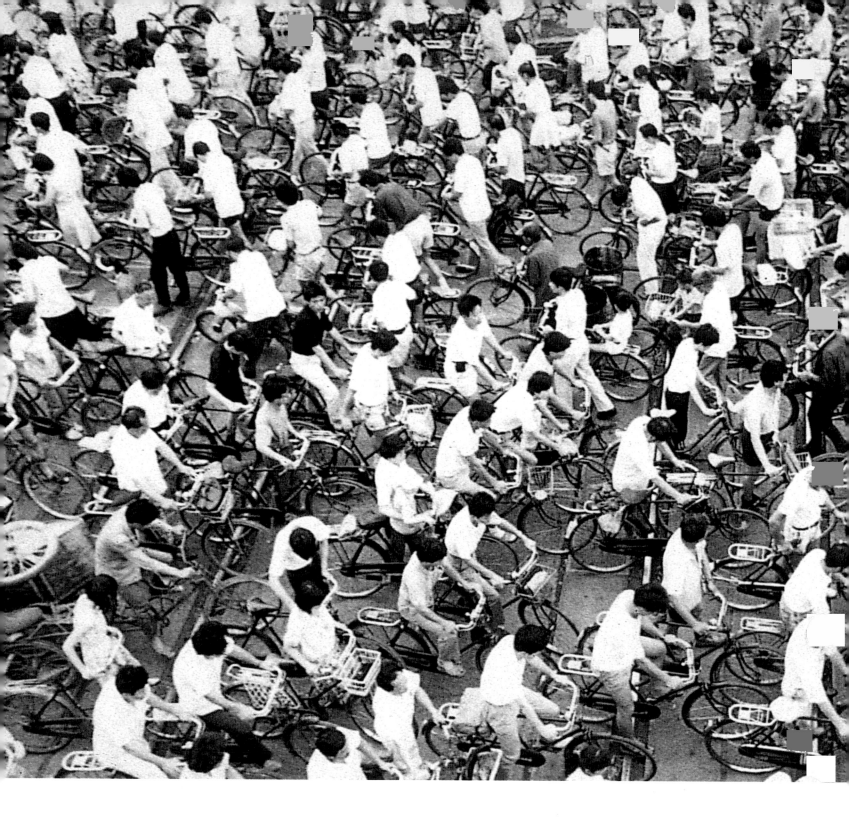

Indeed, as a mode of transport, bicycles and tricycles are more common outside Europe, even though they were originally introduced by Europeans. In Asia alone, bicycles transport more people than do all of the world's automobiles. If Latin America and Africa lack Asia's widespread domestic bicycle industries, these continents still make extensive use of the bicycle. Throughout the so-called Third World, a large number of countries with massive urban populations lack the material infrastructure of mass transit and possess vast hinterlands still not easily accessible by motorized transport; here, the role of the bicycle is essential and growing.

The Indian bicycle industry began in the 1930s, assembling imported parts from the Raleigh company in England. Within years, manufacturers were making frames locally, and soon factories were building complete bicycles. By 1987, India was producing five and a half million bicycles a year. Indian manufacturers export bicycles in large numbers, and have been instrumental in establishing production facilities in other Asian, African, and Caribbean countries.

In 1994, Chinese vendors in the town of Guilin in southern China were selling tourist T-shirts featuring a map of their country and the slogan, "The People's Republic of Bicycles." This is no exaggeration, as any visitor to China can attest: in town and countryside, bicycles remain the essential mode of transportation. In China, traffic noise means the whirring of bicycle wheels and the occasional tinkling of bells along special bicycle avenues. In 1987, China had three hundred million bicycles, one for every four people, compared with only 1.2 million automobiles. By that year, China had become the largest manufacturer of bicycles in the world, producing more than forty percent of the nearly one hundred million bicycles built every year. Since a new bicycle costs the equivalent of three or four months of a Chinese worker's salary, many of these bicycles are made for export, frequently to other developing countries. During the Cuban gas shortage of 1991, China shipped over one million bicycles to the small island nation in less than a year, and sent experts to help set up factories to manufacture bicycles.

The bicycle has brought relief to those who would normally have to walk and carry loads on their heads or backs. It has lessened the daily burdens of gathering wood and water or taking farm goods to market, thereby reducing physical stress and associated health problems. The bicycle's helpfulness may be measured by the amount it increases a person's travel capacity, a function combining speed and load: this is five times higher on a bicycle than by foot. With the addition of a trailer or supports to the frame, a bicycle's efficacy is increased even more, and it can be used to transport loads up to ninety pounds.

Perhaps even more widespread outside Europe and North America are tricycles, adapted either for transporting passengers or equipped with platforms for hauling loads of up to a thousand

Right: Mexico City.

Far right: Beijing, China. Bicycles are the most common delivery vehicle in China.

pounds. In the early years of the twentieth century, few bicycles were to be found in Asia; they had to be imported from Europe or the United States and cost more than three times the price of locally made hand-rickshaws. By the late 1920s, however, because of better road conditions resulting from the increasing use of the automobile, large Asian cities began to use pedal-

1970s, with the rapid growth of urban populations, they enjoyed an important boom. At the same time, motorized tricycles appeared in relatively wealthy countries such as Thailand and Malaysia, and now compete intensively for space in the congested cities of Southeast Asia. In other countries, such as China and Bangladesh, rickshaws continue to be

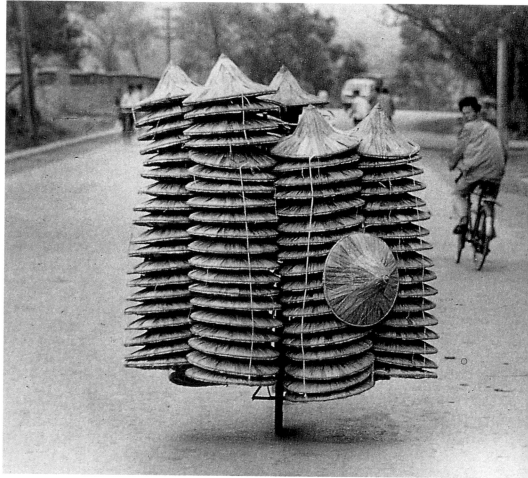

powered rickshaws more widely. Singapore was first to adopt them, followed in the mid-1930s by the large cities of India, Bangladesh, and Indonesia. By 1950, pedal-powered tricycles—variously known as rickshaws, trishaws, becaks, or pedicabs—were in use in every country in Asia; in the 1960s and

powered by human means.
Bangladesh is perhaps the country most reliant on rickshaws: over one million are in use today, and over one million people—including riders, manufacturers, repairmen, owners, and merchants who sell spare parts or patch tires—are engaged in work relating to

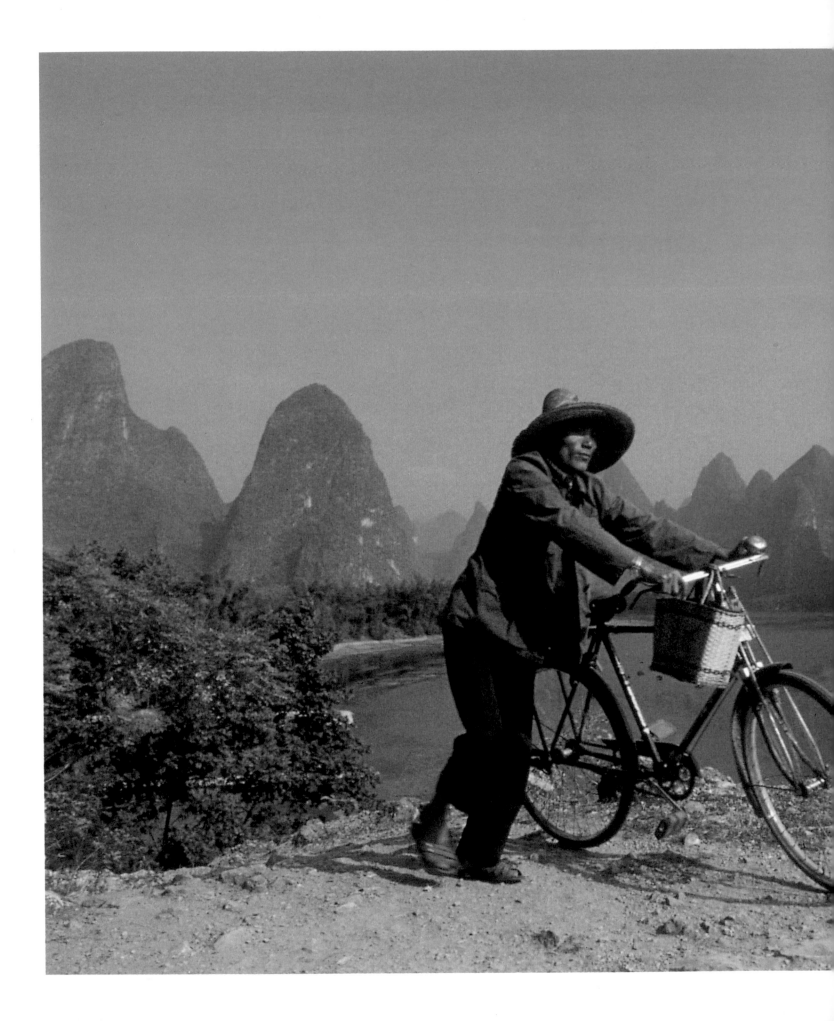

"In rural areas [of China], many girls ask their boyfriends to guarantee them the 'three things that go round': a watch, a bicycle, and a sewing machine, before agreeing to marry them" (Starrs 17). Guilin, southern China, 1988.

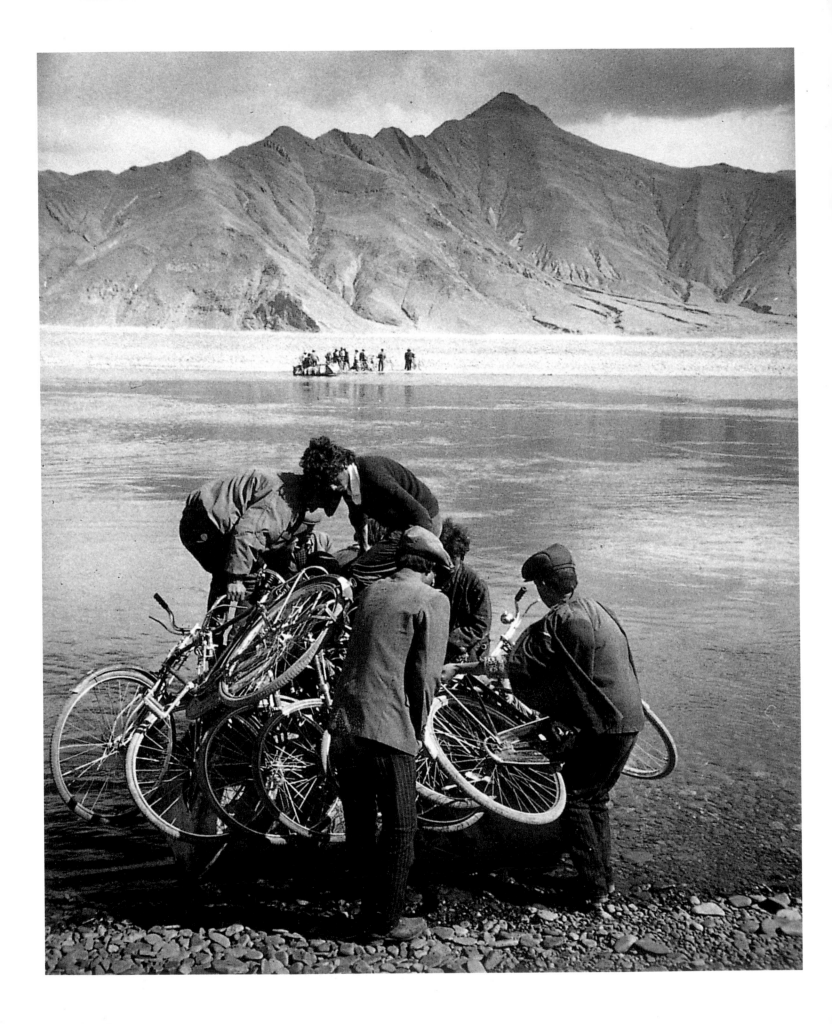

them. In Dhaka, the capital, it is estimated that the rickshaw business provides the largest single form of employment, engaging in different ways twenty-three percent of the workforce; trishaws alone transport more tonnage than all other motor vehicles combined.

At a time when the Western world is beginning to reconsider the bicycle as transport, however, the pendulum in many developing countries is beginning to swing away from bicycles and rickshaws toward automobiles. In the eyes of westernizing elites, the bicycle is seen as primitive, backward, and poor, while the automobile represents the twentieth-century values of progress, prosperity, and speed—even if fewer than one percent of the Third World's

At the same time, to make room for the expected surge in automobile use, China's wonderful tree-lined bicycle avenues, many five or six lanes wide, are gradually being replaced by an extra car lane. In large cities, bicycles are beginning to be banned from certain streets where they are held responsible for congestion, despite the fact that they often travel faster than the motorized traffic.

China's turn toward the automobile has been encouraged by the World Bank, which provides transport funds to developing countries, and which failed to use the word "bicycle" in its comprehensive four-hundred-page report on transportation in China published in 1985. However, it is only

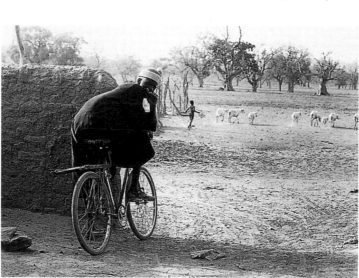

population can afford one. Even China has embarked on the development of an automobile industry. Officials in the world's most populous country expect to be producing three million vehicles annually by the year 2000, and recently announced plans to manufacture a car within every family's economic means.

fair to point out that the bank is currently financing bicycle projects in Peru, Kenya, and Brazil, as well as a clean air project for Mexico City and public transit links in Brazil and Eastern Europe. Such efforts result, in part, from the advocacy of the Institute for Transportation and Development Policy (ITDP),

Far left: Lake crossing. Tibet.

Center: Residents of Cardenas. Cuba stop to admire a new steel monument honoring the bicycle. erected on 8 March 1995. The Cuban government has been advocating the use of bicycles for the past few years in an attempt to cope with the country's energy crisis.

Left: Mali.

founded in New York in 1985. The ITDP not only convinced the World Bank to review its policy, but also helped to coordinate the Bikes Not Bombs project, a recycling campaign that collected donations of used bikes from around the United States and sent them to Third World countries.

In Bangladesh, the government's disdain for rickshaws was clearly expressed in its Third Five Year Plan of 1985–90, which stated that, "Slow-moving vehicles such as pedal-rickshaws, push and pull carts, etc., should be gradually eliminated through development of automotive vehicles and training of existing operators for such vehicles" (Gallagher 9). In Djakarta, Indonesia, fifty thousand becaks were thrown into the sea and used to build a reef to shelter fish between 1980 and 1985, in an attempt to rid the city of tricycles. The plan was temporarily delayed when fisherman salvaged the vehicles and sold them at reduced rates. In Kenya, the government has imposed a one-hundred-percent duty on bicycles, classifying them as luxury goods, fundamentally misapprehending their potential as transport.

Still, not all developing countries are turning away from the bicycle. Many continue to implement the dictum of a minister to Salvador Allende, who led a short-lived experiment in socialist government in Chile from 1970 to 1973: "Socialism can only be achieved on a bicycle" (Illich 1). In Tanzania, the bicycle became an essential part of a decentralized governmental health program,

enabling vaccines and medical care to reach otherwise inaccessible villages (McGurn 190). Under socialist governments, Nicaragua, Mozambique, and Angola all set up bicycling manufacturing plants, most of which only lasted as long as their governments. Such was also the case in Eastern Europe and the Soviet Union, which belatedly launched a revival of bicycling as part of environmental and transportation strategies, as was done in the Lithuanian city of Siauliai in 1979. But the dismantling of socialist state planning has meant the end of government subsidies for bicycles as alternatives to the automobile.

BMX and Mountain Biking

Meanwhile, bicycling culture in the West has been reinvigorated since the 1970s by new kinds of bicycles conceived at the epicenter of cycling innovation—California. These new designs developed from the desire to ride off-road. The first was the BMX, named after the organized sport of bicycle motocross and modelled directly on motorcycle motocross—races over rough terrain with steep hills and sharp curves. Riding bicycles called Stingrays made by Schwinn between 1964 and 1969, young enthusiasts began participating in unorganized BMX races in Los Angeles dirt fields in the early 1970s. The first official track, Palms Park in Santa Monica, California, was also the site of the very first race, held in 1972.

The pioneer BMX racers made

their own vehicles by stripping down Stingrays and turning them into single gear bikes, then adding motorcycle handlebars and handle grips. Transformation kits with plastic tanks, motocross handlebars, and blister handgrips came on to the market in 1974.

The same year saw the first manufacture of BMX bicycles. The earliest makers were Gary Littlejohn, Skip Hess (Mongoose Bicycles), Linn Kasten (Redline Bicycles), and Gary Turner (GT Bicycles). Their bikes were light and very maneuverable, with a single low 55-inch gear that rendered them unsuitable for long-distance riding. The first races on BMXs were therefore quite short, with sprints lasting a mere thirty seconds on tracks 1,000 to 1,200 feet long. The races included jumps off wooden ramps and power slides where the rider locked the back brake and skidded the rear wheel sideways on turns. This technique was also used for dramatic stops.

Today, racers come from a wide range of backgrounds, from blue collar to wealthy, and compete in numerous age classifications, from five years and under to over forty-five years. Kids as young as three, recently freed from their training wheels, have been known to participate. In 1977, the numerous bodies sanctioning races were replaced by the American Bicycle Association, which united all the BMX tracks under one set of rules. Currently, there are approximately seven hundred BMX racetracks in the United States, and BMX bicycles are ridden in just about every country in the world.

Freestyle riders are a distinct group from the BMX crowd. They ride bikes with front brakes and pegs added to the front forks, allowing them to perform acrobatic tricks such as riding the bike like a pogo stick. Other stunts include somersaults off steep inclines, rivaling another human-powered form of reckless youthful entertainment—skateboarding.

The second great innovation to emerge from California, mountain biking, developed in the north of the state among an eclectic group riding bicycles with 1930s balloon tires. These off-road riders were attracted to Mount Tamalpais in Marin County, a wilderness haven with numerous fire roads and single-track trails, known locally as Mount Tam.

One of the first group of cyclists to experience the thrill of riding the mountain's steep slopes were the "Canyonites" from neighboring Larkspur, California. In the late 1960's, they rode "clunkers" and "cruisers" down the treacherous trails, sometimes in informal races. By 1974, their activities had inspired members of the Velo Club Tamalpais, a local group of first-class road racers groomed on sleek lightweight state-of-the-art full Campy Italian racers. One of their members, Joe Breeze, described his first ride, on a 45-pound one-speed ballooner: "It was such a beast compared to our 20-pound, road-racing bikes...the contrast...was what I liked so much—it was like the difference between ballet and football!" This was, he said, an "outlet for my primitive side" (*Mountain Bike Action* May 1991:

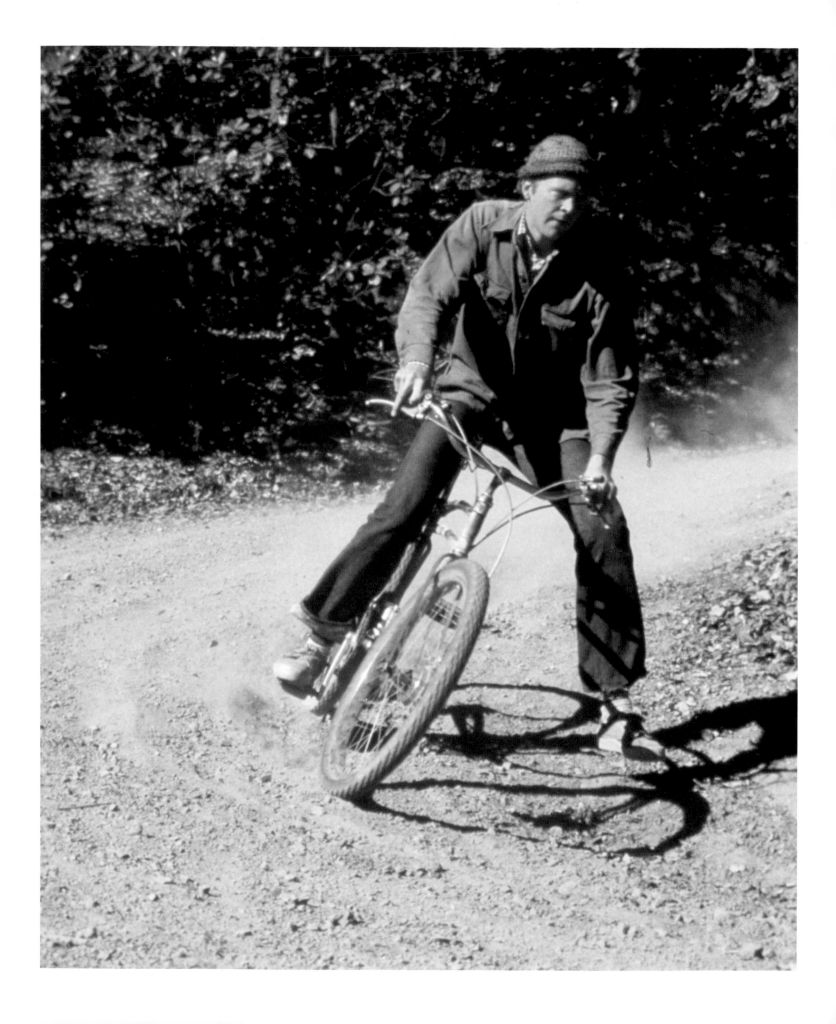

51; interview with author).

Members of the club soon preferred these bikes to their racers for routine errands and riding at night to their club meets, for as member Charlie Kelly remarked, racing bikes were not practical; they were like "driving a Ferrari to go down the street to the store" (ibid.) There was also a much smaller chance of getting flats with ballooners, and almost no risk of them being stolen.

Bicycles with balloon tires were fairly easy to come by. Racer Gary Fisher found his in a farmer's chicken coop. Considered to have been the main driving force of the group, Fisher usually had the most mechanically advanced ballooner. Among his first improvements was the addition of a front drum brake with motorcycle brake levers. His success with this

their one-speed bikes on their backs or hitch rides in pick-up trucks, sometimes waiting half a day for a lift. In December 1974, several cyclists from the vicinity of San Jose in southern California showed up at the West Coast Open cyclocross race. They had balloon-tire bikes equipped with derailleurs. Fisher took great interest in this improvement, and the following summer became the first cyclist in Marin to add a derailleur and five speeds to his bike. He soon began incorporating the latest Japanese wide range gear designs, adding a Shimano rear cluster with derailleur and a Suntour front derailleur. This gave him a total of eighteen speeds, with a gear range of 22.5–85.5. Now the group could also ride up the mountains, searching out the steep rugged hills, though

Far left: Gary Fisher riding down Repack trail on Pine Mountain. c. 1975.

Left: Gary Fisher's original 5-speed clunker. c. 1975.

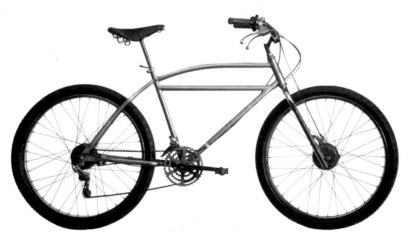

combination led him to buy about twenty old bike frames, preferring the strong-framed Schwinn Excelsior and similar models with high-bottom brackets for greater pedal-to-ground clearance. He then scavenged about for parts to complete the bikes.

To get up Mount Tam, the riders would either hike with

some, such as Joe Breeze, whose rallying cry was "one speed or die," stuck with one gear, which helped him to stay in shape in the off-season.

As riding down Mount Tam grew in popularity, two groups of riders emerged, both including first-class road racers: it was time to square off and see who was fastest off-road. The first of many

timed off-road races was held on 26 October 1976 on Pine Mountain, just north of Mount Tam. These races and the trail they used were soon known by the name "Repack," because the racers had to repack their brakes and bearings with grease after a day tackling the steep, 1,300-foot drop of the 2.1-mile course. These and other races were photographed by Wende Cragg, nicknamed the "Queen of Klunking." Cragg earned this epitaph as the first female mountain biker, beginning her rides in August 1975, and for riding the mountain trails for more than a hundred consecutive days.

Besides being a testing ground and an opportunity to exchange design ideas, Repack races helped promote off-road biking. Fisher continued to "cobble" bikes from scavenged parts for friends, and other riders began to follow his lead. By 1977, there were about a hundred cyclists in the area riding souped-up bikes, all captivated by a new terrain far from cops, cars, and concrete. Demand for a bike frame specially designed for the rugged mountain trails came from Charlie Kelly, who had broken several recycled frames. In 1977, his appeals finally convinced frame-builder Joe Breeze to design a new frame using chrome-moly airplane tubing. The result was the Breezer, the first mountain bike with all new parts.

In 1979, Gary Fisher and Charlie Kelly founded a company in Fairfax, California, called MountainBikes, a name that has become the preferred term for these bicycles. Their frame, designed and built by twenty-year-old Tom Ritchey, was an improved version of the Breezer, having a simpler form with fewer but thicker tubes. The company was run by cycling enthusiasts and mechanics lacking business acumen, working in a tremendously creative if chaotic time. By contrast to today, when mountain bike builders can order a wide selection of matching components from a couple of distributors, the team had to hunt down parts from over fifteen different sources, then modify each one to meet the demands of its new use.

The success of mountain bikes today is self-evident. Recent figures indicate that they represent over ninety-five percent of adult bicycles sold in the United States. Built for rugged

terrain and often clad with knobby tires designed for better traction on dirt, these bikes are predominantly used on level pavement. Although the current fashion may be due, as Fisher once put it, to the "romance of the product—a macho in-your-face image," mountain bikes are practical and have encouraged

Far left: Joe Breeze pitching his Breezer n°1 sideways on Repack's turn n°4. October 1977.

Left: Wende Cragg, "Queen of Klunking," the first woman mountain biker, riding a Breezer at Loon Lake, Sierra Nevada, July 1978.

people to ride. They get very few flats, and the upright riding position is comfortable. Still, the classic three-speed Raleigh with front and rear fenders and enclosed chain is an ideal bicycle. This is especially true in cities, where starting up after frequent stops is facilitated by the immediate change to first gear. Very recent upgrades on this theme are Shimano's four- and seven-gear rear hubs, which are winning over converts from derailleurs.

Since the late 1980s, the mountain bike has enjoyed an increasing success in certain European countries, most notably France. In part, its success rides the more general boost given to European cycling by the oil crisis of 1973; in Britain, for example, the level of cycling rose an estimated three hundred percent in the ten years after 1974. In part, the appeal of the off-terrain bike is fed by the desire to cover greater distances than could be done on foot. On a fall Sunday afternoon in any of the major forests near Paris, the woods are filled with riders on off-road vehicles.

While BMX cycling and the mountain bike developed and gained immense popularity in the United States, European countries continued to support an extensive network of professional and amateur racing and touring. It is curious that those European countries which seem to be the least concerned with the politics of the bicycle—France, Belgium, Italy, and Spain—remain today the "spiritual homelands" of professional cycling (McGurn 179). Since the 1950s, when

bicycle manufacturers lessened their sponsorship due to a recession in the industry, other commercial concerns—be it manufacturers of children's clothing or television sets—have stepped in to assume the leading sponsorship roles. The professional racers themselves, who number less than one thousand, live in a world all their own. They are organized in a series of sponsored teams, each with its stars and its "servants." Their lives revolve around a demanding professional racing season linked by a series of "classic" city-to-city races, a number of smaller "tours" held early in the season, and three great "tours": the Vuelta a España, the Giro d'Italia, and the greatest of them all, the Tour de France, held annually in July. This ends the season, leaving riders free to participate in track meets or "criterium" (circuit rides around town centers) and represent their national teams at the world championships in the fall.

For Sunday riders and more serious amateurs, organized mass rides have become a popular form of urban sociability. In New York City, the Five Boro Bike Tour began in 1978 with 250 cyclists riding thirty-six miles; by 1995, there were over thirty-five thousand riders. Usually organized by cycling clubs or associations, and frequently used to raise money for charitable causes, such tours (as opposed to races) can be found all over the world. According to the *Guinness Book of Records*, the largest gathering of cyclists for a mass ride took place at the ninth annual Tour de

l'Ile de Montreal in 1993, when forty-five thousand cyclists rode a distance of thirty-seven miles. The London to Brighton ride in England attracts about twenty thousand riders each year; in Rio de Janeiro, a weekly Wednesday evening ride attracts some eight thousand cyclists; and in the United States, the annual Ride Across America (RAAM) draws thousands of participants over its three weeks.

A much more rigorous event is the Triathlon World Championship, held in Hawaii every year since 1978. It starts with a 2.4-mile ocean swim followed by a 112-mile bike race and a 26.2-mile marathon, all to be completed within seventeen hours. Since its inception, seventy-eight countries have been represented in this prestigious endurance event. In the cycling part of the race, rules prohibit any devices that reduce wind resistance, and drafting—riding a rival's slipstream—is forbidden. Triathlons are also held in New Zealand, Australia, Germany, Japan, and Canada. For those who visit Hawaii and would rather coast downhill, there is the popular ride down Haleakala, the world's largest dormant volcano, on the island of Maui. The ride, conceived by "Cruiser Bob" Kiger in 1983, starts at the volcano's peak, 10,023 feet above sea level, and winds down the gentle slopes for thirty-eight memorable miles.

HPVs:
Record-Breaking Bicycles

From the first hobby-horse, two-wheeled transport unleashed the potential of human energy, and with it the desire and passion for speed. As the bicycle reached its modern form in the 1890s, riders quickly noticed that speed could be greatly increased by decreasing wind resistance. Racers learned to do this by cruising in the wake of their fellow riders, a tactic called drafting or pacing. "Mile-a-Minute" Murphy's celebrated ride, when he doubled the unpaced speed record by racing behind a train, effectively proved that a cyclist expends more energy moving air than propeling the bicycle.

In the search for ever-increasing speed, aerodynamic designs have used streamlined fairings and horizontal bicycles, called recumbents. Marcel Berthet undertook an early experiment with a fairing in France in 1913, when he rode a bicycle enclosed in an egg-shaped shell called the Torpedo Bicycle (Vélo-Torpille). Twenty years later Berthet reappeared on the Velodyne, a model with a fairing remarkably similar to recent record-breaking bicycles. In 1933, he attained a speed of 48.6 kilometers an hour, just under the elusive barrier of fifty kilometers an hour with which he and other racers were flirting.

In 1934, horizontal bicycles, where the rider sat in a reclining position with his feet forward, became popular within the rarefied world of French racers on experimental machines. The low, elongated form of these vehicles reduces wind resistance by approximate twenty percent, and the seat back helps to increase pedal pressure. But their

Left: Mile-a-Minute Murphy behind a train at the start of the mile race. Maywood, South Farmingdale. 30 June 1899.

use for record attempts created controversy, which led the Union Cyclists Internationale to class them separately from bicycles. Although numerous models were on view at the 1935 Paris salon, horizontal bicycles were deemed impractical and fell out of favor for several decades.

In the 1970s, shortly after the world oil crisis, interest in both streamlined and reclining bicycles blossomed. A number of imaginative and experimentally minded cyclists entered their designs (all with fairings, some of which were recumbents) in a speed championship in Ontario, California, in 1977. That same year, Chester Kyle formed the International Human-Powered Vehicle Association

involving air, land, water, and submarine human-powered vehicles around the world.

In 1984, the Du Pont company offered a prize of $15,000 to the first human-powered vehicle to attain a speed, on flat surface, of sixty-five miles an hour. The race was on. In May 1986, twenty-nine year old Fred Markham, a member of the 1976 United States Olympic team, reached a speed of 65.48 miles an hour on a paved highway at Big Sand Flat, California. His bicycle, *Gold Rush*, was a recumbent constructed by Gardner Martin of the Easy Racers. Its fairing, designed with the help of computers, was made of a Du Pont material called Kevlar, weighing half of a fiberglass hard shell.

Clockwise from top left: Oscar Egg riding his "vélo-fusée." Though this fairing was conceived to reduce drag, its effect was questionable. In 1934, Oscar Egg built a more successful faired recumbent with levers.

"Vélo-Torpille," M. Branger, 1913. It was made by Étienne Buneau-Varilla, an inventor who designed streamlined bodies for aircraft and automobiles. Marcel Berthet raced in the Vélo-Torpille in 1913.

"The Horizontal—Bicyclette normale" by M. Challand, "La Nature," 17 October 1896. This model, exhibited at The Exhibition in Geneva of that year, was conceived with horizontal pedaling to enable the rider to give greater thrust to each turn of the pedals, estimated by its inventor to be three times the weight of the rider. The lower riding position also offered greater stability and easier mounting and dismounting of the machine.

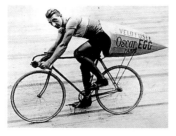

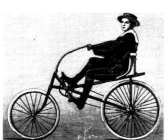

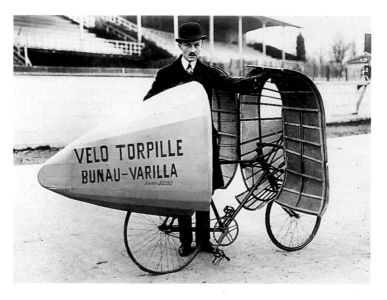

(IHPVA), "dedicated to promoting improvement, innovation, and creativity in the design and development of human-powered vehicles," according to its newsletter's masthead. This organization has since become the locus for information on the activities of individuals, teams, and events

In 1992, the land speed record was shattered again, when Chris "The Punisher" Huber attained a speed of 68.73 miles an hour at Grand Sand Dune Monument in the Colorado desert. His bicycle, *Cheetah*, was designed by Kevin Franz, Jon Garbarino, and James Osborn, engineering undergraduates at the University

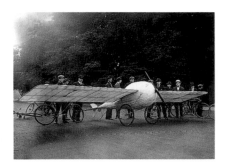

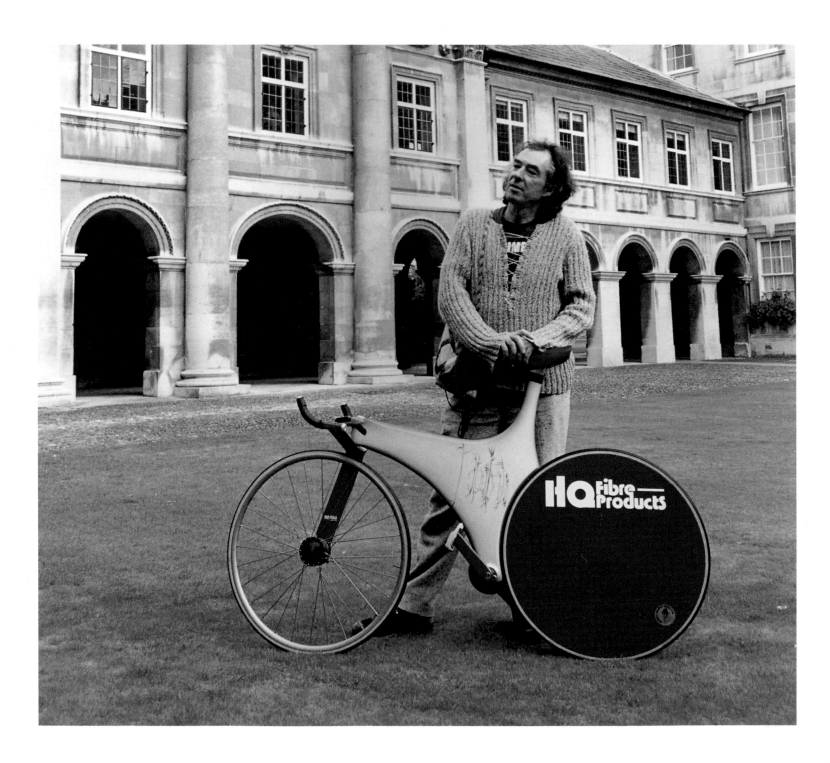

of California, Berkeley.
The fairing, made of carbon-fiber composites, used aerospace bonding agents to increase strength and reduce vibration detrimental to speed. According to Garbarino, "riding the Cheetah is like trying to hold a piece of cardboard straight in the wind" (*Popular Science* October 1993: 80).

Human-powered flight records also continue to be broken. In France, Robert Peugeot (of the bicycle-turned-automobile manufacturer) subsidized the early attempts that followed the Wright brothers' first flights. He offered the huge sum of 10,000 francs for the first winged bicycle that could fly ten meters at a meet set for 2 June 1912. Enthusiasts proceeded to design

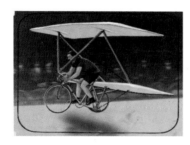

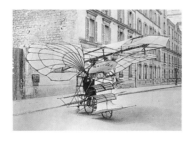

and build aviettes and aerocycles, some with fixed wings, others—called ornithopters—with flapping wings. Of the 198 entrants, only twenty-three showed up, even though a second prize of 1,000 francs was offered for a "flight" of one meter at a minimum height of ten centimeters. Still no one

managed to get off the ground. Then at a second contest on 4 July, the world professional sprint champion Gabriel Poulain subsequently hopped one meter to win the second prize. Poulain then teamed up with Edouard Nieuport, a former bicycle racer and builder of air force planes, to build a new aviette that they subjected to extensive wind-tunnel tests. On 9 July 1921, at the Longchamps racetrack in the Bois de Boulogne in Paris, Poulain flew 11.98 meters at an altitude of 1.5 meters to win the Peugeot prize.

Decades later, in 1959, the British industrialist Henry Kremer offered a prize of $100,000 for the first controlled human-powered flight. This huge sum was the catalyst for further activity and experimentation. The rules, set forth by the Royal Aeronautical Society, called for a figure-eight course around two poles half-a-mile apart. In 1977, *Gossamer Condor* won the prize. Named after the largest bird in the western hemisphere, the *Condor* was designed by Paul MacCready, a "crusader for the environment, viewing human-powered flight as a symbol of how extremely careful use of resources could reconcile technology with the environment" (*Insight*, June 1990: 12) His Californian company's motto is "Doing more with less for fun and profit."

Two years later, an amazing event took place, perhaps as important as the Wright brothers' first flight: twenty-six-year-old Bryan Allen pedaled MacCready's *Gossamer Albatross*

(named for the largest seafaring bird) across the English Channel. It was a horribly strenuous ride and twice, exhausted from battling the strong winds, Allen let the 70-pound craft with its 96-foot wingspan dip within a foot or two of the water.

Inspired by the 3,500-year-old myth of Daedalus, Greek Olympic cyclist Kanellos Kanellopoulos pedaled an aerocycle between the islands of Crete and Santorini in 1988. He flew the distance of seventy-four miles in just under four hours, breaking all human-powered flight records. The *Daedalus* was a joint venture of the Smithsonian Institution in Washington and the Department

forty-eight-hour period, only one rider was physically capable of completing the trip. The *Daedalus* may well hold the record for human-powered flight for some time.

On water, speed records by human-powered vehicles have recently been broken. Mark Drela, the senior engineer on the *Daedalus* project who was responsible for its aerodynamic design, went on to create a different type of flying bicycle: a hydrofoil called *Decavitator*. In 1991, he set an official speed record of 18.5 knots over a 100-meter course on Boston's Charles River, winning the $25,000 Du Pont Watercraft Speed Prize. Built under Drela's direction by a

Clockwise from top left: "Like a graceful white bird, the Gossamer Albatross touched down triumphantly on the beach here this morning to complete the first crossing of the English Channel on a man-powered plane." Made of carbon filament tubing covered in Mylar and made by Du Pont, the Albatross weighed 70 lbs., and its 96-foot wingspan was wider than that of a DC-9.

Front page of the International Herald Tribune, 13 June 1979.

Karl Heeb's FAU boat, 1993.

Right top to bottom: "Vélocipèdes Marins," invented by M. A. Du Buisson, commander of the yacht. Jérôme-Napoléon. c. 1869. An early example of pedal power successfully applied to boats.

The Decavitator, pedaled by Mark Drela, flies on the small wing in a practice run on the Charles River, Boston, 1991.

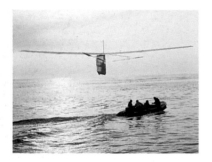

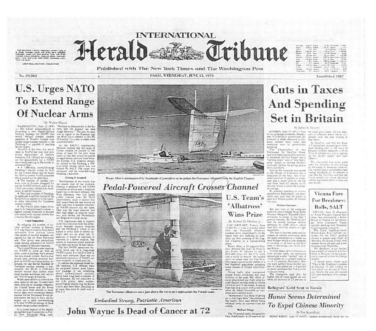

of Aeronautics and Astronautics at the Massachusetts Institute of Technology in Cambridge, Massachusetts. As the choice of day for the flight depended on weather conditions and the distance demanded enormous stamina, a team of four "pilots" rotated their peak performance training such that in any given

team of students at MIT, *Decavitator* had two underwater hydrofoil wings made of solid carbon fiber and positioned directly under the rider. As the vehicle gained speed, the submerged wings lifted its pontoons above the water, reducing water resistance.

Finally, underwater speed

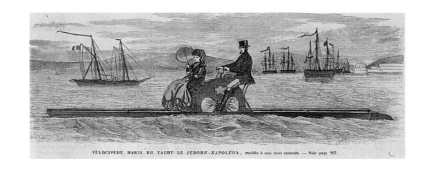

VÉLOCIPÈDE MARIN DU YACHT LE *JÉROME-NAPOLÉON*, modèle à une roue centrale. — Voir page 207.

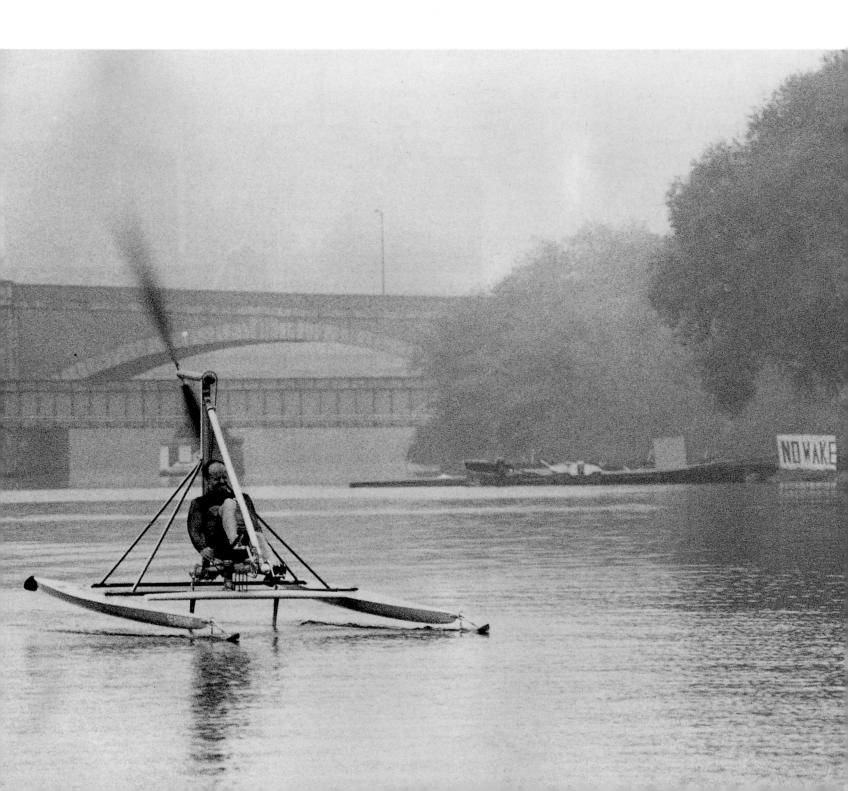

records, set by human-powered submarines, have been challenged since the beginning of organized races in 1989. The first races were held in Florida, where variable ocean conditions made time certification difficult. In 1993, the First West Coast Submarine Invitational, organized by the Scripps Institution of Oceanography, was held at the Offshore Model Basin, located inland in Escondido, California. It was classed as an event, not a race. Karl Heeb's FAU Boat, named for the Florida Atlantic University, attained a Guinness World Record for a 5.94 knot sprint, just short of the elusive six-knot barrier. Its hull was constructed of a foam core sandwiched between two layers of fiberglass cloth, the surface made hydraulically smooth to reduce drag. Propellers of varying efficiency and speed were used, depending on the strength of the rider and the duration of the race.

The Art of the Bicycle

Transport, pleasure, and sport hardly exhaust the uses of the bicycle, as the work of a wide range of writers, composers, artists, and choreographers attests. Indeed, many artists derived their inspiration from the practice of cycling itself. Sir Arthur Conan Doyle, who owned a tricycle, found that ideas came to him while he rode, and Sir Edward Elgar admitted that he was musically inspired when cycling the hills of Malvern, composing in his head such works as *The Enigma*

Variations and *The Dream of Gerontius*. More recently, Iris Murdoch, whose love stories often include bicycles, described its essence through a character in an early novel: "The bicycle is the most civilized conveyance known to man. Other forms of transport grow daily more nightmarish. Only the bicycle remains pure in heart" (Murdoch 29).

Since the invention of the running machine, artists, lithographers, photographers, and film-makers have all found uses for the bicycle. From satire to paean, idealized or demonized, in commercial advertising or in the photography of urban landscapes, the bicycle has figured, sometimes prominently, sometimes incidentally, in the artistic world. In the twentieth century, numerous artists have deconstructed the bicycle, using its parts or its whole in a variety of different media and styles. Perhaps the two most famous

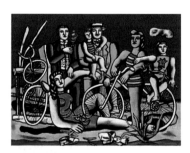

examples are Marcel Duchamp's "ready made" of 1913, with its bicycle fork and wheel attached to a stool, and Pablo Picasso's *Bull's Head* assemblage of 1943, made with a bicycle seat and handlebars. Fernand Léger depicted bicycles tangled with people and plants in his painting of the late 1940s. More

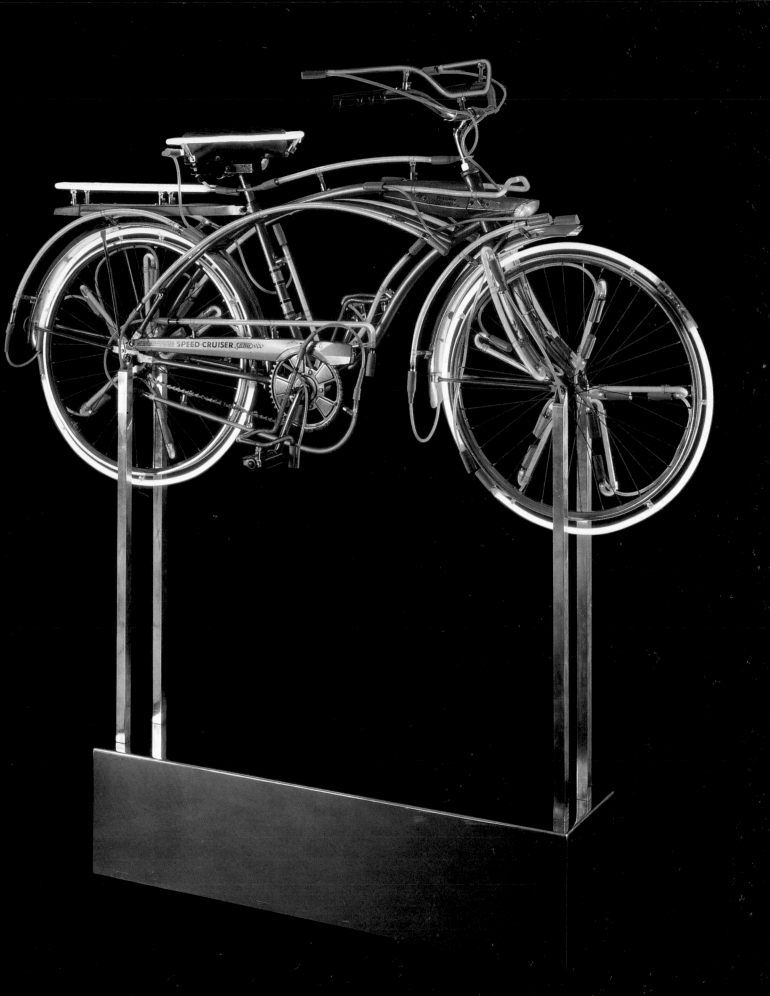

recently, Robert Rauschenberg exhibited approximately a dozen "bicycloids," each fitted with colored neon lighting that traced its contours, while a group of design students in Los Angeles asked neighborhood kids to design their own cycles out of old parts and found objects. The results were displayed in a show at New York's Grand Central Station.

Choreographers have also, on occasion, used bicycles in their creations. Serge Lifar danced with a bicycle in the Ballet Russe's *Pastorale* in the 1920s. In 1988, Eliot Feld, in a New York City Ballet production that premiered as part of the American Music Festival, chose a reproduction of an 1880s tricycle for his choreography to Charles Ives's *The Unanswered Question*, originally composed in 1908. In

by the family trio of Victoria Chaplin, Jean Baptiste Thiérrée, and their son, James Spencer Thiérrée. It is not a circus in the traditional sense: acting out a theme of metamorphosis, the family undergoes a series of transformations into beings that are half-human and half-bicycle. Their world is all bicycle, for bicycle parts grow from their bodies in imaginative configurations, and their movements are charmed by the spin of the wheel.

In the street as well, bicycles often figure prominently in both organized and impromptu performances. A rider on an antique high-wheeler in period costume draws a crowd delighted and awed by a machine that can momentarily transport them to another century.

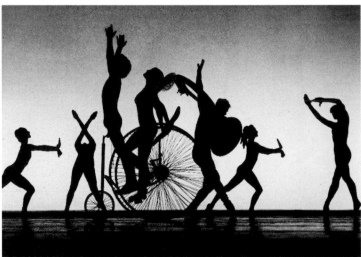

the performance, Buffy Miller, Feld's muse and inspiration, rode a tricycle which appeared to be seamlessly linked to her body and picked up passengers while floating through space like a winged angel.

Another inspiring use of the bicycle can be found in *The Invisible Circus*, a performance

Eric and Deborah Staller of New York specialize in street performance. In 1991, they created OCTOS, their fifth "urban UFO," a quadricycle with motorcycle wheels and an aluminum frame, engineered by Tim Mills. This huge cycle supports eight riders, all facing one other and pedaling while

Left: "The Unanswered Question", choreography by Eliot Feld to music by Charles Ives. A New York City Ballet American Music Festival Production in 1988. Buffy Miller pedals while Damian Woetzel steers a tricycle.

Right: "La Pastorale" with Serge Lifar, performing with the Ballet Russe under Diaghilev in the 1920s.

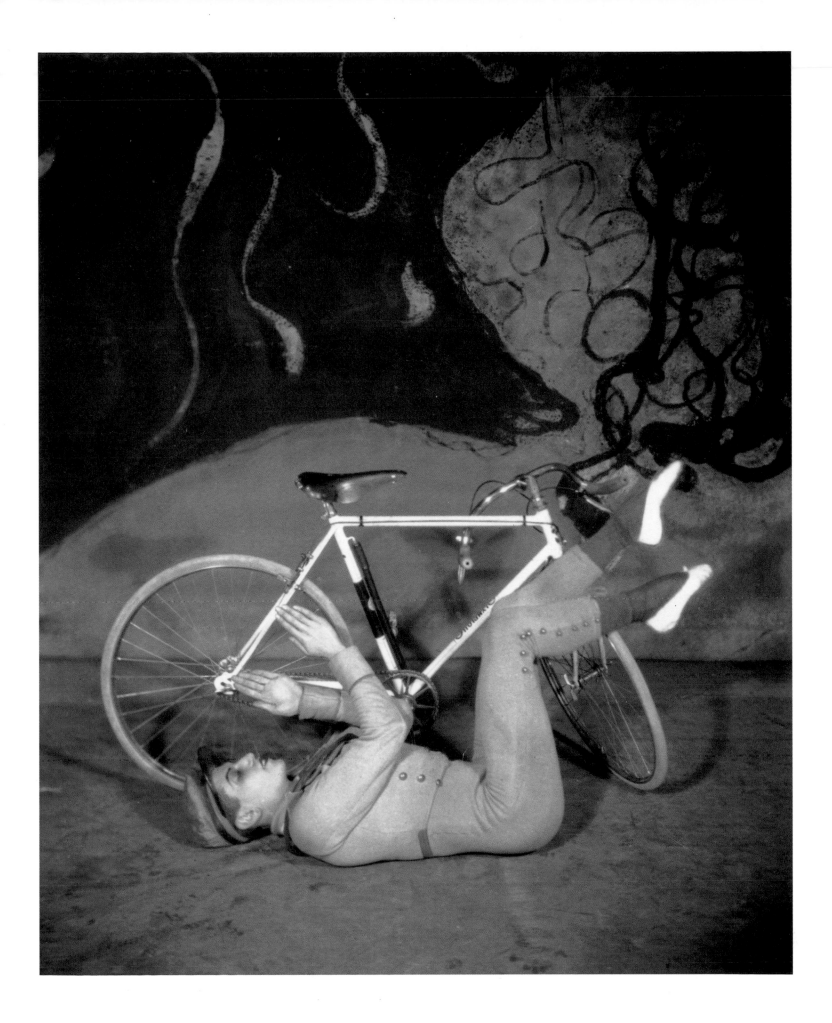

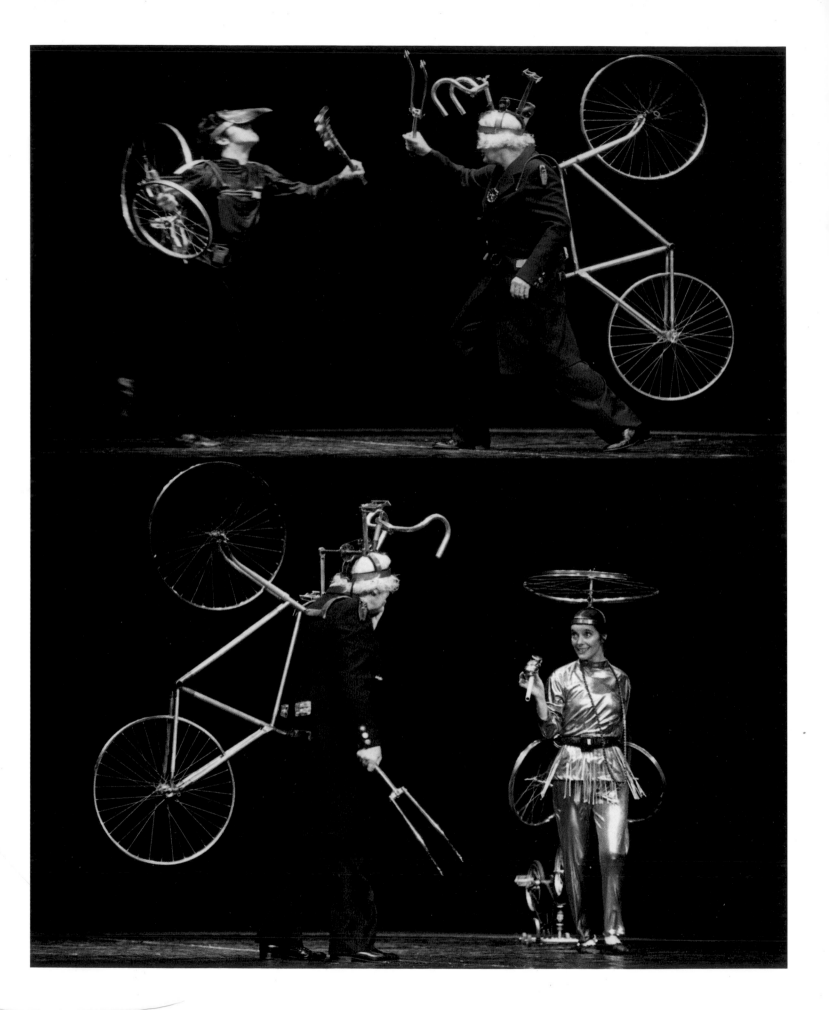

one steers. As the Stallers explain, "The experience of OCTOS is ephemeral; it glides by in seconds, silent and dream-like, leaving questions unanswered: What is it? Is it art? Is it science? Is it serious or humorous? Practical or absurd? Faces seem to soften in a childlike response; we hope that this moment is a glimpse of optimism about the future" (correspondence with author).

An all-Japanese crew rode OCTOS when it was exhibited in Japan at the Nagoya Museum of Art Biennial in 1991. The costumes, designed by the

Stallers, were intended to "fragment the human form, give the impression of more moving parts and further remove the experience from the viewer's sense of reality." They think of their art vehicles as "metaphors for future travel. People have this fear of the future, that technology is going to be dehumanizing, or that the future will be dehumanized by technology. With our pieces, we try to say 'yes, the future is going to be more technological and—it can be human'" (ibid.)

Far left and left, top: "The Invisible Circus" with Victoria Chaplin, Jean Baptiste Thiérrée and James Spencer Thiérrée.

Left, center, clockwise: The Young Theater of Riga performing Brecht's "Fear and Misery in the Third Reich" on bicycles. The Latvian company's production was staged by Shapiro.

"The Invisible Circus."

OCTOS, an "urban UFO," at the Nagoya Museum of Art Biennial in 1991.

During the bicycle renaissance of the last few decades, the number of organizations, publications, and interest groups has grown considerably. This guide could never be a comprehensive list of contacts; there are too many to list in a few pages. But it will give readers some starting points to find out more about the history and current areas of activity of the cycling world. Since the opening times of museums and collections are subject to change without notice, the reader is advised to telephone before visiting.

Guide to the World of Cycling

Railcycles: Doc Richard Smart

Advocacy Groups

Great Britain

Velo-City Secretariat (ECF)
31 Arodene Road
London SW2 2BQ
Tel. 0181 674 5916 Fax 0181 671 3386

Cyclists' Touring Club (CTC)
Cotterell House
69 Meadrow, Godalming
Surrey GU7 3HS
Tel. 01483 417217 Fax 01483 426994

France

Fédération Française des
Usagers de la Bicyclette (ECF)
4 rue Brûlée
F-67000 Strasbourg
Tel. 88 75 17 50 Fax 88 22 56 07

Fédération Française de Cyclisme
5 rue de Rome
93561 Rosny-sous-Bois
Tel. 49 35 69 00

Fédération Française de Cyclotourisme
8 rue Jean-Marie-Jégo
75013 Paris
Tel. 44 16 88 88 Fax 44 16 88 99

Italy

Federazione Ciclista Italiana
Via Leopoldo Franchetti 2
Roma 00194
Tel. 6-36 85 72 75 Fax 6-36 85 71 75

Bici & Dintorni
Associazione Ciclisti Urbani
Via Pianfei 5
Torino 10144
Tel. 11-473 32 63

Germany

Allgemeiner Deutscher Fahrradclub
(Cities for Cyclists secretariat) (ECF)
Postfach 107747
D-28077 Bremen
Tel. 421-346290 Fax 421-3462950

Switzerland

Union Cycliste Internationale
Route de Chavannes 37
1007 Lausanne
Tel. 21-626-0080 Fax 21-626-0088

The Netherlands

Fietserbond ENFB (European Cyclists'
Federation Coordination)
Postbus 2150
NL-3440 DD Woerden
Tel. 34-8023119 Fax 34-8017058

Denmark

Dansk Cyklist Forbund (European
Cyclists' Federation policy office)
Rømersgade 7. DK-1362 Copenhagen K.
Tel. 33-323121 Fax 33-327683

The United States

League of American Bicyclists (formerly
League of American Wheelmen)
190 W. Ostend Street, Suite 120
Baltimore, Maryland 21230–3755
Tel. 410-539-3399 Fax 410-539-3496

Bicycle Federation of America
(Pro Bike Directory)
1506 21st Street NW, Suite 200
Washington, D.C. 20036
Tel. 202-463-6622 Fax 202-463-6625

International Bicycle Fund
c/o David Mozer
4887 Columbia Drive South
Seattle, Washington 98108–1919
Tel. & Fax 206-628-9314

Institute for Transportation &
Development Policy
611 Broadway, Room 616
New York, New York 10012
Tel. 212-260-8144 Fax 212-260-7353

International Human Powered Vehicle
Association
c/o Leonard M. Brunkalla
P. O. Box 727
Elgin, Illinois 60121-0727
Tel./Fax 847-742-4933
World Wide Web: http://www.ihpva.org

Railcycles
Doc Richard Smart
3502 Buckskin Road
Coeur d'Alene, Idaho 83814
Tel. 208-765-2831

Canada

Canadian Cycling Association
1600 James Naismith Drive, Suite 810
Gloucester, Ontario K1B 5N4
Tel. 613-748-5629

Le Monde à Bicyclette
C. P. 1242, succursale La Cité
Montréal, Québec H2W 2R3
Tel. 514-844-2713 Fax 514-844-6622

Vélo Québec
La Maison des Cyclistes
1251 rue Rachel Est
Montréal, Québec H2J 2J9
Tel. 514-521-VELO Fax 514-521-5711

Japan

Japan Bicycle Promotion Institute
9-3 Akasaka 1-chome
Minato-ku
Tokyo 107
Tel. 3-5572-6410 Fax 3-5572-6407

History Groups

Great Britain

Veteran-Cycle Club
c/o Les Bowerman
Send Manor
Ripley, Surrey GU23 6JS

International Veteran Cycle Association
Valerie Dalzell Pears
22 Woodbank Road
Groby, Leicester LE6 0BN

The Fellowship of Cycling Old-Timers
c/o Jim Shaw
2 Westwood Road
Marlow, Buckinghamshire SL7 2AT

France

La Vélocithèque
c/o Gérard Salmon
Le Bois
69590 Pomeys
France
Tel. 78 48 45 67

The United States

The Wheelmen
c/o Mary Peoples
55 Bucknell Avenue
Trenton, New Jersey 08619–2059

National Bicycle History Archive of
America (classic bicycles)
c/o Leon Dixon
Box 28242
Santa Ana, California 92799
Tel. 714-647-1949
E-mail OldBicycle@aol.com

Museums and Collections

Great Britain

Mark Hall Bicycle Museum
Muskham Road Harlow, Essex CM18 6YL
Tel. 01279 439680

Science Museum
Exhibition Road
South Kensington, London SW7 2DD
Tel. 0171 938 8000

Birmingham Museum of Science and Industry
Newhall Street Birmingham B3 1RZ
Tel. 0121 236 1022

Christchurch Tricycle Museum
Quay Road
Christchurch, Dorset BH23 1BY
Tel. 01202 479849

Knutsford Courtyard Coffeehouse
92 King Street
Knutsford, Cheshire WA16 6ED
Tel. 01565 53974

Museum of British Road Transport
St. Agnes Lane, Hales Street
Coventry, CV1 1PN
Tel. 01203 832425

Museum of British Road Transport.
H.W. Bartleet: racer, collector, writer

Pinkerton Collection
The Stables, Arbory Hall
Nuneaton, Warwickshire CV10 7PT
Tel. 0121 350 0685

Snowshill Manor
near Broadway Worcestershire WR12 7JU
Tel. 01386 852410

Glasgow Museum of Transport
Kelvin Hall
1 Bunhouse Road Glasgow G3 8DP
Tel. 0141 357 3929

France

Musée d'Art et d'Industrie de Saint-Etienne
Place Luis Comte 4200 Saint-Etienne
Tel. 77 33 04 85

Conservatoire National des Arts et Métiers
292, rue Saint-Martin 75003 Paris
Tel. 40 27 27 37

Gérard Buisset
Couvent de l'Abbaye 24480 Cadouin
Tel. 53 63 46 60

Italy

Museo Fermo Galbiati
Via Mameli 15
Brugherio, Milano 20047
Tel. 2-87 01 24

The Netherlands

National Fietsmuseum Velorama
Waalkade 107
6511 XR Nijmegen
Tel. 080-225851 Fax 080-607177

The United States

Bicycle Museum of America
North Pier, 435 E. Illinois Street
Chicago, Illinois 60611
Tel. 312-222-0500

Pedaling History: The Burgwardt Bicycle
Museum
3943 North Buffalo Road
Orchard Park, New York 14127
Tel. 716-662-3853 Fax 716-662-4594

Smithsonian Institution
Washington, D.C. 20560
Tel. 202-357-2700

Bicycles: History—Beauty—Fantasy
An itinerant exhibition in the United States of
the author's collection of bicycles, posters,
prints, and various related objects. For current
and future venues, please consult the
World Wide Web site:
users.aol.com/pryordodge/bicyclexpo

Canada

National Museum of Science and Technology
(by appointment)
1867 St. Laurent Boulevard
Ottawa, Ontario K1G 5A3
Tel. 613-993-6667 Fax 613-990-3636

Japan

Japan Cycling Association & Bicycle Culture
Center
Jitenshakaikan No. 3 bldg.
1-9-3 Akasaka
Minato-Ku, Tokyo 107
Tel. 3-3583-5628 Fax 3-3583-5987

The Cycle Center
165-6, Daisen Nakamachi
Sakai City, Osaka 590
Tel. 6-722-43-3196 Fax 6-722-44-4119

Publications and Publishers

The Tortoise and the Hare: Bike Culture 2

Great Britain

Bike Culture Quarterly & Encyclopedia
Open Road Ltd.
4 New Street
York Y01 2RA
Tel. 01904 654654 Fax 01904 671707

The United States

The Cyclists' Yellow Pages (international
directory of cycling organizations)
Adventure Cycling Association
Bikecentennial
P. O. Box 8308
Missoula, Montana 59807-8308
Tel. 406-721-1776

Bicycle Books, Inc.
P. O. Box 2038
Mill Valley, California 94942
Tel. 415-381-2515 Fax 415-381-6912

Worldwatch Institute (occasional publications
on cycling and transportation)
1776 Massachusetts Avenue, NW
Washington, D.C. 20036
Tel. 202-452-1999

Famous Cycling Videos
704 Hennepin Avenue
Minneapolis, Minnesota 55403
Tel. 612-333-4594

Selected Bibliography

Abbott, Allan V. and Wilson, David Gordon,
eds. *Human-Powered Vehicles*. Champaign,
Illinois: Human
Kinetics, 1996.

Adams, G. Donald. *Collecting and Restoring
Antique Bicycles*. Blue Ridge Summit,
Penns.: TAB Books, 1981. Reprint. New
York: Pedaling History Bicycle Museum,
1996.

Andric, Dragoslav. *Les Bicyclettes*. Lucerne: Ars
Mundi, 1990.

Arnold, Schwinn and Co. *Fifty Years of
Schwinn-Built Bicycles*. Chicago, 1945.

Bartleet, Horace Wilton. *Bartleet's Bicycle
Book*. London: J. Burrow and Co., 1931.
Reprint. Birmingham, U.K.: Pinkerton
Press, 1983.

Beeley, Serena. *A History of Bicycles*. London:
Studio Editions, 1992.

The Boneshaker. Magazine of the Veteran-
Cycle Club, England, 1955–96.

Borgé, Jacques, and Viasnoff, Nicolas. *Le Vélo,
la Liberté*. Paris: Balland, 1978.

Bowerman, Les. *John Keen—The Life of a
Cycling Pioneer*. Proceedings of the Fourth
International Cycle History Conference,
Bicycle Books, 1993.

Bury, Viscount, and Hillier, G. Lacy. *Cycling*.
London: Badminton Library, Longmans,
Green, and Co., 1887 and 1896.

Calif, Ruth. *The World on Wheels*. New York
and London: Cornwall Books, 1983.

Card, Peter W. *Early Vehicle Lighting*. Princes
Risborough, U.K.: Shire
Publications, 1987.

Clayton, Nick. *Early Bicycles*. Princes
Risborough, U.K.: Shire Publications,
1986 and 1990.

Crouch, Tom D. How the Bicycle Took
Wing. *American Heritage of Invention
and Technology*, vol. 2, no. 1, 1986.

Crushton, the Hon. [Blake,
Walter E.], ed. *History of the Pickwick Bicycle
Club*. London: Pickwick Bicycle Club,
1905.

Daschle, Gregory, J. An Army on Bicycles.
American Heritage of Invention and Technology,
vol. 10, no. 2, 1944, pp. 46–50.

Fisk, Fred, and Marlin, W. Todd. *The Wright
Brothers—from Bicycle to Biplane*. Dayton,
Ohio: Toddfisk Books, 1990.

Foster, S. Conant. *Wheel Songs;
Poems of Cycling*. New York: White Stokes
and Allen, 1884.

Gallagher, Rob. *The Rickshaws of Bangladesh*.
Dhaka: University Press, 1992.

Galbiati, Fermo, and Ciravegna, Nino. *La Bicicletta*. Milan: BE-MA Editrice, 1989; San Francisco: Chronicle Books, 1994.

Geist, Roland C. *Bicycle People*. Washington D. C.: Acropolis Books, 1978.

Goddard, J.T. *The Velocipede, its History, Varieties, and Practise*. New York: 1869.

Griffin, Harry Hewitt. *Bicycles and Tricycles of the Year 1889*. London: L. Upcott Gill. Reprint. Birmingham, U.K.: Pinkerton Press, 1985.

Hadland, Tony. *The Sturmey-Archer Story*. Birmingham, U.K.: Pinkerton Press, 1987.

Herman, Michele. *Bicycle Blueprint; a Plan to Bring Bicycling into the Mainstream in New York City*. New York: Transportation Alternatives, 1993.

Humber, William. *Freewheeling—The Story of Bicycling in Canada*. Erin, Ontario: Boston Mills Press, 1986.

Illich, Ivan. Energy and Equity. *Toward a History of Needs*. New York: Pantheon; London: Calder and Boyars, 1978 (chapter 5).

International History Conference Proceedings. Glasgow, 1990; Sainte-Etienne, 1991; Neckarsulm, Germany, 1992; Boston, 1993; Cambridge, 1994; Stellenbosch, South Africa, 1995; Orchard Park, N.Y., 1996.

Kobayashi, Keizo. *Histoire du Vélocipède de Drais à Michaux 1817–1870, Mythes et Réalités*. Paris: l'Ecole Pratique des Hautes Etudes; Tokyo: Bicycle Cultural Center, 1993.

—*Pour Une Bibliographie du Cyclisme*. Paris: Féderation Française du Cyclotourisme, 1984.

Komanoff, Charles, and Ketcham, Brian. Should Drivers Pay More? Win-Win Transportation Analysis. *City Cyclist*, Auto-Free Press vol. 4 no. 2 (November–December 1992).

Kron, Karl. *Ten Thousand Miles on a Bicycle*. New York: Karl Kron pub., 1887.

Laget, Françoise, and Laget, Serge. *Le Cyclisme*. Courlay, France: Jadault et Fils, 1978.

Laget, Serge. *La Saga du Tour de France*. Paris: Gallimard, 1990.

Lessing, Hans-Erhard. The Reception of the Front-Wheel-Driver Velocipede in Germany. Procedings of the Fourth International Cycle History Conference, Bicycle Books, 1993.

Lightwood, James T. *The Romance of the Cyclists' Touring Club*. London, 1928.

Lockert, Louis. *Manuel de Vélocipédie*. Paris: Manuels-Roret, 1896. Reprint. Paris: Leonce Laget, 1983.

Lowe, Marcia D. *The Bicycle: Vehicle for a Small Planet*. Washington, D. C.: Worldwatch Institute, 1989.

Mackenzie, Jeanne. *Cycling*. Oxford: Oxford University Press, 1981.

McCullagh, James C., ed. *Pedal Power—In Work, Leisure, and Transportation*. Emmaus, Penns.: Rodale Press, 1977.

McGurn, James. *On Your Bicycle*. London: John Murray, 1987.

McIntyre, Douglas. Wings for Man. Odyssey of the Flyer. *American History Illustrated*, January–February 1994.

Morissette, Claire. *Deux roues, un avenir*. Montreal: Ecosociété, 1994.

Mozer, David. *Bicycling in Africa*. Bellevue, Wash.: International Bicycle Fund, 1989.

Murdoch, Iris. *The Red and the Green*. New York: Viking, 1965.

Oliver, S. H. and Berkebile, D. H. *Wheels and Wheeling*. Washington, D. C.: Smithsonian Institute Press, 1974.

Palmer, Arthur Judson. *Riding High*. New York: E. P. Dutton and Co., 1956.

Perry, David. *Bike Cult*. New York: Four Walls Eight Windows, 1995.

Pratt, Charles. *The American Bicycler*. Boston: Pope Mfg. Co., 1879.

Pridmore, Jay and Hurd, Jim. *The American Bicycle*. Osceola, Wisconsin: Motorbooks International Publishers and Wholesalers, 1995.

Rennert, Jack. *100 Years of Bicycle Posters*. New York: Darien House, 1973.

Ritchie, Andrew. *King of the Road*. London: Wildwood House; Berkeley: Ten Speed Press, 1975.

—*Major Taylor—the Extraordinary Career of a Champion Bicycle Racer*. San Francisco: Bicycle Books, 1988.

Roberts, Derek. *Cycling History—Myths and Queries*. Birmingham, U.K.: Pinkerton Press, 1991.

Saunier, Louis Baudry de. *Les Mémoires de Terront*. 1893. Reprint. Paris: Prosport, 1980.

Schwinn, Frank W. *Personal Notes on the Bicycle Industry*. 1942. Reprint. Chicago: Bicycle Museum of America, 1993.

Seray, Jacques. *Deux Roues—La Véritable Histoire du Vélo*. Rodez, France: Editions du Rouergue, 1988.

Sergent, Pascal. *Paris-Roubaix*. 2 vols. Roubaix, France: Véloclub de Roubaix, 1989–91.

Sharp, Archibald. *Bicycles and Tricycles—An Elementary Treatise on Their Design and Construction*. London: Longmans, Green, and Co., 1896. Reprint. Cambridge, Mass.: MIT Press, 1977.

Smith, Robert A. *A Social History of the Bicycle*. New York: American Heritage Press, 1972.

Snell, Bradford C. *American Ground Transport*. Washington, D. C.: U. S. Government Printing Office, 1974.

Starrs, James E. *The Noiseless Tenor, The Bicycle in Literature*. New York and London: Cornwall Books, 1982.

Stevens, Thomas. *Around the World on a Bicycle*. London: Sampson, Low, Marston, Searle, and Rivington, 1887 and 1888.

Taylor, "Major" Marshall W. *The Fastest Bicycle Rider In The World*. Worcester, Mass.: Wormley Publishing Co., 1928. Reprinted, Freeport, New York: Books For Libraries Press, 1971.

Ulreich, Walter. *Das Steyr-Waffenrad*. Hinterbrühl, Austria: Weishaupt-Verlag, 1995.

Vant, André. *L'Industrie du Cycle Dans la Région Stéphanoise*. Lyon: Editions Lyonnaise d'Art et d'Histoire, 1993.

Variable Gears. compiled and illustrated by staff of *Cycling*, c. 1909. Reprinted, Birmingham, U.K.: Pinkerton Press, 1986.

Velox [Tom Burgess]. *Velocipedes, Bicycles and Tricycles*. London: Routledge, 1869.

Watts, Heather. *Silent Steeds, Cycling in Nova Scotia to 1900*. Halifax: Nova Scotia Museum, 1985.

The Wheelmen Magazine of The Wheelmen, U.S.A., 1970–96.

Willard, Frances E. *How I Learned to Ride the Bicycle*. Sunnyvale, Calif.: Fair Oaks Publishing, 1991.

Williams, Edward. *A Bibliography of Cycling Books*. Warwick, U.K.: National Cycle Archive (CTC), Warwick University, 1993.

Wilson, David Gordon, and Whitt, Frank Rowland. *Bicycling Science*. Cambridge, Mass.: MIT Press, 1982 and 1990.

Wolf, Wilhelm. *Fahrrad und Radfahrer*. Leipzig: Verlag und Drud von Otto Spamer, 1890. Reprint. Die Bibliophilen Taschenbücher, 1980.

Woodforde, John. *The Story of the Bicycle*. London: Routledge and Kegan Paul, 1970.

Picture Credits

p. 184: ©Hulton Deutsch; p. 185: Coos Dam; p. 186: © Le Tour de l'Ile de Montréal/Jean-François Leblanc (top), ©Le Tour de l'Ile de Montréal/Jean-François Leblanc (bottom); p. 187: Courtesy Transportation Alternatives, New York; p. 188: © Mousse/Reuter/MAXPPP (top), © George T. Nelson/Transportation Alternatives (bottom); p. 191: Courtesy Transportation Alternatives, New York; p. 193: © Wang Wenlan/The Bicycle Network; p. 195: © Frans Stoppelman/The Bicycle Network (left), © Wang Wenlan/The Bicycle Network (right); p. 196: © Agence VU/Manuel Vimenet; p. 198: © Wang Wenlan/The Bicycle Network; p. 199: © Terry Frost/The Bicycle Network (left), © AFP/Adalberto Roque (right); p. 202: © Wende Cragg; p. 203: © Gary Fisher; p. 204: © Wende Cragg (left); © Larry Cragg (right); p. 206: Suffolk County Historical Society; p. 207: all col. & photo PD; p. 208: © Times/Mirror Group (top left); col. Jacques Borgé (top center); col. Jacques Borgé (top right); col. & photo PD (bottom); p. 209: col. Jacques Borgé (top); © Hulton Deutsch (bottom); p. 210: © Don Monroe (top left); Reproduced with permission of the International Herald Tribune, Paris (right), © Florida Atlantic University (bottom left); p. 211: col. & photo PD; (top), © Steve Finberg (bottom); p. 212: © RMN/G. Blot; p. 213: © ADAGP/Larry Massing; p. 214: © Paul Kolnik; p. 215: © Hulton Deutsch; p. 216: © Friedemann Simon; p. 217: © Friedemann Simon (top), © Friedemann Simon (right center), ©Friedemann Simon (bottom right), © Eric and Deborah Staller (bottom left), © Gunar Binde/The Bicycle Network (center left); back jacket. (top to bottom) Fürstlich Fürstenbergisches Archiv, Donaueschingen, Germany; col. & photo PD; col PD, photo Photographic Concepts; col. & photo PD; col. & photo PD; © Gary Fisher.

Poetry Sources

p. 11 Ján Kollár, *Slavy dcera*, [Slavic daughter], 1817.

p. 23 Blackwoods Magazine, May 1821.

p. 25 A.S.G., *Original Poetic Effusions*, Boston, 1822.

p. 30 Refrain from *Le Vélocipède*, with words by Alfred Poullion and music by Achille Campisiano, 1869.

p. 57 Walter Parke, *Songs of Singularity*, 1874.

ISBN: 2-08013-551-1

Numéro d'édition: 1114

Dépôt légal: April 1996

Acknowledgments

I am very grateful to a substantial number of people and organizations who in various ways assisted me with this book.

Efforts to research methodically all aspects of cycling history began in 1955 with the formation of the Southern Veteran-Cycle Club (now Veteran Cycle-Club) in England, and the creation of its journal, *The Boneshaker*. This periodical, with Derek Roberts as editor and principal contributor for its first 21 years, is the first to be devoted to cycling history. In the USA, The Wheelmen, a club modeled on the SV-CC, and "dedicated to the enjoyment of our bicycling heritage: riding, collecting, restoring, research, history," was founded in 1967, and offered its members a similar magazine, called *The Wheelmen*. From 1990, International Cycling History Conferences have been held annually in various countries, further stimulating research in the subject. I am grateful to this international network of historians for the speed with which they answered my detailed queries. Most of those to whom I am indebted helped in many different ways, from general information, to access to their collections. In the following list, however, there is room only to mention their main contribution.

Those people to whom I am particularly grateful for their time and efforts are Edward Berry, Joe Breeze, Nicholas Clayton, Leon Dixon, John Dowlin, Fred Fisk, Georg Goerlipp, David Herlihy, Keizo Kobayashi, Serge Laget, Professor Hans-Erhard Lessing, Charles Meinart, Gert-Jan Moed, Andrew Ritchie, Jacques Seray, Glynn Stockdale, and Carl S. Wiedman.

With the help of fellow collectors and other repositories of bicycle material who graciously allowed me to reproduce numerous interesting items, I was able to enhance the scope and quality of this book beyond my personal collection. I would like to thank Walter Branche, Peter Card, Wende Cragg, Russell Mamone, Gérard Salmon, Pascal Sergent, Roger Street, Linda Toppin, Walter Ulreich, Bibendum Restaurant, Bicycle Museum of America, Galerie de l'Imagerie, Library of Congress, Mark Hall Museum, Musée d'Art et d'Industrie de Saint-Etienne, National Woman's Christian Temperance Union, Smithsonian Institution, Transportation Alternatives, Tabley House, and Vélo Québec.

The authors of the periodical articles cited in the text are as follows:
The Boneshaker: Roy Barrett, Les Bowerman, A. B. Demaus, Alastair Dodds, W. W. Eades, Allen Hawkes, Raymond Henry, Richard D. Katz, H. J. Maynard, E. B. Parker, Bob Rolfe, Ron Shepherd, Aad Streng, Dick Swann, Dave E. Twitchett, 'Alf Wheeler, Frank R. Whitt.
The Wheelmen: Frank Cameron, Roland C. Geist, Edwin G. Gerling, Irving A. Leonard, Larry Schmidt, D. E. Twitchett.
Proceedings of the International Cycle History Conferences: Nadine Besse, Les Bowerman, Alastair Dodds, Augusto Marinoni, Andrew Millward, Nicholas Oddy, Rüdiger Rabenstein.

I received very helpful additional information from Arianne Boris, Dr. Volker Briese, Marti Daly, Karl Edwards, Gary Fisher, Gork (Craig Barrette), H. David Higman, Charlie Kelly, Bill Kline, Jan Králík, Alexandra Lapierre, Gerry Moore, Albert A. Pope (Col. A. Pope's great-grandson), Claude Reynaud, Charlie Sewell, and Otis Taylor.

In the very important area of information and research on bicycle advocacy, I am grateful to George Haikalis, Walter Hook, Brian Ketcham, Charles Komanoff, Karen Overton, Bob Silverman, and Steve Stollman.

I would also like to thank the following people who were of help in a variety of ways: Don Adams, Steve Bagley, Norman Batho, Carlos Brillembourg, Jacques Borgé, Patrice Brunet, Elli Buk, Max Cardillo, David Comey, Jacques Coupry, Jean-Denys Devauges, Jim Hurd, Ralph Igler, Meg Kaufman, John McVey, Peter Mann, Douglas Marchant, David Mozer, David Patton, John Pinkerton, Sid Pultorak, Melissa Roberts, Olivier de la Rosière, Philip Saunders, Lawrence L. Stitt, Michael Vitucci, Graham Williams and Roger B. White.

Finally, at Flammarion I would like to thank my editor Suzanne Tise for commissioning this book, and I am also grateful to Philippa Hurd and Diana Groven for their help.

Publisher's Acknowledgments

The Publisher would like to thank Peter Sahlins for his considerable assistance in the preparation of the manuscript.